Architectural Conservation and Restoration in Norway and Russia

Norway and Russia have been closely related through the ages, both geographically and historically, and have experienced similar problems relating to climate, building maintenance and national wooden architecture. As a result, the parallel study of architectural conservation and restoration theories and practices in both neighbouring Northern states makes for a stimulating collective monograph.

Architectural Conservation and Restoration in Norway and Russia delves into the main challenges of historic and contemporary architectural preservation practices in the two countries. The book consists of three main parts: the discovery and preservation of historical architecture in the late nineteenth to early twentieth century; contemporary approaches to former restorations and the conservation and maintenance of historical architecture; and, finally, current questions concerning preservation of twentieth-century architectural heritage which, due to different building technologies and artistic qualities, demand revised methods and historical evaluation.

This is a valuable resource for academics, researchers and students in different areas of architecture (medieval, nineteenth-century, wooden and contemporary architecture) as well as in the fields of art, architectural history, cultural heritage and Scandinavian and Russian studies.

Evgeny Khodakovsky is Head of the Department of Russian Art History at St Petersburg State University, Russia.

Siri Skjold Lexau is Professor of Art History at the University of Bergen, Norway.

Routledge Research in Architectural Conservation and Historic Preservation

The Routledge Research in Architectural Conservation and Historic Preservation series provides the reader with the latest scholarship in the field of building conservation. The series publishes research from across the globe and covers areas as diverse as restoration techniques, preservation theory, technology, digital reconstruction, structures, materials, details, case studies, and much more. By making these studies available to the worldwide academic community, the series aims to promote quality architectural preservation research.

https://www.routledge.com/architecture/series/RRACHP

Architectural Conservation and Restoration in Norway and Russia
Edited by Evgeny Khodakovsky and Siri Skjold Lexau

Architectural Conservation and Restoration in Norway and Russia

Edited by
Evgeny Khodakovsky and
Siri Skjold Lexau

Routledge
Taylor & Francis Group

LONDON AND NEW YORK

First published 2018 by Routledge

2 Park Square, Milton Park, Abingdon, Oxfordshire OX14 4RN
52 Vanderbilt Avenue, New York, NY 10017

Routledge is an imprint of the Taylor & Francis Group, an informa business

First issued in paperback 2018

British Library Cataloguing-in-Publication Data
A catalogue record for this book is available from the British Library

Library of Congress Cataloging-in-Publication Data
Names: Khodakovsky, Evgeny, editor. | Lexau, Siri Skjold, 1951– editor.
Title: Architectural conservation and restoration in Norway and Russia /
 edited by Evgeny Khodakovsky and Siri Skjold Lexau.
Description: New York : Routledge, 2017. | Includes bibliographical
 references.
Identifiers: LCCN 2017016569 | ISBN 9781138279926 (hb) |
 ISBN 9781315276205 (ebook)
Subjects: LCSH: Architecture—Conservation and restoration—Norway. |
 Architecture—Conservation and restoration—Russia (Federation)
Classification: LCC NA109.N8 A73 2017 | DDC 720.28/8—dc23
LC record available at https://lccn.loc.gov/2017016569

ISBN: 978-1-138-27992-6 (hbk)
ISBN: 978-0-367-20802-8 (pbk)

Typeset in Goudy
by Apex CoVantage, LLC

Contents

Figures

Editors

Evgeny Khodakovsky is the Head of the Department of Russian Art History at St Petersburg State University, Russia. He lectures on the history of the art and architecture of the Russian North, Russian Medieval Art, folk art, wooden architecture and the history of restoration in Russia and Europe.

Siri Skjold Lexau is Professor of Art History at the Department of Linguistic, Literary and Aesthetic Studies, University of Bergen, Norway. Her primary research activity is linked to the history of architecture and urban studies. She has published widely on the history of transformation of sites and buildings.

Contributors

Ilya Antipov, Assistant Professor, PhD at the Department of the History of Russian Art, St Petersburg State University. The main topic of his research is the history of Old Russian architecture, building materials and technology. He has conducted archaeological investigations on many monuments of Novgorodian architecture of twelfth to seventeenth centuries. Laureate of the Prize of the Government of Russia (2015).

Andrei Bode, Architect-Restorer, PhD in Architecture. Researcher at the Institute of Theory and History of Architecture and Urban Planning, Moscow. Research and creative interests: history of wooden architecture, ancient traditions. Author of books and articles on the wooden architecture of Russia and problems of restoration.

Ksenia Chemesova, independent researcher. She holds a Master's Degree in Art History from St Petersburg State University. Her fields of interests are the medieval architecture of Scandinavia and Western Europe, as well as restoration history.

Hans-Henrik Egede-Nissen is a cultural heritage conservation officer at the Norwegian Defence Estates Agency. His PhD thesis (2014) from the Oslo School of Architecture and Design raises questions about the universal relevance of authenticity. He takes a particular interest in nineteenth-century architecture as well as military architecture from all periods.

Emilia Khodinitu, Public Relations Manager, Department of Marketing, the Palace of Culture for Educators – the Yusupov Palace, St Petersburg, Russia. Her fields of interests are contemporary museum architecture, urban planning, museum management, digital museum learning.

Daria Liubimova, independent researcher. Her primary research interest is the history of Soviet architecture from early constructivist theories to the city-planning and urban development of the 1950s–1960s.

Maria Medvedeva, Head of the Research Archive at the Institute for the History of Material Culture, Russian Academy of Sciences. She holds a PhD in

History. Her main fields of interest are the archival research and the cultural heritage management in the Russian Empire and early Soviet Russia.

Dag Myklebust, former Senior Adviser at the Norwegian Directorate of Cultural Heritage. He has a Master's Degree in Art History, and from 1984 he worked with Building Preservation in the Directorate. From 1991 on, he shifted to international work, representing Norway in the Cultural Heritage Committee in the Council of Europe. Between 1995 and 2010, he was the leading specialist in the Norwegian-Russian co-operation on Cultural Heritage Protection. He provides research on the early history of the Norwegian Directorate of Cultural Heritage.

Arina Noskova, Research Fellow and the Scientific Secretary of the Department of the Wooden Architecture at the Scientific-Research Institute of the Theory and History of Architecture and Urban Planning. She specializes in wooden ecclesiastical architecture of north-western Russia and archival research.

Per Schjelderup, Restoration Architect, Schjelderup & Gram Architects, Stavanger. Associate professor at the Faculty of Arts and Humanities, University of Stavanger. He is, together with partner Live Gram, responsible for several cultural heritage restorations of national significance.

Ekaterina Staniukovich-Denisova, Senior Lecturer at the Department of Russian Art History, St Petersburg State University. Her main fields of interest are the architecture of St Petersburg of the eighteenth and nineteenth centuries, Russian-European relationships in art and culture, Swedish and Finnish architecture, archival collections, city-planning and culture heritage.

Dmitriy Yakovlev, Project Architect at the Central Scientific-Restoration Project Workshops (Moscow), Historian of Architecture, a member of the Union of Restorers of Russia, Laureate of the Prize of the Government of Russia (2015). His projects are mostly related to the Russian medieval architecture (Moscow, Novgorod the Great, Solovetsky monastery).

The Northern neighbours and their heritage

A Russian-Norwegian cultural millennium

Evgeny Khodakovsky and Siri Skjold Lexau

The joint view taken by art historians and restorers from Russia and Norway of the tasks of studying and preserving monuments of architecture and urban planning that is presented in this book is shaped by several factors. In the early twenty-first century, the two countries have a long-shared journey behind them, and, looking back, it is possible to state with confidence that this journey has been a millennium not only of geographical and economic but also of cultural interaction. A location on the remote northern and north-eastern periphery of the continent, which by the end of the first millennium had come through the extremely important stage of antiquity and even managed to begin to interpret it in the era of the Carolingian Renaissance, meant a relatively late entry into the European cultural space for Norway and Russia. When, around the year 1300, Dante listed representatives of the peoples of Europe in the *Divine Comedy* and delineated the bounds of the medieval oecumene, the Italian put Portugal on its western fringes, Serbia on the East and Norway in the North (*Paradiso*, XIX, 139). So, for him, Norway symbolically represented the northernmost, remotest extremity of Europe.

Russia began to open up to foreign travellers even later, only in the late fifteenth century, at the same time as it freed itself from subservience to the Golden Horde. As a result of this "peripherality" (from the viewpoint of the Italo-centric or classical vision of the development of art and culture in Europe), many processes in the two countries took place almost simultaneously, and the character of those phenomena was akin in many ways. For example, Russia and Norway adopted Christianity from their older "godmothers" – Byzantium and Britain respectively. Together with the Greek and British clergy who set off on their mission to Rus' or Scandinavia by ship (across the North or Black Sea), both countries adopted architectural and artistic traditions that became the basis for the distinctive national character of medieval art in Russia and Norway. The Cathedral of St Swithun in Stavanger, the restoration of which is the subject of Chapter 5 in this book, still bears testament to this English impulse. The process of Christianization took place almost simultaneously in the two countries – over the course of the eleventh century, gradually overcoming paganism that went underground. Both countries laid strong foundations for the subsequent centuries-long development of wooden architecture, and the review of joint work in the sphere

of preserving our wooden heritage given in Chapter 9 represents a sort of symbolic coming together of two great timber-building traditions. The twelfth century in both Russia and Norway saw an upsurge of masonry construction, some of it under the influence of the pan-European Romanesque style. Finally, geographical proximity, the convenience and speed of the water routes across the Baltic connecting Scandinavia and Rus', was conducive to the Nordic factor becoming from the first an extremely important motive force in Russian history. For example, according to several medieval Scandinavian sources, Olaf Trygvasson was in the service of Prince Vladimir back in the 980s, and in the historic memory of Scandinavia the constructive union of those two great figures, associated with the arrival of Christianity in each of their countries, would find reflection in the legendary prophecy about Olaf's future that Prince Vladimir's mother supposedly made to her son:

> I do see a great and momentous sight. At this time in this year has been born a prince in Norway who will be fostered in this land. He will become a distinguished man and a glorious leader, and he will do no harm to your realm. But rather he will give it manifold increase on your behalf. Then he will return to his land still young in years and acquire the kingdom he is born to rule. He will be a king and shine brightly, and he will come to the aid of many men in the northern regions of the world.[1]

Then, the sojourn in the late 1020s of King Olaf the Saint of Norway and his son Magnus in Novgorod, at the court of Prince Iaroslav and his wife Irina (Ingegerd), became one of the early emblematic examples of how the historic courses of Russia and Norway interwove. The memory of that event endured for a long time in Novgorod, where soon after Olaf's canonization a church appeared dedicated to the new saint, and it was symbolic, too, that Olaf became a saint of a still-undivided Christian Church. Common approaches and aims brought the positions of Russians and Norwegians together later as well. In 1251, when Norway was ruled by the great monarch Haakon the Old, the *Rex Insularum* whose power extended across practically the whole North Atlantic, while Novgorod continued to rely on the illustrious Prince Alexander Nevsky to represent and defend it, a treaty was concluded between Rus' and Norway demarcating their border in the Kola region. The negotiated, rather than military, determination of zones of influence speaks of the high cultural standard of relations between the two peoples. The treaty of 1251 was reconfirmed by a new agreement in 1326. For a long time, Russia and Norway, which was part of the Kingdom of Denmark, practiced a sort of "dual hegemony" in Finnmark, effectively ruling the territory jointly and each collecting tribute from the natives. A few years after the adoption of the Norwegian Constitution at Eidsvoll in 1814 (see Chapter 8), a new boundary treaty was concluded in 1826, and the line of the border was not called into question even in the highly complex period at the end of the Second World War. Thus, the frontier between the present-day Russian Federation and the Kingdom of Norway is the oldest of all Russia's land borders despite the convoluted twists and turns of Northern European history over recent centuries.

The intensive development of contacts between Russia and Norway in the tenth to fourteenth centuries was later checked by unfavourable factors: the conclusion of the Union of Calmar in 1397 effectively meant that Norway lost its independence. In the political sphere it was Denmark that assumed the dominant role in Scandinavia, while economically it was the Hanseatic League, which promoted not only German financial interests but also German architecture and art. To this day, the Hanseatic influence determines the distinctive look of construction in Bergen. Back then, that influence made itself felt not only in western Norway but also in Novgorod, creating a common commercial-and-economic and cultural zone embracing Norway and north-western Rus'. Novgorod, which still retained its presence in the Baltic, demonstrated extremely close contacts with the region, not least by the fact that in 1433 Archbishop Efimii brought in German craftsmen to build his palace in the Novgorod kremlin. The history and restoration of that unique edifice, the only example of medieval North German Gothic architecture on Russian soil, is presented in Chapter 6 and, alongside the analysis of the restoration of St. Swithun's Cathedral in Stavanger, reveals distinctive features of the approaches to the restoration of medieval masonry structures taken by present-day Russian and Norwegian architects.

From the late sixteenth century right up to the foundation of Saint Petersburg in 1703, Russia had no access to the Baltic Sea, but that did not sever ties between the two countries. On the contrary, while in the Baltic at that time the dominant role was played by Sweden, the active use of the Barents and Norwegian Seas by Russian merchants and mariners to bypass the Baltic provided direct, rapid communication between the Russian North and the Norwegian coast. The bulk of trade between Muscovy and Europe took place along that very route, around the top of the Scandinavian peninsula. The appearance of Saint Petersburg in the mouth of the Neva as a new capital and a port on the Baltic transformed the economic configuration of the Russian North, but it could not completely end those long-standing ties that had become established between the northern neighbours. Trade, commerce, fishing and timber all furthered the formation of a special northern Russo-Norwegian zone that even developed its own pidgin language – Russenorsk, while in churchyards in both countries one often finds gravestones bearing Russian and Norwegian surnames.

Our two peoples are linked too by a spirit of exploration and discovery: back in the early Modern Era, Russians and Norwegians reached the edge of the world – Spitsbergen. Russian and Norwegian winter camps existed on the Svalbard archipelago, where survival is only possible if you help one another. Despite the fact that for the past century both countries have viewed the place chiefly as a source of mineral resources, today another vector in the development of the territory is also emerging: abandoned settlements are becoming platforms for extremely interesting experimental architectural projects, making it possible to speak of a modern, distinctively "Arctic" aspect to the question of evaluating and preserving heritage (see Chapter 13).

After the adoption of the Constitution in 1814, Norway still had a long way to travel over almost a century before regaining its independence. It was a journey

that involved not only political construction but also a gradual, steady recognition of the nation's cultural identity. In the 1830s–1860s, publications on medieval Norwegian buildings by Dahl in German and Nicolaysen in English made the country's architecture accessible not only to Europeans but also to the Russian scholarly community. As early as the 1870s and 1880s, Norway was visited by prominent Russian architects and restorers, such as Ieronim Kitner and Vladimir Suslov, who not only acquainted Russian readers with the architectural monuments of the Scandinavian country but also put forward a first attempt to understand them in the broad context of Russian and European construction (see Chapter 1). This acquaintance swiftly had an effect too in the special "Northern" character of Russian wooden architecture around the turn of the twentieth century, which in parallel with the masonry Finno-Swedish Jugendstil in Saint Petersburg architecture produced extremely interesting examples of the "Dragon Style" in timber edifices from the suburbs of the capital of the Russian Empire to distant Tomsk in Siberia (Chapter 2). It is not surprising that the long-standing ties, almost of kinship, between the Russian North and the Barents region caused Savva Mamontov to turn his attention to Norway, and he came to regard the country as a sort of model for provision of the necessary economic infrastructure and the creation of a road network. Such a rapid and profound response could not have taken place if there had not been such a deep-seated mutual understanding of old between the cultures of Russia and Norway.

It was at just this time that Norway left the union with Sweden and acquired its independence. Russia was one of the first countries to recognize the new state, and that again was in keeping with the old, positive traditions of peaceful coexistence and mutual respect. In the middle of the twentieth century, relations between the two countries stood up with honour to the test under the difficult conditions of the Second World War: on 7 October 1944, Soviet forces entered Northern Norway to liberate it from the Nazis and, having fulfilled their mission, withdrew after less than a year, on 16 September 1945, reinstating the historical border between the two countries and reaffirming commitment to the treaties of 1251, 1326 and 1826.

In the second half of the twentieth century, the welfare state model that formed the basis of the Norwegian, and more generally Scandinavian, economic and social system gave rise in both our countries to the phenomenon of social housing (see Chapters 10 and 11). At one time the idea even went around that it was after a visit to Norway that Nikita Khrushchev adopted the idea of mass housing construction that would make it possible to do away with communal living and give every Soviet family its own separate apartment. Although Khrushchev visited Norway only shortly before he was ousted in 1964, while the construction of *khrushchevki* began back in 1955, the similar character of social housing in Soviet Russia and Norway can be explained. It is connected not only with the Socialist paradigm but also in part with the distinctive role played by the rural populace of both countries, who in a process of urbanization began to actively move into the major cities. Of course, the scale of this phenomenon was completely different in Russia and Norway, and the numbers involved are incommensurable, but in this

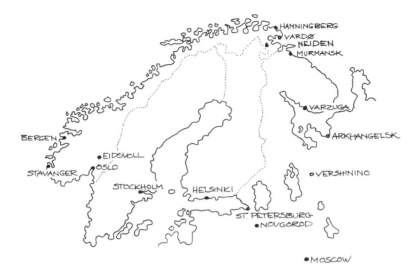

Figure 0.1 Architectural conservation and restoration in Norway and Russia: an overview
 map. Drawing: Siri Skjold Lexau.

context it is necessary to note the common agrarian aspect to the history of both
countries in the preceding period as a background to those radical changes that
took place in public thinking in the post-war era. This in turn casts a wholly new
light on the question of how we should view the architecture of the second half
of the twentieth century – not as "the burden of errors of the past" (especially
when speaking of the Soviet past) but specifically as heritage to which terms such
as "hated" or "neglected" cannot be applied. The post-war architecture brought
substantially better living conditions to people with average income, who earlier
had to cope with overpopulated rooms and with bad sanitary standards and water
supply.

The fall of the Iron Curtain in 1991 reopened the border between Russia and
Norway, and the frontier that follows practically the same line agreed between
the representatives of Haakon the Old and Alexander Nevsky in the mid-
thirteenth century even has a special arrangement now, allowing inhabitants of
the immediate border areas visa-free crossing in both directions. It is very impor-
tant to stress that Russia and Norway are in contact not only in the fields of oil
and gas production, fisheries and marine biology. Collaboration in the humani-
ties and in education is also developing strongly. Work on this book, too, was
made possible through the support of the Norwegian Centre for Internationaliza-
tion in Education (SIU) as part of the project of collaboration between the Uni-
versity of Bergen and Saint Petersburg University, both leading institutions of

higher education in their respective countries. The book combines the efforts of teams of art historians and architects in Russia and Norway in the field of the restoration of architectural monuments. They look back into the past, analyze present-day practice and raise questions that have not previously come up because a considerable stratum of twentieth-century architecture is still not perceived as "heritage" in the customary sense. We would like to think that this joining of forces is no chance occurrence but rather destined to become one of the symbolic embodiments and a logical continuation of that long-standing tradition of working together that can with pride and joy be described as the Russian-Norwegian Cultural Millennium.

Siri Skjold Lexau, Evgeny Khodakovsky
Bergen – St. Petersburg, 21 March 2017

Note

1 Oddr Snorrason, *The saga of Olaf Tryggvason*. Translated from the Icelandic with Introduction and Notes by Th. M. Andersson. Ithaca: Cornell University Press, 2003.

Part I

Nation building, assessment of historic monuments and cultural heritage management

1 Norwegian medieval architecture in Russian accounts (late nineteenth to early twentieth century)

Evgeny Khodakovsky and Arina Noskova

After the gradual decline of Late Classicism in Russian architecture in the mid-nineteenth century, a search for new paths of development began in the ideological atmosphere prevailing in the reign of Nicholas I (1825–1855), who personally encouraged people to look to national and medieval heritage. Nevertheless, the origins of that heritage were a matter for great discussion among Russian scholars. The *Western* tendency dominant in Russian architecture since the Petrine revolution of the early eighteenth century was challenged by three others – *Oriental*, *Southern* and, of most interest for our present topic, *Nordic*.

Indeed, in the 1860s–1880s, the "Early Russian" trend, represented by Konstantin Thon and his outstanding Cathedral of Christ the Saviour in Moscow (constructed in 1839–1883), raised the question of the nature of Russian medieval art itself, positioned between the European and Eastern worlds. The most influential book to discuss this matter was Eugene Viollet-le-Duc's *L'Art Russe*, published in 1877, where the subject of *Ex Oriente lux* in Russian architecture is examined in detail. Although today considered old-fashioned and naïve, this publication encapsulated the general idea of an Oriental impact on Russian national tradition.

At the same time, the Southern or "Byzantine" source for Russian art was provided by Prince Grigorii Gagarin (1810–1893), whose research into Byzantine and Caucasian ornaments and architecture laid the foundation for the Russo-Byzantine style in the late nineteenth century, the taste for which was bolstered by the Russo-Turkish War of 1877–1878 in the Balkans. This tendency naturally merged with the general Oriental trend and viewed Russian art within a general system of Byzantine and Eastern artistic culture.

The powerful Oriental and Southern trends tended to overshadow the *Nordic* line of Russian scholarly interest, which can be traced back to the late 1850s and early 1860s. Yet this Scandinavian aspect appears entirely natural, given Russia's geographical location and its traditional "Northern", even specifically Scandinavian, identity, which came to the fore after the great celebrations for Russia's *Millennium* in 1862, measured from the arrival of the Scandinavian prince Riurik and his brothers, mentioned in the chronicles under the year of 862. In this respect, the accounts of Russian travellers, especially architects, who paid particular attention to the national specifics of medieval Norwegian buildings, are of great importance.

The first Russian architect to professionally examine the character of Nordic medieval architecture in the broad context of European art was Ieronim Kitner (1839–1929), who visited Norway for the first time in 1861. Kitner would become an outstanding figure in St Petersburg artistic life in the late nineteenth century and is known for his buildings and also for teaching at the Institute of Civil Engineers.

His accounts of Scandinavia were published in the magazine *Zodchii* (The Architect) in 1872 and 1874 and present a detailed survey of Norwegian wooden architecture (see Appendix). Recalling his journey in 1861 and opening up this direction for architectural history in Russia, Kitner wrote:

> The idea of a journey with an architectural purpose around such a country as Norway may seem at first sight somewhat paradoxical, but on closer acquaintance with this country, apparently totally isolated from the rest of Europe, it emerges that construction practice has always been quite successful on the Scandinavian peninsula and today, too, it does not lag behind the other states of our continent.
>
> (Kitner 1874: 141)

It is remarkable that Kitner manifested his interest and shared it with contemporary readers almost at the same time as Nicolay Nicolaysen was extensively exploring the stave churches of Norway and making them accessible through his drawings and measurements. Indeed, Kitner gives references to publications by J.C. Dahl (1788–1857) and N. Nicolaysen (1817–1911), whose role in spreading knowledge of Norwegian wooden architecture internationally is indisputable. The significance of Kitner's notes goes further, however, due to his historical assessment of the Nordic phenomena; his account echoes the discussions on the course of development of architecture in Russia, like Norway on the periphery of Europe, and its possible openness to various influences:

> A closer acquaintance with Norwegian wooden churches shows that for all their distinctive character they are, nonetheless, not purely Scandinavian architecture, but rather have traces of borrowing clearly to be seen in their construction and ornamentation. There can be no doubt that Romanesque prototypes had a certain amount of influence on the development of Norwegian architecture.
>
> (Kitner 1872: 26)

Being a child of his time, Kitner brings in the Oriental aspect here as well, linking some of the decorations with the possible Eastern influences:

> The patterns in some decorations are reminiscent of the most ancient ornaments of the Northern pagan world, carried thither perhaps as a tradition of the Goths from Asia.
>
> (Kitner 1872: 26)

At the same time, Kitner makes a noteworthy observation relating to Byzantine features in Norwegian stave church architecture, pointing out:

> The centralized plan and general arrangement of the parts bear the mark of Byzantine influence, which is to some degree explained by the Norsemen's contact with the Greeks back in the times when the Varangians waged their campaigns against Constantinople by way of Early Rus'.
>
> (Kitner 1872: 26)

Finally, discussing the Urnes carvings on the columns in the nave, he compares them to illuminated manuscripts, pointing in the right direction for the discussion of the origins of these masterpieces of Norwegian medieval art. Kitner expressed concern about the evident tendency to renovate the old wooden structures, advocating the idea of preserving these unique masterpieces:

> If the centuries have spared these edifices, then our own time should exert every care for their preservation, otherwise, under the influence of the spirit of innovation and change that is constantly growing in society, they might easily disappear altogether and we shall be forever deprived of the precious remnants of old Norwegian architecture.
>
> (Kitner 1872: 26)

Thus, the first professional accounts made by a Russian architect of Norwegian stave churches indicate highly important directions for the further study of the subject, such as the European (Romanesque) context, external influences (Byzantine, Oriental), and the carvings in their relation to manuscript tradition, and, most significantly, they also express a sincere and deep concern for the past, proclaiming the necessity for preservation and maintenance, which was not so evident in that period.

It is not surprising that in Russia, where from the early 1870s an interest in the country's own wooden architecture had been emerging ever more strongly, attempts were almost immediately made to view Russian wooden construction in the broadest context of European architecture. A historical and comparative review of Scandinavian wooden architecture was presented by Count Alexei Uvarov (1825–1884), whose name is one of the best known in mid-nineteenth-century Russian archaeology. He is remarkable for his extensive researches into the antiquities of Southern Russia in the Crimea, as well as early burial mounds in the Suzdal area. Uvarov played an essential role in organizing and administrating archaeological researches in Russia. He was one of the founders of the Moscow Archaeological Society and also the first person to put forward the idea of archaeological congresses, bringing scholars together to share their research. Uvarov's paper *On the Architecture of the First Wooden Churches in Russia*, presented at the 2nd Archaeological Congress in 1871, can be considered a pioneering attempt to comprehend the phenomenon of wooden architecture of Christian Europe in general, beyond the borders of the Russian lands. Uvarov

compares the chronology of church construction in Russia and Scandinavia in the tenth and eleventh centuries, at the time of Harald Bluetooth, Olaf the Saint and Harald Hardråde. In his survey, the count focusses on the principal difference between Slavic and Scandinavian building techniques, explaining in detail the method of vertical stave frame construction. Both Uvarov and Kitner refer to Nicolaysen's drawings of Hurum (Høre) stave church as a typical example of this kind of architecture. Uvarov claims that stave construction is best suited to elongated buildings, such as basilicas, finding confirmation in a reference to King Cnut's "*in lignea basilica*" in medieval sources. The Slavic log framework, forming a rectangular volume of horizontal rows, produces quite another vector for the compositional development of the architectural space. Uvarov states that

> all these examples clearly show that both the actual method of building the Scandinavian churches and their outward appearance are entirely different from our churches and have nothing in common with them.
>
> (Uvarov 1876–1881: 8)

Indeed, the question of the relationship between the two traditions of building with wood in northern countries becomes of great importance, since Russia and Scandinavia seem to have similar conditions for the development of timber construction in terms of climate, types of forest, and close economic and political contacts in the Viking age and later. These factors made it very tempting to speculate about cross-currents and connections between Russian and Scandinavian timber buildings. In spite of the earlier hesitations on these issues, expressed by Count Uvarov, who had produced a theoretical study on Christian wooden building in Europe, his younger contemporary Vladimir Suslov applied to the Imperial Academy of Arts for finance to make a journey to Sweden, Norway and North Russia to gain empirical knowledge on the art of the neighbouring countries in relation to Russia's Northern art.

Suslov's journey resulted in a large book, *Travel Notes on Northern Norway and Russia*, published in St Petersburg in 1888. From the very beginning of his route, while exploring the art collections of Stockholm's Nordic Museum with the kind permission of Artur Hazelius himself, Suslov noted that pieces of peasant applied art (carved distaffs, cups, furniture and other household articles) were strikingly similar to ones he had seen previously while travelling in the Russian North, mentioning, among other things, a possible Indian origin for a pattern on a cup seen in both Russian and Scandinavian carvings. In church architecture, Suslov detected no likeness, linking the roots of Scandinavian architectural tradition with Western Europe, while he considered the way of decorating churches with fantastic images and plants to be of the local origin, dating back to the Bronze Age. Meanwhile, making his way north-westwards, Suslov displayed a great interest in the structure of Scandinavian farmhouses, since he was one of the first scholars to consider the question of peasant architecture in Russian architectural history. In this respect, his attitude to the neighbouring tradition was quite reasonable.

Suslov had his drawings printed in the margins of his book, depicting some of the most characteristic objects of Scandinavian architecture – the Swedish bell-tower in Oro, the ground-plan of a typical farmhouse, Borgund stave church, Trondheim fortress and barns. This first-hand Scandinavian experience was of great significance for Suslov, shaping a comprehensive approach to the study of Nordic artistic culture. Although he confirmed the earlier observation of Count Uvarov about the inherent differences between Russian and Scandinavian architecture, his close attention to detail and pattern brought him to a broader and deeper understanding of the nature of a wooden structure in general. In the late 1880s to early 1900s, he played a major role in researching historical buildings (both masonry and timber), making drawings, discovering historical records and, finally, revealing the wide panorama of Russian medieval architecture. His approaches to the task of working out the appearance of a traditional church could be compared with Peter Andreas Blix's restorations of the 1880s. Both Suslov and Blix cared for the past for the sake of its revival, evoking the deepest national feelings, making their contemporaries able to read the message of the traditional architectural form. Since most of the medieval objects in Norway and Russia suffered severe alterations and losses, hidden or damaged architectural details could distort the ideal look of a church, which in turn embodied the image of national history itself. This attitude, displayed by Eugene Viollet-le-Duc, was shared by most of the restorers of the nineteenth century and led to stylistic renovations of historical buildings.

Although Suslov had no direct contacts with Blix or Nicolaysen and hardly any of his restoration projects for wooden churches were actually implemented, they can be regarded in relation to a common approach to the task of revealing the image of the wooden church as an expression of a pure national style, accomplished by Blix and Nicolaysen in those culminatory decades in Norwegian history. A comparison of Blix's restoration in Hopperstad (1885–1891) and the series of projects devised by Suslov and published in the late 1890s (Suslov 1895–1901) clearly brings out shared principles of caring for the past, and balance between romantic stylization and an archaeological approach. They both draw on analogues, preserving the authentic details. Blix re-creates turret, dragons and gallery, which derive from the Borgund church. In designing the stepped porch for the Nenoksa church, Suslov was evidently inspired by the Maloshuika church that retained the characteristic *bochka* (barrel) roof in the mid-1880s. The proximity of the restored projects to these analogues was an important consideration: the location of Hopperstad and Borgund in the Sognefjord area, and of Nenoksa and Maloshuika on the White Sea coast, justify the inclusion of the specific corresponding features. But the most important and remarkable thing is that, in general, both Norwegian and Russian architects follow the stylistic approach of Viollet-le-Duc in their fantasies about the architectural form of the national wooden church, yet at the same time they follow the empirical, historical method by, for example, restoring the galleries from the traces of the joints.

Russian interest in the architectural heritage of neighbouring Norway was not, however, confined exclusively to works of wooden architecture. Norway of the era of Ibsen and Grieg, a country which was building up strength so as to be

reborn in 1905 as an independent, sovereign state, acquired in the eyes of Russian architects and ordinary travellers ever-greater individuality, while at the same time its ancient edifices were increasingly becoming perceived as a part of the history of common European architecture.

The sight mentioned ahead of any other by the authors of descriptions and guidebooks was unquestionably the grand cathedral in Trondheim, the ancient spiritual and political centre of Norway. Its restoration began in 1869 and became a symbolic reflection of the restoration of Norwegian statehood. Sof'ia Shil', the author (under the pen-name Sergei Orlovskii) of a guidebook to Scandinavia published shortly before the proclamation of Norway's independence, indicates that in that imposing edifice "at present much has already been restored and put right, so this cathedral is worth viewing" (Shil' 1903: 123; see also Appendix). As early as 1911, in the words of another Russian traveller,

> the majestic cathedral, constructed in 1160–88 by Bishop Øystein, stands in all its medieval splendour with its shapely vault and its pillars, where each stone has been carefully carved and put in its place. The Bishop's Palace is also a very interesting building.

> (Anon. 1911: 83)

In the 1910s, Russian travellers were strongly recommended to visit not only such well-known buildings as the cathedral in Trondheim but also Stavanger, "where another splendid cathedral has survived from the Middle Ages, giving us possibly a more powerful mood than any other church in Norway, despite the fact that it does not have the impressive grandeur of the cathedral in Trondheim" (Norvegiia s.a.: 51; see also Chapter 5 on the restoration of Stavanger cathedral), or Bergen to see "St. Mary's Church (the German Church), a reminder of German dominion in the city". Before the First World War, Russian-language guidebooks listed even such edifices as might seem of secondary significance, such as the monasteries of Lysekloster outside Bergen (Moskvich 1914: 269) and Selje in the Sogn region (Norvegiia s.a. 102), and also the ruins of the cathedral in Hamar (Norvegiia s.a.: 98).

These experiences of Russian travellers and their accounts of Scandinavian architectural monuments made a significant contribution to the study of Nordic art and culture as part of the search for a Northern identity in Russia and Scandinavia in the late nineteenth and early twentieth centuries; and at the same time this fresh insight developed into an interesting new tendency, forming the distinctive "Nordic" trend within Russian *Moderne* (Art Nouveau) architecture in the early twentieth century.

Appendix

Ieronim Kitner

The ancient wooden churches of Norway

Once as I was descending from a high mountain into a valley, I was suddenly struck by the picturesque silhouette of some structure presenting itself indistinctly in the distance. As I drew closer, the outlines of the building emerged ever more clearly and to my delight soon I could make out a wooden church with old architecture. It was one of those rare and interesting edifices that are all but the only presently surviving examples of ancient wooden constructions.

A closer acquaintance with Norwegian wooden churches shows that for all their distinctive character they are, nonetheless, not purely Scandinavian architecture, but rather have traces of borrowing clearly to be seen in their construction and ornamentation. There can be no doubt that Romanesque prototypes had a certain amount of influence on the development of Norwegian architecture, but its development in this direction was determined by the building material, i.e. wood, from which these structures were erected in Scandinavia. The patterns in some decorations are reminiscent of the most ancient ornaments of the Northern pagan world, carried thither perhaps as a tradition of the Goths from Asia. The centralized plan and general arrangement of the parts bear the mark of Byzantine influence, which is to some degree explained by the Norsemen's contact with the Greeks back in the times when the Varangians waged their campaigns against Constantinople by way of Early Rus'. The plan of the church takes the form of a regular rectangle, almost a square, surrounded almost on three sides by galleries, while of the fourth, facing East, it ends in a semicircular projection (apse) for the chancel. Quite often, to give the church greater capacity, projections are built on to the central part – as was done in Byzantine churches – giving the ground-plan the form of a cross. The upper walls of the church are supported by means of semicircular wooden arches on slender log pillars. In the middle part of the church, in all likelihood, there were previously open wooden rafters. Nowadays they have been replaced by wooden panelling in the form of a barrel vault.

The church that I am describing was of altogether very inconsiderable size (around 35 square sazhens [160m^2]). The surrounding galleries, covered with

steep shingle roofs with a large overhang, give these buildings a picturesque, totally distinctive appearance. Such an arrangement of roofs evidently had the aim of protecting the lower parts of the building from the influence of snow and provides at the same time a refuge for worshippers from inclement weather. The outward facing windows and doors, as well as the main body of the church, the aisles and nave, are covered with steep pitched (tent) roofs. Rising from the middle of the central roof is a four-cornered tower ending in a slender spire.

On the outside of the churches one finds artistic fanciful carved wooden patterns, with remarkable composition and exquisite execution. Quite often it is even possible to see painted ornament. The gables, window and door architraves, and all the conspicuous parts generally are covered with fanciful arabesques whose tracings are reminiscent of the flourishes in the most ancient manuscripts. . . .

Such in general terms are the wooden churches of old Norway. Many of them have managed in part to lose their original appearance due to alterations and various improvements. In more remote and impoverished places, though, where the locals gave little care to the upkeep of these precious structures, they have preserved their former appearance, full of an original character. Very often these were only minor (auxiliary) churches, where services were held a few times a year, and the task of maintaining them was the responsibility of the community or even individuals, who were satisfied to do no more than daub them outside with tar against atmospheric influences, which of course contributed considerably to their preservation. This circumstance alone is not, however, the reason that we see these churches in their original form: popular superstition, which would not permit reconstructions in them, saved for us the distinctive features of the Scandinavian sacred places and thus added a few interesting pages to the history of ancient art.

If the centuries have spared these edifices, then our own time should exert every care for their preservation, otherwise, under the influence of the spirit of innovation and change that is constantly growing in society, they might easily disappear altogether and we shall be forever deprived of the precious remnants of old Norwegian architecture. . . .

Ancient wooden churches of the type described can at present be found only in Norway. A few churches built of oak have admittedly survived in England, but they are dissimilar in ground plan and in decoration to the Norwegian ones. The latter are most like the rural Orthodox churches that existed in Russia at the time of Olearius's journey in the seventeenth century, although the differences in religion between the two peoples does not permit a complete resemblance between their places of worship. Russian churches take the form of *sruby* [cribs] in which logs are placed one on another horizontally. In Norwegian churches, on the contrary, the logs are set vertically. This difference in the placing of the beams can in part be explained by a difference in the properties of the varieties of wood that served as building material. In Russia people used pine logs, which are, as we know, prone to warping, and so they were laid in horizontal rows. The Norwegians, meanwhile, used oak for their structures, which is not prone to warping and therefore the posts could be placed upright.

The most famous of these churches are located in south-western Norway, specifically in Borgund, Hitterdal [now Heddal, Fig. 1.1], Tine [sic] and Urnes.

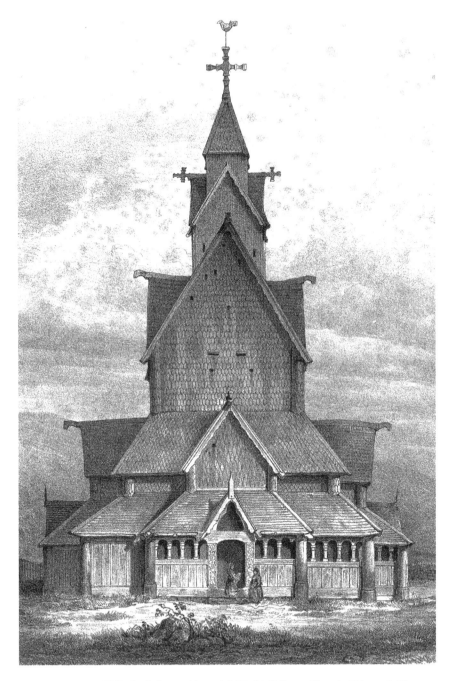

Figure 1.1 Frantz Wilhelm Schiertz. Hitterdal (Heddal) Stave Church, Telemark, Norway. Thirteenth century. (Dahl 1837, III: Tab. VI)

Due to reconstructions and improvements, the ancient church in Urnes has already lost its original character. Nevertheless, on the basis of certain extant details, it can be ranked alongside the highly remarkable Borgund and Hitterdal churches. On the surviving pillars one can see relief decorations that are exceptionally varied in their design. Probably not only these, but also the portals and all the boards were embellished with similar carving and only later replaced with smooth boards and plain pillars.

We know that medieval styles, Byzantine, Romanesque and also Gothic, permitted very great variety in the furnishing of details, and, since Norwegian architecture came under their influence, it is not surprising that we encounter the same thing here. In Norwegian buildings we do indeed find, for example, cornices, door frames and the like, that not only do not resemble one other, but even differ in length and breadth. A further possible explanation for this state of affairs might be that the Norwegians re-used material and decorations from previously demolished buildings in new constructions.

Norwegian churches are for the most part gloomy inside because light enters through windows placed quite high above the floor and additionally fitted with panes of glass painted with grey paints on a grey background, as was the custom of the time (the sixteenth and seventeenth centuries). The darkness inside them is increased still more by various extensions that do nothing to adorn the churches themselves. According to the testimony of the locals, the Urnes church was built in 1073, but later it was probably restored, which is borne out by the date 1663 in an inscription made on one of its bells. A fire that occurred in this church during a service and took the lives of almost all the congregation prompted a government order for the reconstruction of the doors in all churches. This measure, intended to protect people from danger and suffering the same fate as the parishioners of Urnes, had the most deleterious consequences for ancient Norwegian edifices.[1] Because of this order, the artistically precious portals and doors that were one of the chief adornments of the churches were destroyed. Only the small side doors, which were usually kept locked, were preserved.

There you have the few lines with which I intended to draw attention to ancient Norwegian architecture which has sunk into oblivion. Yet even today it presents us with examples in the form of buildings that are in parts still excellently preserved and inevitably attracting attention, both for the originality of their shapes and the beauty of the design of the details. After an existence of many centuries, they seem only to be waiting to receive a mention in the history of art so as then to disappear from the face of the earth, as something obsolete, but with a remarkable charm that does not come from age alone. . . . Our indifference would be unforgivable towards such remnants of ancient architecture that, having survived down to our own time and providing every opportunity for their study, were left without proper, thorough research, especially considering the nature of the material itself, which is easily destroyed and leaves no indications of the forms in which the ancient builder's idea was embodied. We are grateful to our forefathers for tarring the Norwegian edifices, but in using

that same method for their preservation we would scarcely be doing a favour to our descendants. An Egyptian obelisk or a Pompeiian vase will serve them as visual examples of ancient art, but a wooden church that has already stood for centuries can leave a memory of itself only in a description or a drawing. Sadly, though, research in respect of Norwegian architecture that finds expression in wooden structures, is limited to a few Swedish writings,[2] upon which we have drawn in part in compiling the present article, and even those works are now a bibliographical rarity.

(Kitner 1872: 25–27)

Count Alexei Uvarov

On the architecture of the first wooden churches in Russia

In the North, in Denmark, Sweden and Norway, wooden architecture also existed, but it had no influence, as we shall see further, on the method of constructing Russian churches.

In Denmark, after his conversion to Christianity, King Harald Bluetooth (936–980) built the first three wooden churches in Jutland, while the Church of the Prophet Elijah already existed then in Kiev.

Christianity was introduced in Norway at practically the same time as in Denmark. Olaf I Trygvasson (996–1000) was already a Christian, while Olaf II the Fat (1017–1030), later canonized, zealously engaged in converting the people to Christianity and constructed in his castle of Nidaros [Trondheim] the first wooden church, dedicated to Saint Clement. It was only from that time that Christianity began to develop in Norway, something that was probably furthered by the Scandinavians' constant dealings with Constantinople. We know, for example, that King Harald Hardråde (1047–1066), St. Olaf's half-brother, was for a long time the commander of the Varangians in Constantinople.

In England, Norway, Sweden and Denmark the churches, and even private houses, were built with upright timbers. . . . In the Scandinavian countries, due to the vertical placement of the timbers, the churches themselves came to be known as Stawkirken or Reiskirchen.

The walls were constructed of thick logs, set as vertically and linked together by slots into which part of the log fitted; besides which, the pillars at the corners and the foundation logs held the building together still more firmly. The whole upright structure of these churches can clearly be seen on the attached cross-section of the church in Hurum. This particular placement of logs and beams is especially convenient given the shape of the elongated churches of the ancient basilica type that was probably preferred over all others in the Scandinavian lands, as can be assumed from the diploma signed by the Dane Cnut (1016–1042) which contains the words "*in lignea basilica*". When, however, the builders sought to deviate from the long but narrow basilica shape, as, for example, in the

church at Burgund [Borgund], the structure of the roof became considerably more complex.

They had to make a single common roof, which with a square ground plan and a protruding sanctuary was highly inconvenient, or several small roofs, a separate one for each part of the building. In that case, the multitude of roofs, of different sizes and almost always with two slopes, gave the Scandinavian churches that distinctive outward appearance thanks to which the Burgund [Borgund] church in particularly stands out picturesquely from all other churches in other countries.

With the vertical placement of the timbers and pillars, the entire stability of the building depended on the firmness of those posts. Therefore in countries where they followed this building method, they took special measures to safeguard to posts from any deliberate damage. Thus some of the most ancient barbarian laws laid down harsh punishment for anyone who sawed into the main timbers in a building.

All these examples clearly show that both the actual method of building the Scandinavian churches and their outward appearance are entirely different from our churches and have nothing in common with them.

<div align="right">(Uvarov 1876-1881: 7–8)</div>

Sofia Shil'

On Trondheim cathedral

The most remarkable building in Trondheim is the cathedral. In this age-old cathedral, the kings of Norway are crowned. King Olaf the Saint was buried in ancient Nidaros and so in the eyes of the Norwegian people the city became the capital and holy place of the country.

The cathedral was built over many years. The masons and builders who began the cathedral grew old and died; a new generation, new people continued the work and decorated it in their own way. . . . In that way work on the building went on and on for over a hundred years, and the builders invested all their ardent faith and all their superstitions in it. Now the cathedral has already suffered from time, from fires and destructive wars. After all, it has been standing for seven centuries. Yet despite the fact that many of the adornments are somewhat marred and the walls are ruined in places, this cathedra still makes a powerful impression on one.

When the Lutheran faith spread in Norway, the locals took white lime and clay and daubed over the wonderful carvings covering the walls and pillars. It seemed to them that those depictions of people and plants desecrated a place of worship. They applied a thick layer over all the work that simple-hearted builders and masons had laboured upon in the olden days. The cathedral was disfigured with lime and remained so until our own time, when a love of the native past suddenly awoke in the Norwegian people. Then they remembered the only ancient edifice – Trondheim cathedral and cautiously set about removing the two-foot-thick layers of lime, began to gather the fragments of the wrecked pillars and carvings and to return them to their places.

The popular assembly of Norway allocated several thousand roubles for the restoration of the church. And lo and behold, little by little there appeared from beneath the lime the marvellous carved embellishments on which the skilled masons had laboured long ago with love, reverence and exceptional craftsmanship. From the city of Trondheim they extracted a soft green stone that can be easily carved and from that green stone they fashioned everything that their imagination suggested to them. The builders of the church naively expressed their childlike faith, their sufferings and hopes, their doubts and sorrows. . . .

Next to the face of a saint, glowing with love and a striving after God, the masons placed a carving of Satan with a malevolent grin; next to angels they carved dragons that that were supposed to embody all that is sinful and gloomy residing in the human soul. The columns are embellished in a particularly amazing manner. Around the cornice the builders placed a dense wreath of human heads looking out one from behind another. Here you will find a great variety of faces: young, old, beautiful and repulsive, suffering and jolly, morose and joyful, meek and filled with anger and bitterness. It is as if the people who built the church and carved these faces wanted them to represent the whole of humanity, all its passions, the sins and sufferings of all people who would gather here before the face of the Deity in the hope of finding calm and relief from their misery.

(Shil' 1903: 121–123)

Notes

1 Here Kitner gives inaccurate information: the fire that killed more than 100 parishioners, causing changes in building regulations and resulting in the demolition of many medieval churches due to their failure to comply with the new rules, took place in 1822 in the parish of Grue.
2 Kitner is referring to the works of the discoverers of Norwegian wooden architecture – Nicolay Nicolaysen and Johan Christian Clausen Dahl, mistakenly believing that they were of Swedish ancestry (see: Nicolaysen 1860–1866; Dahl 1837).

References

Anon. (1911). *Cherez Shvetsiu v Norvegiu. Sputnik turista* [Across Sweden to Norway: A Tourist's Companion]. St. Petersburg: Rodnik.

Dahl, Johan Christian (1837). *Denkmale einer sehr ausgebildeten Holzbaukunst aus den frühesten Jahrhunderten in den innern Landschaften Norwegens*. Vols. I – III. Dresden: Druck Louis Zöllner.

Kitner, Ieronim (1872). "Drevnie dereviannye tserkvi Norvegii" [Ancient Wooden Churches of Norway] In: *Zodchii [The Architect]*, No 3. pp. 25–27.

Kitner, Ieronim (1874). "Putevye nabroski" [Travel Sketches]. In: *Zodchii [The Architect]*, No 11. pp. 141–142.

Moskvich, Grigorii (1914). *Illiustrirovannyi prakticheskii putevoditel' po Finliandii, Shvetsii i Norvegii* [An Illustrated Practical Guidebook to Finland, Sweden and Norway]. St. Petersburg: Redaktsiia Putevoditelei [Guidebook Editorial Office].

Nicolaysen, Nicolay (1860–1866). *Norske Bygninger fra Fortiden. Foreningen til norske fortidsminnesmerkers bevaring*. Christiania: C.C. Werner.

Norvegiia (s.a.). *Norvegiia. Kratkoe opisanie naibolee izvestnykh marshrutov, dostoprimechat-elnostei, a takzhe uslovii prebyvania v Norvegii vo vremia kanikul dlia otdykha kak letom, tak i zimoi* [Norway. A Brief Description of the Best-Known Routes and Sights, and Also of the Conditions for Those Staying Norway During Holidays in Both Summer and Winter]. Christiania: Grendahl and Son printers.

Shil', Sofia [under the pen-name Sergei Orlovskii] (1903). *Puteshestvie po Norvegii* [A Journey Around Norway]. Moskva: Posrednik.

Suslov (Souslow), Vladimir (1895–1901). *Pamiatniki drevnego Russkogo zodchestva/Monuments de l'ancienne architecture Russe* (in both Russian and French), Books I – VII. St. Petersburg: Imperial Academy of Arts.

Suslov (Souslow), Vladimir (1888). *Putevye zametki o severe Rossii i Norvegii* [Travel Notes on the Russian North and Norway]. St Petersburg: A.F. Marx printer.

Uvarov, Alexei (1876–1881). "Ob arkhitekture pervykh dereviannykh tserkvei na Rusi" [On the Architecture of the First Wooden Churches in Russia]. In: *Trudy 2-go Arkheologicheskogo S'ezda. [Proceedings of the 2nd Archaeological Congress]*. Issue II, part IV.A. Saint Petersburg: Tipografia Imperatorskoi Akademii Nauk. pp. 1–24.

2 Historical knowledge and inspiration

Nordic impact on Russian architecture (1870s–1910s)

Evgeny Khodakovsky and Ksenia Chemezova

Russian architects' interest in Scandinavian heritage had a visible impact on the course of development of Russian national architecture in the late nineteenth and early twentieth centuries. The Scandinavian, or so-called "dragon", style became one of the most exotic and, at the same time, most anticipated phenomena that resulted from the accounts and studies provided by Russian travellers and scholars in the 1860s–1890s. Analyzing the development of European architecture in the nineteenth century, the academician Lev Dal' (Dahl) came to the following conclusion:

> Abroad people have long since turned their attention to the medieval buildings of Europe. A thorough study of works from various eras of medieval construction has given architecture a new, rational direction, a new supply of strength that was sapped everywhere by the French style of the Baroque and the era of Neo-Classicism that followed on from it.
>
> (Dal' 1872: 10)

Those words neatly capture the situation that unfolded in the architecture of Norway and Russia. The processes of developing a new style founded upon national characteristics that were taking place in both countries in parallel, their geographical proximity and their rich national traditions of timber construction make it possible to identify within the rich polyphony of Russian architecture in the late 1800s and early 1900s a separate leitmotif that quite distinctly represents a creative rethinking of romanticized images of Norwegian architecture.

After the appearance of the very first publications about Norwegian stave churches in German and English (Dahl 1837; Nicolaysen 1860–66), the next powerful impulses towards international recognition of Norwegian medieval wooden buildings and also their contemporary rethinking came from the special German-language edition of Lorentz Dietrichson's work on the subject – *Die Holzbaukunst Norwegens* – published in collaboration with Holm Hansen Munthe (Dietrichson, Munthe 1893) the year after the Norwegian book (Dietrichson 1892) was printed in Christiania. The German version broke through the language barrier that had been isolating Norwegian research from the European academic community and made it widely accessible to the public. Motifs from

Norwegian medieval architecture became a significant source of inspiration for the European Art Nouveau/Jugendstil, suggesting alternative treatments and embellishments. In 1899, six years after the German publication of Dietrichson and Munthe's book, Olaf Christiansen brought out his book, *Der Holzbaustil* (Christiansen 1899), uniting ideas from the national wooden architecture of European countries in a general international overview of timber as a primary material and its potential within the aesthetics of the Jugendstil.

Another possible source for the spread of historical knowledge about Nordic architecture could have been the rulers of Germany, who had displayed interest in Norwegian medieval architecture since 1841, when the church from Vang was moved and reassembled in Silesia at the expense of King Frederick William IV of Prussia, known for his romantic enthusiasm for medievalism. This devotion to the Nordic style became a tradition with Prussian rulers and was reconfirmed by Kaiser Wilhelm II, who commissioned a new hunting lodge at Rominten in East Prussia (now Kaliningrad oblast, Russia), not far from the borders of the Russian Empire. The parts of the buildings, designed by Hans Holmen Munthe and Peter Andreas Olsen Diggre, were prepared in Norway and brought to Prussia for assembly at Rominten in 1891. After the Second World War, the actual Kaiser's wing of the lodge was removed to Kaliningrad (the former Königsberg) and reassembled, but without the outbuildings and embellishments (Belintseva 2013: 312).

The process of internationalization of historical knowledge on wooden architecture was taking place in Norway as well. In the 1890s, as well as his own country's architecture, Lorentz Dietrichson included in his well-known fundamental monograph on Norwegian stave churches one of the earliest scholarly surveys of Russian wooden architecture written in a Western European language (Dietrichson 1892: 102–119). His study was based on material that he himself obtained from personally examining works of Russian wooden architecture during a journey to Russia in 1884. This reflected Dietrichson's striving to place Norwegian architecture in a global context. The greatest opportunities to internationalize knowledge of national building traditions were, however, provided by world's fairs. One of the largest, the Exposition Universelle, held in Paris in 1900, which aimed to spotlight national achievements in art and culture at the turn of the new century, obliged each of the participating countries to present the essence of its distinctive identity on every scale – from the architecture of the nation's pavilion to the smallest objects in the display. In the book on Norway specially published in English for the 1900 exhibition, the chapter on architecture gives a separate description of the evolution of the country's wooden architecture and the character of the decoration of stave churches:

> The doorways of the nave are richly ornamented. The jamb is covered with a deeply carved, though as surface decoration correctly conceived, ornamentation of Romanesque dragons and vine tendrils. Occasionally they represent scenes from Germanic legends (Sigurd Favnesbane) or Scripture. . . . The carved ridge-piece of the church generally terminates in fantastic dragons'

heads, projecting far beyond the gables; and the barge courses of the roof are protected by barge-boards that are often highly ornamental.

(*Norway* 1900: 610f)

The style of the Norwegian pavilion, regarded as a kind of a symbolic gateway to the national culture, illustrated these statements from the official publication. The pavilion had clearly visible national characteristics, expressed in the typical framework structure of the building with wooden decorations and recognizable turrets, inherited from Borgund stave church, or, more recently, from Peter Andreas Blix's restorations in Hopperstad, completed just few years before, in 1891. A contemporary Russian visitor gave this description of the building:

Constructed of Norwegian wood to plans by Sinding[1] and painted red, the pavilion accurately conveys the appearance of a Norwegian house and stands out sharply from the neighbouring, Belgian and German, palaces with its simplicity. Inside on the lower floor is a rich display, a sort of ichthyological museum, where a host of items acquaint visitors not only with the present-day wealth of the Norwegian fishing industry, but also with its history, and with that of fishing tackle. Here too is a model of that famous ship, the *Fram*, on which Dr. Nansen made his journey to the North Pole, along with an exhibition of objects relating to that journey. In the gallery is an exhibition of Norway in the distant past. There is an interesting model of the quay in Bergen, a monument to Hanseatic dominion in the Middle Ages. Finally, there is an exhibition of "The Museum of the Norwegian People" with precise photographs and models of urban and rural dwellings from the 13th to 19th centuries.

(Nenashev 1900: 38)

This description testifies that the Norwegian pavilion on the eve of the country's independence in 1905 should be regarded as an assertive demonstration of the nation's potential and creative ambitions. Thus, the Exposition Universelle – along with travel accounts, reviews, translations and other publications – significantly contributed to the exchange of ideas, promoting and advancing the Scandinavian style into other schools.

The Nordic theme was to become an inseparable part of culture in Norway and Russia in the late nineteenth century. The search for a national identity in the neighbouring countries led them both to look to the North as a powerful source of inspiration. The peaceful engagement between Russia and Norway in Fennoscandia and the Arctic from the Middle Ages onwards – the extensive trade and commerce, fisheries and timber industry – even led to the formation of a Russian-Norwegian pidgin (Russenorsk). One indication of Russians' perception of the Norwegian North as some special domain, in both mentality and culture, is the grandiose scheme promoted by the businessman Savva Mamontov (1841–1918), an outstanding patron of the arts and artists, for the construction of a Northern Railway. The first stretch of the line, between Moscow and Sergiev Posad, the

location of the Trinity–St. Sergius Monastery, had been constructed as far back as 1858–1862 by the prominent public figure and industrialist Fëdor Chizhov (1811–1877). That railway was extended as far as Yaroslavl and then, in 1870, on to Vologda. Chizhov planned a whole package of measures to open up the North economically, including establishing steam ship services and the development of the banking system. To his way of thinking, this project had among other things a "civilizing" aspect to it, and it was Norway which had developed its remote territories in the North that became a particular model for Russia's visionary industrialists. It is notable that Chizhov intended to carry out the construction of the railway to Vologda "using a new method, the way they do it in Norway" (Simonova 2002: 222). But Chizhov's death in 1877 prevented him from accomplishing his ambitious plans, and the baton of promoting a flourishing "Russian Norway" passed to Savva Mamontov (Simonova 2002: 283; Arenzon 2011: 49). In 1894, Mamontov and the minister of finance, Sergei Witte, who had previously been minister of railways and in his new post continued to devote much attention to the development of that sphere, made a journey to the North. They first travelled down the Northern Dvina to Arkhangelsk. Their route then took them by way of the Solovetskii Monastery to the ice-free harbour of Ekaterininskaia Gavan' on the Barents Sea. Rounding the North Cape, Mamontov and Witte continued around the Norwegian coast, visiting several places, including Christiania. They then returned to Saint Petersburg by way of Stockholm and Finland.

The continuation of the railway from Vologda to Arkhangelsk had extremely hazy prospects financially, but Mamontov regarded the project as more than just an expansion of the existing rail network in a northerly direction. For Mamontov, the North was a special phenomenon. By involving prominent artists of the day – Konstantin Korovin and Valentin Serov – in the project with the aim of giving it a greater public profile, Mamontov contributed to the emergence of the "Northern theme" in Russian art of the late nineteenth and early twentieth centuries. "The folk culture of the Russian North was that connecting factor, a sort of bridge between the 'national styles' of the Nordic countries and Russia" (Petukhova 1999: 100). Soon after Mamontov's Northern journey, the large-scale National Artistic and Industrial Exhibition of 1896 in Nizhny Novgorod attracted contributions from a number of notable architects and artists, including Korovin, who exhibited his Northern paintings. That same 1896 exhibition saw the appearance of one of Russia's first buildings in the "Scandinavian style", designed by Leontii Benois – the pavilion of the forestry and hunting section with a shingle-roofed tower. In the words on one contemporary,

> peeping through the forms of this building, simple to the point of coarseness, was that fascinating charm that is noticeable in all L.N. Benois's works [investing it with] a "medieval-Scandinavian' character".
>
> (Baranovskii 1897: VI)

Special mention must be made of the role of the creator of the pavilion at the Nizhny Novgorod fair of 1896, Leontii Benois (1856–1928), in the introduction

and spread of the Norwegian "Dragon Style" in Russian architecture. This member of the highly creative Benois family is known more as an all-rounder, an exponent of eclecticism, who felt equally at home with various styles and historical eras. As an independent and mature architect, Benois did not permit himself direct borrowings, but as an eclecticist he combined in his creations subtle features of different styles, using one or other set of models to supplement his own stock of ideas and pass them on to his pupils. At the 1900 Exposition Universelle in Paris, for example, he singled out the pavilion of Finland for its national characteristics. Leontii Benois was also known for his teaching activities in the architecture school of the Academy of Arts, where his studio had the largest number of students. Oscar Muntz, one of Leontii Benois's pupils, wrote of his mentor's teaching methods:

> Fighting against the routine academic style, L.N. Benois directed his pupils . . . towards the study of historical styles. In his opinion, though, that study ought to be made not on the basis of generally known works, whose motifs had entered into general circulation, and certainly not on the basis of "gold medal programmes", but on fresh works that had not yet been "academically" processed. The library, numerous photographs, in part brought back by Benois from his many journeys abroad, and his highly competent explanations founded on personal impressions served as working materials.
>
> (Lisovskii 2003: 293)

Vladimir Lisovskii noted that Benois's students displayed a clearly heightened interest in "national style" (Lisovskii 2006: 338). It was not without reason that his studio produced one of the Russian Empire's outstanding architects of the early twentieth century, Fëdor Lidval. Lidval had Swedish roots, and he was an exponent of the regional romanticized version of the Art Nouveau that took hold mainly in Finland and Scandinavia and later became known as the "Northern Moderne" (Lisovskii 2006: 317).

Other pupils of Leontii Benois – Aleksandr Vladovskii, Ludwig Schröter and Vicenty Orzeszko – drew directly upon the motifs of Scandinavian wooden architecture.

Aleksandr Vladovskii (1876–1950) and Ludwig Schröter (1878–1911) were the strongest exponents of the Norwegian "Dragon Style" in Saint Petersburg architecture of the early 1900s. This was assisted by the competition announced in 1903 by the editorial board of the periodical *Arkhitekturnyi muzei* (Architectural Museum) in the Higher Art College attached to the Imperial Academy of Arts. One of the tasks in the competition programme called for the design of a wooden suburban dacha (it is noteworthy that suburban dachas constitute a whole separate chapter in Leontii Benois's architectural oeuvre). Vladovskii's design for a building "in the Norwegian style" was awarded first prize (*Motivy dereviannoi arkhitektury*: 2–3; Fig. 2.1).

The most striking feature of the building is the dynamically upward-soaring slopes of the roof above the main volume. This is at one and the same time reminiscent of both the medieval stave church in Reinli, known outside Norway

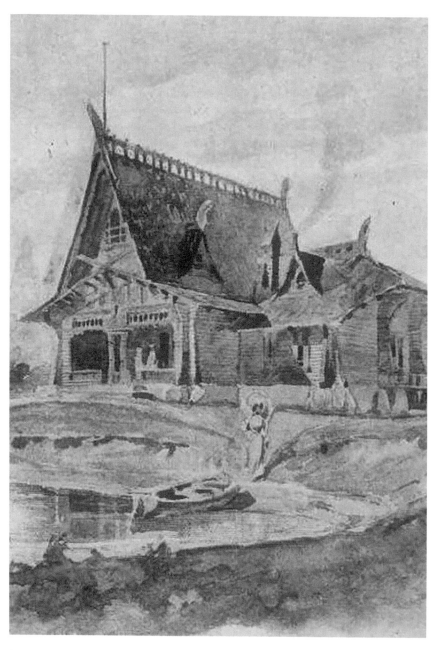

Figure 2.1 Aleksandr Vladovskii (1876–1950). Design for a dacha in the Norwegian style. 1st prize. 1903. (*Motivy dereviannoi arkhitektury*: 2–3)

from Nicolaysen's publications (Nicolaysen 1854: Pl. V, 1), and Russian wooden churches with a tall sharply angled "wedge" roof. Interestingly, a year later, Ivan Bilibin would associate the dynamic quality of the wedge roof on Russian churches specifically with Norwegian architecture:

> On many churches with a pitched roof the ridge is very sharp and raised very high. One senses the closeness of the Scandinavians. In my opinion, these churches are no less beautiful than tent-roofed ones, and in them the North is somehow stressed with particular clarity.
>
> (Bilibin 1904: 310)

The question of whether there was such a direct mutual influence between the architectural traditions of the neighbouring northern countries is unlikely to be settled definitively, but the impressions and associations expressed by Bilibin, one of the leading Russian artists and also highly knowledgeable about Northern architecture, are very important and indicative for a characterization of the period.

A second distinctive feature of Vladovskii's project was the decoration of the roof ridge with openwork carving and the actual "dragons", an element that became *de rigueur* and gave the name to this whole tendency in Russian and European architecture at the turn of the twentieth century. For a comprehension of the "Dragon Style", it is interesting to compare Vladovskii's competition entry from 1903 with the design for the villa of Doctor Hällberg near Mariehamn on the Åland Islands created in 1896 by the Finnish architect Lars Sonck:

> The elongated body of the villa has torn free, as it were, from the mass of a forested hill and surged towards the sea (that is just how it is depicted in the perspective view included in the project). The dynamism of that impulse was splendidly expressed by the sloping gable, whose expressive shape was to a considerable degree determined by the dragon set on the ridge. In that way the architect recalled the "Dragon Style" of neighbouring Norway. But the dragon, carved after a drawing by Sonck, lost its "portrait resemblance" to its fabulous prototype and acquired a geometric schematism in accordance with the "new style", which did not in the least impair the expressiveness of that detail.
>
> (Lisovskii 2016: 102–103)

Ludwig Schröter's 1903 competition entry was more eclectic (*Motivy dereviannoi arkhitektury*: 25). The only reminder of Norway is the "dragons", while the tall spire atop the tower was more probably inspired by motifs from the Western Ukrainian architecture of Transcarpathia (similar to the churches in Alexandrovka, Danilovo and elsewhere).

Aleksandr Vladovskii did not merely produce designs for wooden buildings in the "Dragon Style"; he also implemented them. His best-known ensemble is the Russian bathhouse and bathing hut (1903) at Peschanka, the former estate of the prominent lawyer and public figure Fëdor Mikhailovich von Kruse on the River Oredezh south of Saint Petersburg (*Motivy dereviannoi arkhitektury*: 17–19; Fig. 2.2a, b).

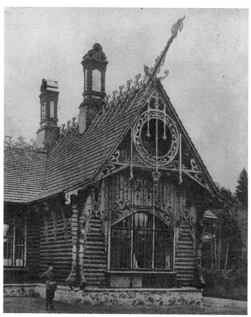

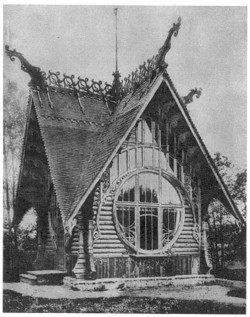

Figure 2.2 a & b Aleksandr Vladovskii (1876–1950). Bathing hut (a) and bathhouse (b) on Fëdor von Kruse's estate. 1903. (*Motivy dereviannoi arkhitektury*: 19–20)

In creating the ensemble, Vladovskii used the same devices as in the dacha project: for both the bathhouse and the bathing hut, the main decorative element is the tall decorative roof ridge and the strongly protruding "dragon" heads. The character of the façade is determined by the steep pitches of the roof; only in the case of the bathhouse there are more gently angled "skirts" at the bottom of the slopes reminiscent of the *politsy* found at the base of wedge-shaped roofs on Russian churches. This sort of eclectic combination of Norwegian decorative motifs and the characteristic "Russian wedge" probably came together in the minds of Vladovskii, Bilibin and their contemporaries to form a unified national concept of the distinctive architecture of the North.

It should be noted that the unrealized projects and the completed works in the "Norwegian Dragon Style" are aesthetically quite distinct from Swedish and Finnish granite buildings, in spite of the manifest geographical and political grounds for Russia absorbing and transforming architectural motifs employed in Finland, which was at that time part of the Russian Empire, its Nordic outpost on the Gulf of Bothnia. It is also noteworthy that these wooden "Dragon Style" constructions were built out to the south of Saint Petersburg, where the influence of Finnish architecture was not so evident. Another important aspect is that Swedish and Finnish architecture had a deeper impact on Saint Petersburg itself, located close to the border with the Grand Duchy of Finland. The capital's wealth led to a predominance of masonry construction, and in such a setting the influence of Norwegian rural timber architecture could not be strong or decisive. Wood had traditionally had been regarded as a rustic building material of lower social status, and so, in Russia, Norwegian architecture had greater impact in the countryside, specifically on timber architecture in various provinces, where wood has always been used for building.

Besides the North-Western Russian phenomenon associated with Benois, Vladovskii and Mamontov with his ephemeral "Nordic idea", Siberian wooden architecture of the early twentieth century also displayed distinctive, direct borrowings from the Scandinavian "Dragon Style". This tendency was rooted in the idea that North European architecture is more relevant to the nature and climate of Siberia, where the forests are regarded as a major resource and a symbol of this vast region. Another factor was the rethinking of the Northern Moderne of Saint Petersburg architecture, a Russian version of the Jugendstil or Art Nouveau seen in the buildings of the Swedish architect Fëdor Lidval, Aleksei Bubyr and others. Tomsk was already one of Siberia's most remarkable and picturesque cities by the time the Art Nouveau was introduced there by the architect Andrei Kriachkov. In 1902, Kriachkov, a graduate of the Saint Petersburg Institute of Civil Engineers, arrived in Tomsk to work at the Technological Institute. As he himself saw things,

[W]ood still has a major role to play in Siberia. Builders and architects should persevere in working on new, rational types of buildings.

(Zaitseva 2004: 35)

Vicenty Orzeszko (1876–after 1917), who taught at the Technological Institute in Tomsk between 1905 and 1914, after graduating from the Saint Petersburg Academy of Arts, created the most fabulous and spectacular masterpiece of Tomsk's wooden architecture in the "Dragon Style" – the Bystrzycki House (Ulitsa Krasnoarmeiskaia, 68), built in the early 1910s (Zalesov and Kulikova 2016: 74, 122, 379; Fig. 2.3a, b, c).

The concept for this work might have come to him from several sources. During his time as a student in Leontii Benois's studio at the academy in 1901–1902 (Zalesov 2014: 227), Orzeszko would have acquired an extensive knowledge of different European styles and could have picked up Benois's fondness for rural architecture. Orzeszko had also travelled widely in Europe himself in 1907, and that journey contributed to his views on ways and methods of construction. His Polish origins and Catholic faith, together with his position as the chief architect of the Tomsk eparchy of the Russian Orthodox Church, also helped him to absorb different cultures and to be very flexible in his approaches. Finally, the spread of literature such as Dietrichson and Munthe's *Die Stabkirchen Norwegens* and Olaf Christiansen's *Die Holzbaukunst* provided plenty of material for the further elaboration and development of the Scandinavian theme in architecture elsewhere, even in remote Tomsk.

Orzeszko employs a vertical framework on the upper level, reminiscent in some respects of the Scandinavian building technology, while the main volume remains within the horizontal tradition of log construction. This follows the general trend in the perception of the Scandinavian style outside Norway in the late nineteenth and early twentieth centuries, where the secular buildings, in contrast to stave churches, are constructed with horizontal logs, which was common for late medieval Norwegian farms, barns and storehouses. The Holmenkollen Hotel in Oslo and Munthe's hunting lodge at Rominten were built entirely with horizontal logs, that being much more practical and convenient for dwellings. This aspect made the absorption of late medieval secular Nordic architecture into Russian profane construction, like the house in Tomsk, easier and more natural. However, a local peculiarity in the design of the Bystrzycki House must also be emphasized: the rectangular corner projection above the entrance that contains the staircase to the second storey, with its confident vertical volume and uniform tiers of logs, seems to hark back to the traditions of Siberian defensive architecture, more specifically the corner towers of stockades.

As usual, dragons – inspired by the ones on Borgund stave church and those re-created on the Hopperstad, Gol and Fantoft stave churches in the 1880s – became the most characteristic feature of the building, responsible for conveying the spirit of the "Norwegian" style to the beholder. The dragon heads create the mood and form the image of a particular national architecture, unmistakably identifiable as Scandinavian. This impression is reflected in one of the contemporary guidebooks, describing Fantoft stave church and calling attention, first of all, to the Dragon Style decoration:

> Not far from Bergen there is an old church. It was built 700 years ago. The wood has darkened with age, but the church is well preserved. It takes the

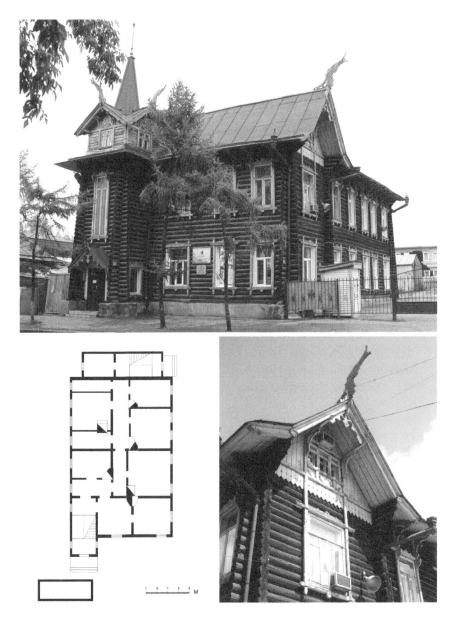

Figure 2.3a, b & c Vicenty Orzeszko (1876–after 1917). House of B. Bystrzycki (1910s). Ulitsa Krasnoarmeiskaia 68, Tomsk. Photograph by Irina Kulikova. (Zalesov and Kulikova 2016: 122)

form, as it were, of several log huts placed one up against another. Both the roofs and the walls are covered with wooden shingles. Most astonishing of all are the ridges of the roofs. They are in the shape of the head of a fabulous serpent. Such serpent heads also adorn some other ancient churches, such as the one in the village of Hitterdal [Heddal] in Telemark. Evidently at the time when the church was built pagan beliefs and legends were still alive among the Norwegians.

(Shil' 1903: 102)

Norway's wooden architecture was quite well known to Russian travellers. Guidebooks from the 1910s mention not only the best-known examples but also works of the "second rank":

In Telemark the old wooden churches – Eidsborg and Hitterdal near Notod-den . . . Valdres – old wooden churches: near Reinli . . . and near Lomen . . . Old wooden churches in Vågå and Lom . . . Sogn and Hardanger – old wooden churches near Borgund close to Lærdal and near Urnes, not far from Solvorn in Sogn.

(*Norvegiia*, s.a.: 95, 98, 102)

A separate entry in Russian tourist literature was even devoted to the 1914 jubilee exhibition marking the hundredth anniversary of the Norwegian Constitution, proclaimed at Eidsvoll on 17 May 1814:

The architects have given the buildings in which the agriculture and farming sections are concentrated, the building of a peasant farm and others, a suitable specifically Norwegian style.

(*Skandinaviia* 1914: 130)

Those guidebooks and essays – just like the publications of Kitner and Suslov, and the buildings and designs by Benois, Vladovskii and Schröter – are evidence that by the early 1910s, when Orzeszko created the celebrated "House with Dragons" in Tomsk, the interest of Russian architects and the Russian public generally in Norwegian traditional wooden architecture had already lasted almost half a century. In the architecture of Tomsk, the eclectic mix of Siberian tradition and Norwegian motifs again harks back to Vladovskii's similar experiment and, overall, to a general idea of a distinctive Northern (or Siberian) identity that was characteristic of the age of the Moderne in Russia and the Jugendstil in Northern Europe.

In speaking of this sort of combination of Russian and Norwegian elements in Russia's wooden architecture and presenting examples of the direct use of the "Dragon Style" in Russian buildings around the turn of the twentieth century, it is possible to suggest, with caution, that to some degree we might view in this same context the distinctive "cockerel style", which gets its name from the extensive use of carved figures of cockerels on the ridges and ends of roofs. This

style emerged as far back as the 1870s thanks to fantasy projects "on a Russian theme" published in issues of the periodical *Motivy russkoi arkhitektury* (Motifs of Russian Architecture). Those designs were mainly the work of Ivan Ropet and Viktor Hartmann (Gartman). Although intended to be representative of the Russian style, they were viewed as being "pseudo-Russian" and admired or criticized by contemporaries. Despite the fact that the designs were meant to promote specifically "motifs of Russian architecture" (including, for example, the Russian pavilion at the 1878 World's Fair in Paris), such images of cockerels were not common on traditional peasant buildings in Russia. Perhaps such inclusions of abundant imaginative decoration were inspired by other sources – quite possibly drawings and prints showing Scandinavian animal-based decorations – and converted into a "Russian" form. Images of horses have more genuine associations with Russian peasant architecture, but the way of placing them and the cockerels – both creatures that feature extensively in the nation's fairy tales – on the ridges represents a "Russification" of an idea taken from Scandinavian carvings. For instance, the carved plank that is part of the elaborate *prichelina* (bargeboard) on the porch of Hartmann's "Atelier" at Savva Mamontov's Abramtsevo estate, completed in 1873, features the image of a dragon, while the overall composition and decoration of the building tends towards the "Russian". It is possible to assume that a knowledge of Norwegian medieval decorations gleaned from drawings – published earlier by Kitner or, quite possibly, Nicolaysen himself – gave Russian architects an impulse, directing their search for Russian motifs towards animal and fairy-tale imagery. In the early twentieth century, cockerel ornamentation existed alongside the dragon type in the wooden architecture of Tomsk as well (Ulitsa Krasnoarmeiskaia, 67a; architect: Pëtr Fëdorovskii, built in 1903). It is symbolic that the "House with Dragons" that Orzeszko built for Bystrzycki roughly ten years later is literally a few steps along the same street as Fëdorovskii's "House with Cockerels".

Several generations of Russian and Scandinavian architects drew upon the principles of decoration seen in medieval buildings to enrich their own methods and approaches to construction. Scandinavian "dragons" and Russian "cockerels" co-existed as two facets of a single phenomenon. Later, at the turn of the century, due to increased historical knowledge, the rustic image of the Norwegian "dragon" came to denote the enchanting wooden alternative to the aristocratic Swedish and Finnish Nordic granite style. Although the impact of the "Dragon Style" on Russian architecture did not evolve into a full-blooded phenomenon, it is possible to speak about a Nordic mood or, better still, a Nordic theme in the charming symphony that is Russian architecture of the late nineteenth and early twentieth centuries.

Note

1 Here, the Russian author is referring to Petter Andreas Holger Sinding-Larsen (1869–1938). Sinding is mentioned without any sort of explanation and even without his initials, which would imply that the Norwegian architect's name was quite well known to a Russian readership.

References

Arenzon, Evgenii (2011). *Iskusstvo i zheleznye dorogi* [Art and the Railways]. Moscow: Generalnyi direktor.

Baranovskii, Gavriil (1897). *Zdaniia i sooruzheniia Vserossiiskoi khudozhestvenno-promysh-lennoi vystavki 1896 goda, v Nizhnem-Novgorode* [The Buildings and Structures of the All-Russia Art and Industry Exhibition of 1896 in Nizhny Novgorod]. Saint Petersburg: editorial board of the magazine Stroitel' [The Builder].

Belintseva, Irina (2013). "Pamiatnik norvezhskogo 'stilia drakonov' v Kaliningrade. Istoriia poiavleniia i sovremennoe sostoianie" [A Work of the Norwegian 'Dragon Style' in Kaliningrad: The story of its appearance there and its present state]. In: *Dereviannoe zodchestvo. Novye materialy i otkrytiia* [Wooden Architecture. New Materials and Discoveries], ed. Andrei Bode, Issue III. Moscow – Saint Petersburg: Kolo. pp. 296–313.

Bilibin, Ivan (1904). "Narodnoe tvorchestvo Russkogo Severa" [The Folk Art of the Russian North], *Mir iskusstva* [*World of Art*], No. 12, pp. 265–318.

Christiansen, Olaf (1899). *Der Holzbaustil. Entwürfe zu Holzarchitekturen in modern-deutschem, norwegischem, schweizer, russischem und englisch-amerikanischem Stil.* Leipzig: Verlag von Bernh. Friedr. Voigt.

Dahl, Johan Christian (1837). *Denkmale einer sehr ausgebildeten Holzbaukunst aus den frühesten Jahrhunderten in den innern Landschaften Norwegens.* Issues I – III. Dresden: Druck Louis Zöllner.

Dal', Lev (1872). "Istoricheskoe issledovanie pamiatnikov russkogo zodchestva" [A Historical Study of Russian Architectural Monuments]. In: *Zodchii* [*The Architect*], No. 2. pp. 9–11.

Dietrichson, Lorentz (1892). *De norske stavkirker: studier over deres system, oprindelse og historiske udvikling: et bidrag til Norges middelalderske bygningskunsts historie.* Kristiania: Cammermeyer.

Dietrichson, Lorentz and Munthe, Holm Hansen (1893). *Die Holzbaukunst Norwegens in Vergangenheit und Gegenwart.* Berlin: Schuster.

Lisovskii, Vladimir (2016). *Severnyi Modern. Natsional'no-romanticheskoe napravlenie v arkhitekture stran Baltiiskogo regiona na rubezhe XIX i XX vekov* [The Northern Moderne. The National-Romantic Tendency in the Architecture of the Countries of the Baltic Region at the Turn of the 20th Century]. Saint Petersburg: Kolo.

Lisovskii, Vladimir (2006). *Leontii Benua i peterburgskaia shkola khudozhnikov-arkhitektorov* [Leontii Benois and the Petersburg School of Artist-Architects]. Saint Petersburg: Kolo.

Lisovskii, Vladimir (2003). *Leontii Benua* [Leontii Benois]. Saint Petersburg: Beloe i Chernoe.

Motivy dereviannoi arkhitektury: sbornik proektov dereviannykh stroenii, preimushchestvenno premirovannykh na konkurse v Vyssh. Khudozh. uchil. pri Imperatorskoi akademii Khudozhestv [Motifs of Wooden Architecture: a collection of designs for wooden buildings, chiefly prize-winners in the competition at the Higher Art College attached to the Imperial Academy of Arts] (s.a.). 2nd ed, Petrograd: M.G. Strakun publisher.

Nenashev, Alexei (1900) "V Parizh na vystavku: Putevoditel" po Zapadnoi Evrope, Parizhu i Vsemirnoi vystavke 1900 goda [To Paris for the Exhibition: A Guidebook to Western Europe, Paris and the 1900 World's Fair]. Moskva: Tipo-Litographia T-va Vladimira Chicherina.

Nicolaysen, Nicolay (1854). *Mindesmærker af Middelalderens Kunst i Norge,* Vol. 1, Christiania: Chr. Tönsberg Forlag.

Nicolaysen, Nicolay (1860–66) *Norske Bygninger fra Fortiden. Foreningen til norske fortidsminnesmerkers bevaring.* Christiania: C.C. Werner.

Norvegiia (s.a.). *Norvegiia Kratkoe opisanie naibolee izvestnykh marshrutov, dostoprimechatelnostei, a takzhe uslovii prebyvania v Norvegii vo vremia kanikul dlia otdykha kak letom, tak i zimoi.* [Norway: A Brief Description of the Best-Known Routes and Sights, and Also of the Conditions for Those Staying Norway during Holidays in Both Summer and Winter]. Christiania: Grendahl and Son Printers.

Norway (1900). *Official Publication for the Paris Exhibition 1900.* Kristiania: Aktie-Bogtrykkeriet.

Petukhova, Nina (1999). "Vzaimodeistvie 'natsional'nykh stilei' severnykh stran i Rossii v arkhitekturnom komplekse zheleznoi dorogi Vologda – Arkhangel'sk" [The Interaction of the 'National Styles' of the Nordic Countries and Russia in the Architectural Complex of the Vologda – Arkhangelsk Railway]. In: *Arkhangel'sk i severnye strany kontsa XVI – nach. XX vekov. Materialy mezhdunarodnoi konferentsii* [Arkhangelsk and the Nordic Countries From the Late 16th to the Early 20th Century: Materials of an International Conference], ed. Johan Hellstrand and Alexey Usov. Arkhangelsk: Pravda Severa. pp. 87–100.

Shil', Sofia [under the pen-name Sergei Orlovskii] (1903). *Puteshestvie po Norvegii* [A Journey Around Norway]. Moscow: Posrednik.

Simonova, Inna (2002). *Fëdor Chizhov.* Moscow: Molodaia Gvardia.

Skandinaviia. *Putevoditel'-Al'manakh. Norvegiia, Shvetsiia, Daniia* [Scandinavia. A Guidebook-Almanac. Norway, Sweden, Denmark] (1914). (s.l.): (s.n.).

Zaitseva, Zinaida (2004). *Dereviannaia arkhitektura Tomska* [The Wooden Architecture of Tomsk]. Tomsk: D-Print.

Zalesov, Valerii and Kulikova, Irina (2016). *Arkhitektura dereviannykh dokhodnykh domov Tomska (konets XIX – nachalo XX vv.)* [The Architecture of the Wooden Apartment Houses of Tomsk (Late 19th – Early 20th Centuries). Tomsk: Publishing House of the Tomsk State University of Architecture and Building.

Zalesov, Valerii (2014). "Materialy k tvorcheskoi biografii arkhitektora V.F. Orzheshko" [Materials for a Creative Biography of the Architect V.F. Orzeszko]. In: *Regional'nye arkhitekturno-khudozhestvennye shkoly* [Regional Schools of Architecture and Art]. Novosibirsk State University of Architecture, Design and the Arts, No. 1. pp. 226–229.

3 The Imperial Archaeological commission (1859–1918) and cultural heritage management in Russia

Maria Medvedeva

The establishment of legislation on conservation in Russia is traditionally considered to have started in the time of Peter the Great (*Materialy po voprosu o sokhranenii drevnikh pamiatnikov* . . . 1911: 3; Smolin 1917: 124; Poliakova 2005: 18). Over the rest of the eighteenth century and into the nineteenth, state bodies and the Most Holy Governing Synod produced a succession of resolutions and regulations directed towards the preservation of antiquities in Russia; certain articles of judicial code and building regulations included provisions relating to the preservation of historical monuments (Danilov 1886; Smolin 1917: 121–141; Dediukhina et al. 1997: 5; Poliakova 2005: 18–26).

In the nineteenth century, the Ministry for Internal Affairs made a series of attempts to gather information on ancient monuments located in Russia. On several occasions, beginning in 1826, directives were sent out to governors instructing them to immediately provide information on all the ancient monuments situated on the territories under their control with an indication of their state of preservation (Lapshin 2002: 79). However, the incompetence of those carrying this out at a local level and poor communication between administrative bodies meant that in practice the lists submitted were often random in character (Shchenkov 2002: 363).

The problem of a lack of legislation regulating the conservation of monuments began to be felt especially keenly by the middle of the nineteenth century (Poliakov 2005: 30). Sporadic measures were no longer capable of providing sufficiently for the preservation of the nation's historical wealth. The point had been reached where it was necessary to work out a unified legislative basis for the protection of the country's antiquities at a state level. The primary tasks had to be the systematization of the existing incoherent conservation regulations, the compilation of a comprehensive register of ancient monuments on the territory of the Russian Empire that were in need of state protection, and the creation of a central coordinating body.

At that time an upsurge in public activity began in Russia with a growth of interest in antiquities and the problems of preserving historical monuments. State and public organizations were created in the two capitals and the provinces that united the main scholarly resources and had an enormous influence on the development of a system for the preservation of historical monuments

in Russia in the nineteenth and early twentieth centuries (Razgon 1957: 103). These bodies included archaeological societies; archival commissions; museums; archaeological congresses; congresses of artists and architects; societies of devotees of history, archaeology and ethnography; and many others. Their members played an active part in the drafting of legislation on the preservation of ancient monuments in Russia. An important aspect of the societies' activities was their work of public education, aimed at spreading scholarly knowledge to the broad masses of the population, which greatly furthered the formation of public opinion on the necessity and importance of preserving the nation's antiquities. Among the archaeological societies, a major contribution to the resolution of issues relating to the preservation of monuments was made by the Russian Archaeological Society, founded in 1846, and the Moscow Archaeological Society, founded in 1864. The Imperial Archaeological Commission (IAC) also played an important role in developing a state system for the preservation of historical monuments.

The Archaeological commission was founded in St Petersburg by a decree of Emperor Alexander II on 2 February 1859. Throughout the rest of the nineteenth century and into the twentieth, the commission was the leading state institution concerning itself specifically with the study and preservation of Russia's archaeological and architectural heritage. Its activities combined research, organizing and coordinating functions (Medvedeva et al. 2009). Throughout its existence, the archaeological commission was subordinated to the Ministry of the Imperial Court. Its high status as an institution was confirmed by the patronage of the emperor himself, who would regularly visit excavations and exhibitions of ancient finds.

At the very outset, the IAC's main endeavours were concentrated on the archaeological study of Scythian and Graeco-Roman antiquities in the south of Russia. The commission had a small staff and was housed in the palace of Count Sergei Grigor'evich Stroganov, its first chairman. Under its 1859 charter, the IAC was to be responsible for "studying objects from the distant past", gathering information on all ancient monuments, carrying out archaeological researches on the territory of Russia and giving "a scholarly assessment" of the antiquities found, keeping track of all "discoveries of objects of antiquity being made in the state" and of works "entailing the need to destroy any ancient building or dig up an ancient site" (IHMC Archive 1859: ff. 3–5). The commission's rights and duties regarding the organization of the preservation of ancient monuments were not specifically laid down in the charter, but the main fields of the IAC's activities were inseparably bound up with the conservation of antiquities.

Throughout the second half of the nineteenth century, the commission actively exploited its position under the Ministry of the Imperial Court and initiated a series of administrative directives aimed at organizing the preservation of archaeological monuments. One of its most important tasks was the struggle against illicit excavations. In the later 1800s, the practice of private individuals digging at archaeological sites was common across the whole of Russia. The interest in archaeology and excavations was prompted by the general increased popularity of treasure hunting. The excavators belonged to the most varied strata

of society: Cossacks, the landed gentry, peasants, military men and many others. In the majority of cases, they were ordinary treasure hunters, seeking to find valuables to sell on to illicit dealers for their own enrichment. Some justified their activities, claiming an interest in the study of the nation's material past, yet they did not possess an adequate level of knowledge or skills. With the aim of restricting unprofessional excavations and plundering, in 1866, 1882 and 1884, on the initiative of successive chairmen of the IAC, the Ministry for Internal Affairs issued circular directives forbidding the destruction of monuments and forbidding treasure hunting on lands belonging to the state. In 1886, the Ministry sent governors an order banning any excavations without special permission from the Imperial Archaeological Commission (IHMC Archive 1859: ff. 26–40; IHMC Archive 1886: ff. 1v – 5v; IHMC Archive 1903: f. 82v).

As early as the 1860s, the IAC tried to make archaeological supervision of all new construction work compulsory. In 1867, a circular was issued on the procedures to be followed if antiquities were found in the course of construction work. According to that directive, the Board of Transport and Engineering Department was supposed to give advance notice of the planned construction of railways or highways for the organization of archaeological investigation. If a burial mound or settlement site was discovered in the construction area, the IAC was to be informed immediately. Provision was also made for monetary rewards to workers for chance finds. Subsequently, archaeological supervision was implemented during the construction of the railway linking Moscow to the Black Sea, the Moscow–Smolensk, the Kursk–Kharkov, the St Petersburg–Helsingfors and other railways in the late nineteenth and early twentieth centuries (IHMC Archive 1862a).

The IAC's small staff was unable to cope with monitoring the identification of archaeological monuments and their state of preservation across the whole empire, and so state institutions at the local level were called up to handle these tasks. From the 1860s, members of the provincial statistics committees took part in the collection of information on antiquities; from the 1880s, the IAC began to work with archival commissions (Peskareva and Riabinin 1984: 301; IHMC Archive 1862b). The gathering of data for the compilation of a unified register of Russia's historical monuments was performed by the heads of monasteries, urban and rural priests, university lecturers, teachers of *gymnasia* and district colleges, and other interested persons. Sadly, many of them were unable to make a qualified description of the monuments.

The IAC's activities in the sphere of the study, restoration and preservation of Russia's architectural monuments deserve separate attention. Up until the time of the commission's creation, Russia did not have a special scholarly institution for the direction of restoration efforts. There was no unified system of legislation or planning for the preservation of such edifices. Monitoring repair and restoration work on architectural monuments was in the ambit of the Ministry for Internal Affairs, the Ministry of the Imperial Court and the Most Holy Governing Synod. Restoration was often equated with repairs or refurbishment carried out by technicians and civil architects (Pod"iapol'skii et al. 2000: 33).

In the beginning, the IAC's range of activities touched little upon the problems of restoring architectural monuments, although seeking out and restoring ancient fresco paintings was immediately included in the commission's charter as one of the main tasks. That task was, however, actually accomplished only in one project – the restoration of the murals of the Dormition Cathedral in Vladimir, which was carried out under the personal patronage of the emperor (Medvedeva and Musin 2009: 944–946). The start of more active efforts by the IAC in the study and restoration of architectural monuments can be traced back only as far as the 1880s. Prior to that, we know only of rare instances of the commission participating in the resolution of questions relating to the repair and preservation of edifices, for the most part fortifications.

A new stage in all spheres of the IAC's activities began after the appointment of Count Aleksei Aleksandrovich Bobrinskii as its chairman in 1886 (Medvedeva et al. 2009: 110–128). He obtained increases in the size of the commission's staff and its funding, which in turn increased its prominence. This advance was due in no small part to his predecessor, Aleksandr Alekseevich Vasil'chikov, who was only briefly at the helm of the IAC, while at the same time serving as director of the Imperial Hermitage, yet still managed to lay the foundations and formulate the main principles for all subsequent reforms (Medvedeva et al. 2009: 94–99). The IAC relocated to the premises of the Imperial Hermitage, where it remained until 1918. The staff grew and so did the potential for securing the collaboration of leading Russian archaeologists, architects, historians, art historians and scholars specializing in other fields. The geography and subject range of the researches expanded, along with the number of expeditions carried out by the commission's specialists.

Bobrinskii actively pursued the creation of a unified state system for archaeological research and the preservation of historical monuments in the Russian Empire with the IAC in charge, and he accomplished this. In 1889, the emperor signed a decree investing the Imperial Archaeological Commission with the exclusive right to issue permits to conduct archaeological excavations on state and public land, and also the right to oversee all restoration and repair work (jointly with the Academy of Arts) (Beskrovnyi 1978: 133f). A standard form for the excavation permit and the rules for compulsory submission of a report about excavations with an inventory of the finds to the IAC's archive were approved at a meeting of representatives of Russia's scholarly organizations, although many of them were unhappy about such centralization with the IAC having the leading role. In late 1889, a draft agreement was drawn up about the procedure for the allocation, acquisition and publication of archaeological finds. Antiquities of "first-class artistic significance" went into to the collections of the Imperial Hermitage in St Petersburg and the Russian Historical Museum in Moscow; other items were transferred to the stocks of various museums at the discretion of the commission (IHMC Archive 1887: ff. 211–215).

In 1890, rules came into force laying down the procedure for examining requests for the restoration of historical monuments and overseeing repairs and restoration. The IAC had accumulated all applications for carrying out work

"to restore an ancient architectural monument or to carry out major repairs on it, involving changes to its exterior and interior", as well as the projects with detailed technical drawings and a description of the intended work. Members of the IAC staff conducted all the correspondence with the bodies concerned, summoned the parties involved and invited competent specialists to special meetings on restoration matters that were held on the commission's premises. Reports drawn up at the completion of work were also submitted to the IAC's archive. The meetings had to have representatives of the Academy of Arts, the Synod and the Construction Committee attached to the Ministry for Internal Affairs in attendance. Specialists from the Academy of Arts and the IAC were sent on assignment to oversee on the spot the implementation of the repair work and the taking of architectural measurements and records (IHMC Archive 1882: ff. 171f; Beskrovnyi 1978: 137f). The approval of the rules conclusively gave the IAC priority in deciding restoration issues as well. Thus, in 1889–1890, a centralized system of archaeological and restoration research took shape in Russia with the Imperial Archaeological Commission acting as the coordinating centre.

Having consolidated its position in scholarly circles, the IAC continued its activities in the preservation of historical monuments in the 1890s. In 1891 and 1894, at the commission's initiative, the Ministry for Internal Affairs sent out circular directives to all the provinces insisting on compliance with 1889 decree, i.e. that excavations should be carried out only after receipt of official permission from the IAC and that all antiquities uncovered should be placed at its disposal (IHMC Archive 1887: ff. 251, 277, 365–367). In this period the IAC's chairman, Count Bobrinskii, repeatedly submitted to the Ministry for Internal Affairs and the Ministry of Justice legislative proposals aimed at increasing police supervision of the preservation of monuments, introducing a number of clauses in Russian laws making it a criminal offence to carry out unauthorized excavations or to damage ancient monuments, and introducing penalties for those in charge of construction work if they demolished historical monuments or carried out work without informing the commission (IHMC Archive 1887: ff. 258f, 321f; IHMC Archive 1900: ff. 35f, 44f). Sadly, none of these proposals were implemented.

In the 1890s, the architectural-archaeological sphere of the IAC's activities began to evolve rapidly due to the operation of the 1889 decree and the 1890 rules, giving the commission the opportunity to oversee, jointly with the Academy of Arts, all restoration work in Russia. After the introduction of the decree and the rules on restoration, special restoration sessions were held on the premises of the IAC. These meetings were called to examine requests and projects for the repair and restoration of architectural monuments from a wide range of historical periods submitted to the commission from all provinces and territorial divisions of the Russian Empire. The decisions to permit or forbid repairs and to appoint a specialist to oversee the work were taken collectively. These gatherings also heard reports about surveys carried out on architectural monuments. All the project documentation and correspondence ended up in the IAC's archives. In the early 1890s, the commission also received a collection of over 7,000 architectural

dossiers on Russia's churches that had been collected previously on the initiative of the Academy of Arts (Medvedeva and Musin 2009: 981f).

In the nineteenth century, the IAC did not have its own architect on staff. Until the approval of the post of architect in the rolls of the commission in 1902, it invited competent outside specialists to supervise and direct restoration work, to represent its interests in restoration commissions and to take part in Architects' Congresses. They included prominent researchers of Early Russian architecture: members of the Imperial Academy of Arts; Academicians of Architecture Mikhail Preobrazhenskii, Grigorii Kotov and Vladimir Suslov; member of the Interior Ministry's Technical and Construction Committee and Academician of Architecture Ieronim Kitner; Professor and Director of the Institute of Civil Architects Nikolai Sultanov; Professor of the St Petersburg Theological Academy and, subsequently, Director of the Archaeological Institute Nikolai Pokrovskii. The composition of the restoration meetings was not restricted to architects and engineers: all the gatherings were invariably attended by archaeologists belonging to the IAC. In the 1890s, the minutes most often record the presence of Aleksei Bobrinskii, Vladimir Tiesenhausen (Tizengauzen), Nikolai Veselovskii and Vasilii Druzhinin. A considerable influence in shaping both organizational and academic aspects of the IAC's restoration activities was exerted by Nikolai Sultanov (Savel'ev 2009), who was one of the permanent and main speakers at restorations sessions in the late nineteenth and early twentieth centuries. On his initiative, from 1907, restoration issues of the Bulletin of the IAC were published, making it possible to systematize and generalize the material accumulated during the work of the restoration sessions and to acquaint a wide circle of specialists with the state of affairs regarding the preservation of ancient architectural monuments in Russia. Altogether, 19 issues of this sort were published.

The IAC's first practical restoration work took place in the late 1880s and related to a project for the restoration of "three ancient buildings in Vladimir and Pskov provinces" (Medvedeva and Musin 2009: 973–984). In 1886, the prominent Russian photographer Ivan Barshchevskii (who did work for the Russian Archaeological Society, the Academy of Arts and the Moscow Archaeological Society) submitted a note to the Ministry of the Imperial Court about three Early Russian buildings – a chapel near Pereslavl'–Zalesskii (Fig. 3.1), St George's Cathedral in Yur'ev–Pol'skii and the Cathedral of the Transfiguration in Pskov's Mirozhskii Monastery. He pointed out the historical significance of those architectural monuments, expressed concern about their state of preservation and indicated the need to keep them from further deterioration. As proof of his observations, Barshchevskii appended ten photographs to his note. The commission requested his entire collection of photographs of Russian architecture. By February 1887, 610 prints of architectural monuments had been delivered to St Petersburg and, in addition, 697 photographs of ancient objects. This collection became the start of the commission's unique photographic archive (Medvedeva and Musin 2009: 973). As result of the note, Academician Vladimir Suslov tackled the restoration of St Theodore's Chapel in Pereiaslavl'–Zalesskii on an

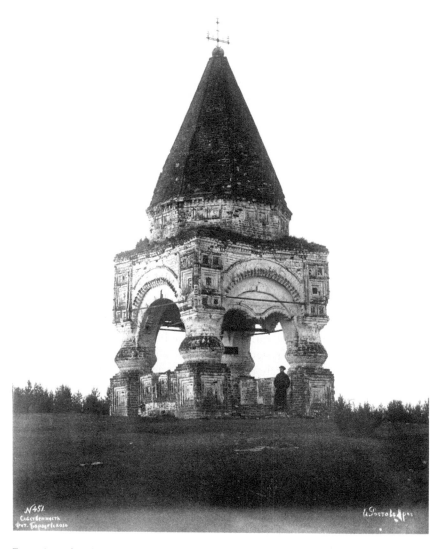

Figure 3.1 The chapel near Pereslavl'–Zalesskii before restoration. Photograph by Ivan
 Barshchevskii. (Photographic Department of the Research Archive, RAS
 Institute for the History of Material Culture, print 0.486/30)

assignment from the IAC (Suslova 1959; Lisovskii 1971; Suslova and Slavina
1978; Suslov 1993; Bonitenko 2000). The same architect surveyed the cathedral
of the Mirozhskii Monastery in Pskov and prepared a restoration project for it.
Up until the end of the century, Suslov was the main person carrying out pre-
restoration research for the Archaeological commission. He is also connected
with the prolonged process of restoration of St Sophia's Cathedral in Novgorod

and with the study of the Dormition Church at Volotovoe Pole, the Church of the Saviour on Nereditsa Hill near Novgorod, and other edifices (Medvedeva and Musin 2009: 990–996).

At the turn of the twentieth century, the scale of illicit excavations in the south of Russia grew considerably, and the export of ancient artefacts abroad acquired catastrophic proportions. This situation was the consequence of increased demand for classical and Scythian antiquities and also for old Russian icons. According to the IAC's information, the prices offered by foreign collectors and museums were so high that it became practically impossible to acquire pieces for Russian museum collections. The idea of restricting the right to export antiques from Russia was raised repeatedly, but no legislative measures were ever taken. The issue of the protection and status of historical monuments located on privately owned land also remained completely unsettled.

In 1898, IAC chairman Bobrinskii submitted to the Ministry of Internal Affairs a brief overview of measures for the preservation of the nation's antiquities and a proposal for the creation of departments responsible for compiling a register of monuments and for their preservation to be attached to the provincial statistics committees (IHMC Archive 1887: ff. 362–365; Beskrovnyi 1978: 145–150), but the proposal was rejected. For its part, in 1901, the ministry tried to compel the provincial authorities to send in yet another set of lists of antiquities requiring protection, but due to the lack of qualified specialists at a local level this instruction again failed to produce the expected results and did not improve the state of affairs with the protection of monuments.

The long-awaited approval in 1902 of the post of staff architect of the IAC provided a new impetus for the rapid development of the commission's restoration activities. The man appointed to the post was the young, gifted and extremely energetic Pëtr Pokryshkin (Mednikova 1995; Medvedeva 2004; Medvedeva and Musin 2009; Platonova 2015) (Fig. 3.2).

He concentrated in his hands all the IAC's research work studying Russia's architectural richness. The commission's restoration researches acquired a more purposeful and systematic character. The number of cases examined at restoration sessions increased significantly. By the 1910s, Pokryshkin had become the undoubted leader of the IAC's practical architectural-archaeological and restoration research work and, for all intents and purposes, was in charge of the restoration sessions. The architect's methodological publications in the Bulletin of the IAC, containing recommendations relating to the repair of ancient buildings, generalized from his priceless practical experience (Pokryshkin 1905, 1910, 1915).

Pokryshkin's astonishing industry and enthusiasm as well as his amazing dedication and high level of professionalism were undoubtedly some of the factors that facilitated the rapid development of the IAC's restoration activities in the early twentieth century and the growth of its scholarly authority in the field of the study and preservation of Russia's architectural heritage. It was Pokryshkin who accomplished the Imperial Archaeological Commission's grandest restoration project in north-western Russia – the work on the Church of the Saviour

Figure 3.2 Pëtr Petrovich Pokryshkin (1870–1922). Photograph taken in Ivan Nedëshov's studio, St Petersburg, 1910s. (Photographic Department of the Research Archive, RAS Institute for the History of Material Culture, print 0.1638/24)

on Nereditsa near Novgorod in 1903–1904 (Pokryshkin 1906; Iadryshnikov 2000: 71–79; Shchenkov 2002: 408–410). For its time, the carrying out of such a large-scale restoration of an architectural monument was a real achievement and heralded a new stage in the development of the Russian school of architectural restoration (Mikhailovskii 1971: 132; Pod"iapol'skii et al. 2000: 36). The documentation assembled in the process of preparing and performing this project became unique source material for the reconstruction of the church after it was badly damaged in the Second World War and for the restoration of its frescoes, which is still continuing today.

The heyday of the IAC's activities in the study and preservation of Russia's architectural monuments is eloquently reflected in the official statistics from reports recording the number of repair and restoration projects discussed at restoration sessions. While in 1894 just a dozen cases were examined at the sittings, in the 1910s around 100–150 were examined each year. In actual fact the number was even higher: some straightforward questions to do with the repair of buildings were decided at ordinary sessions of the Archaeological commission. According to Pokryshkin's data, in 1912, 1913 and 1914 the total number of cases considered each year was over 200 (Medvedeva and Musin 2009: 939).

In a report on the IAC's architectural activities for the previous decade drawn up in 1913, Pokryshkin presented a map of researches (Medvedeva and Musin 2009: 939–943) and a list of his own official journeys made all over Russia between 1903 and 1913 to observe repair and restoration work. In all, the architect covered 166,318 versts (over 177,000 km), and, in the course of his travels, he studied, photographed and measured a huge number of architectural monuments of different periods and styles.

In the early twentieth century, two more architects joined Pokryshkin on the staff of the IAC – Dmitrii Mileev (Jolshin et al. 2015; Khodakovsky and Meliukh 2015; Khodakovsky 2016) and Konstantin Romanov (Medvedeva 2005), who were subsequently to ensure the successful development of his undertakings and to expand the fields of the IAC's architectural-archaeological activities. By the 1910s, the geographical bounds of the commission's practical architectural-archaeological and restoration work expanded. Besides the projects already mentioned to study and preserve monuments of Novgorodian and Pskovian architecture, considerable restoration works connected with the celebration of the three-hundredth anniversary of the Romanov Dynasty were carried out in 1911–1913 at the Ipat'ev Monastery in Kostroma under Mileev's direction (Jolshin et al. 2015: 197–251). In Arkhangel'sk in 1911–1912, Mileev and Pokryshkin's joint efforts accomplished a unique project to straighten the bell-tower of the Dormition Church (Jolshin et al. 2015: 189–197). With his researches in Kiev in 1908–1914, Mileev laid the foundation for the development of a scientific method of architectural archaeology in Russia (Jolshin 2009).

In the 1910s, the Russian Military History Society developed a multidisciplinary programme for the study and preservation of works of defensive architecture in Russia, including taking measurements, making technical drawings and detailed photographic recording, and the preparation of projects for subsequent

restoration. Pokryshkin and Romanov played an active part in this work: they studied and carried out partial repairs of the fortress walls and installations of Pskov, Novgorod, Izborsk and other Early Russian towns. Pokryshkin oversaw the repair of the walls of Smolensk (Medvedeva 2010, 2014; Medvedeva and Musin 2009: 950–966).

An expedition to Central Asia was organized as early as the 1890s, under the leadership of the IAC staff member Nikolai Veselovskii, with the aim of photographing, measuring, making technical drawings and producing a scholarly description of the architectural monuments of Samarkand. This work is considered the start of the systematic study of the historical and cultural monuments of Russian Turkestan (Dluzhnevskaia and Kircho 2009: 790–795, 811). From the late nineteenth century, the archaeologist, orientalist and philologist Nikolai Marr studied the architectural antiquities of Armenia on an assignment from the IAC. Most widely known are his endeavours in studying the medieval city of Ani (Dluzhnevskaia 2014: 26f). In Siberia work was carried out to preserve the wooden stockade of Yakutsk, the towers in Ilimsk and a number of churches in Tobol'sk and Tiumen'.

Mention should be made of the IAC's efforts to restore architectural monuments on the territories of present-day Belarus, Ukraine, Poland, Lithuania, Latvia and Estonia, all then part of the Russian Empire. Best known among them are Pokryshkin's works in Poland. In 1903 he carried out the cleaning of the murals in a Catholic church in Lublin, while in 1910 and 1912 he carried out archaeological explorations of buildings from Daniel of Galicia's time on cathedral hill in Chełm. He also oversaw work to restore the Church of the Saviour at Berestovo in Kiev, Ostrog castle in Volhynia province, the White Tower (Belaia Vezha) in Kamenets-Litovsk in Grodno province, and other projects (Medvedeva and Musin 2009: 1030–47). Thus, in the early twentieth century, the IAC's efforts to preserve the Russian Empire's architectural heritage extended from the Kingdom of Poland in the West to Siberia in the East, from Arkhangel'sk province in the North to the Caucasus and Central Asia in the South.

During the First World War, the IAC took part in tackling questions to do with the preservation of architectural monuments. In 1916, Academician of Architecture Pëtr Pokryshkin was appointed to chair the commission to study the damage inflicted on edifices in the zone of military operations. In 1916–1917, he was with a group of researchers studying buildings behind the front line in Bukovina. In that same period, on assignment from the IAC, Pokryshkin oversaw the laying of a railway near the Church of the Saviour on Nereditsa outside Novgorod, where during the war, in 1916, work began on the strategically important main line from Petrograd to Orël (Markina 2000; Medvedeva 2013).

In the early twentieth century, the IAC had already effectively become the basis for the formation of a scientific centre for the restoration, study and preservation of architectural monuments and icon-painting in Russia, where the commission's architects were to be the leading specialists. Sadly, though, this was not destined to happen. Dmitrii Mileev died young in the summer of 1914. Under the new Soviet regime, Pëtr Pokryshkin declined to work in the Academy

for the History of Material Culture, the successor to the IAC, and entered the Church, becoming a priest (Degteva 2004). Only Konstatin Romanov continued to engage in the study and restoration of works of Early Russian architecture and icon-painting after the revolution. He actively participated in the development of measures for their conservation and remained on the staff of the Academy for the History of Material Culture for many more years.

The history of the Imperial Archaeological Commission ended in 1918–1919, when it was transformed first into the Russian State Archaeological Commission and then into the Academy for the History of Material Culture (Platonova and Musin 2009). Throughout its existence, the commission was the only government institution in Russia whose purpose was to deal with matters of the preservation of archaeological and architectural heritage in its widest interpretation and the coordination of the activities of the scholarly community in that sphere. In a situation where there was a state system enshrined in legislation for the preservation of ancient monuments, and a lack of competent specialists and executive bodies at a local level, the Archaeological commission in practice implemented a variety of measures aimed at preserving Russia's antiquities, using the funding available to it, methods of administrative coercion and the special status that came from being attached to the Ministry of the Imperial Court. Sadly, all these factors applied only to state-owned lands, since the commission's charter restricted its activities to such territories. The issue of organizing protection for monuments on privately owned land was raised repeatedly but never settled.

In 1889, the IAC was granted exclusive rights to deal with questions relating to the study of archaeological antiquities and the restoration of architectural monuments, following which the organizational structure for archaeological and pre-restoration researches was unified across Russian territory. The Imperial Archaeological Commission effectively began to perform the functions of a coordinating and supervising centre in this sphere for the whole of the empire. The practice of the centralized issue of permits to carry out archaeological work and the requirement to provide written reports afterwards, first introduced on the initiative of the IAC in 1889, proved its viability throughout the whole twentieth century and continues to operate today.

In the second half of the nineteenth century, it became evident that the sporadic measures being taken by scholarly societies to preserve Russian antiquities could not save historical edifices and artefacts from being destroyed, plundered or spirited abroad. There was a need to organize an effective state system of legal protection for monuments, to create central and local executive bodies for the preservation of antiquities made up of competent specialists, and to step up public education so as to shape an awareness of the importance of preserving the nation's historical heritage. During the pre-revolutionary period, several government commissions engaged in drafting legislation "on measures for the protection of the monuments of antiquity" and also the review of the existing building code with a view to adding new clauses dealing with ancient monuments and edifices.

Representatives of the IAC participated actively in the work of all the commissions and conferences on preparing regulations on the protection of historical

monuments in Russia. In 1916, IAC president Aleksei Bobrinskii was due to become head of a commission to work out the final version of the draft law. Under conditions of wartime and due to the political changes that took place in Russia, the draft never was finalized. Nevertheless, the scholarly community's activities in devising laws for the protection of the nation's historical heritage in the second half of the nineteenth century and start of the twentieth had a great influence on the subsequent formation of a system for the protection of monuments in Russia: the main legal approaches were worked out; the principles for the formation of a network of executive bodies to provide protection were determined; the importance of implementing a state programme to compile a unified register of antiquities was recognized; criteria were determined for selecting those that should be protected. Many of these principles later became the foundation for Soviet legislation on the protection of historical monuments.

Credit is due to the staff of the Imperial Archaeological Commission for creating a unique archive of photographic and written records and for the formation of a very large collection of books not only on archaeological subject matter but also in a whole range of disciplines in the humanities. Through the intensive functioning of the restoration sessions, the IAK staff accumulated invaluable experience in the study of historical edifices in Russia. During the period of the commission's existence, it assembled a tremendous amount of material better defining the appearance of surviving edifices, and it carried out considerable work to record them in photographs, written descriptions and precise measurements and to devise projects for the restoration of hundreds of architectural monuments. Today, the materials from the IAC, which are kept in the archives and library of the Institute for the History of Material Culture, are of tremendous academic and practical value in the field of the preservation and study of historical monuments, especially as many of them have since been lost.

Literature

Beskrovnyi, Lubomir G. ed. (1978). *Okhrana pamiatnikov istorii i kul'tury v Rossii: XVIII – nachalo XX vv.* [The Preservation of Historical and Cultural Monuments in Russia: 18th – Early 20th Centuries], an anthology of documents from the USSR Academy of Sciences Institute of the History of the USSR and Institute of Archaeology (Leningrad branch) and the Central State Historical Archive of the USSR. Moscow.

Bonitenko, Adiia K. (2000). "'Ia bezzavetno sluzhil iskusstvu vsiu svoiu zhizn'.' Iz vospominanii akademika arkhitektury V. V. Suslova" ['I devotedly served art all my life.' From the memoirs of Academician of Architecture V. V. Suslov]. In: *Liudi i sud'by na rubezhe vekov. Vospominaniia. Dnevniki. Pis'ma. 1895–1925* [People and Destinies at the Turn of the Century. Memoirs, Diaries, Letters. 1895–1925], ed. Adiia K. Bonitenko. Saint Petersburg: Liki Rossii. pp. 146–163.

Danilov, Ivan G. (1886). "Pravitel'stvennye rasporiazheniia otnositel'no otechestvennykh drevnostei s imperatora Petra I, osobenno v tsarstvovanie imperatora Aleksandra II" [Government Ordinances Regarding the Nation's Antiquities Since Emperor Peter I, Especially in the Reign of Emperor Alexander II]. In: *Vestnik arkheologii i istorii* [*Bulletin of Archaeology and History*]. Vol. 6. Saint Petersburg: V. Bezobrazov & Co. Printers. pp. 1–50.

Dediukhina, Valentina S., Maslenitsyna, Svetlana P., Shestopalova, Lidiia V., Lifshits, Lev I. and Potapova, Natal'ia A. (1997). *Sokhranenie pamiatnikov tserkovnoi stariny v Rossii XVIII–nachala XX vv. Sbornik dokumentov* [The Preservation of Ecclesiastical Ancient Monuments in Russia 18th – Early 20th Centuries]. Moscow: Otechestvo.

Degteva Ol'ga V. (2004). "Sluzhenie Otechestvu i tserkvi" [Service to Country and Church]. In: *Nizhegorodskaia starina* [Olden Times of Nizhny Novgorod], ed. Arhimandrite Tikhon (Zatekin). Issue 9. Nizhny Novgorod: Poligraflend. pp. 34f.

Dluzhnevskaia, Galina V. (2014). *Arkheologicheskie issledovaniia v Evropeiskoi chasti Rossii i na Kavkaze v 1859–1919 gg. (po dokumentam Nauchnogo arkhiva Instituta istorii material'noi kul'tury RAN)* [Archaeological Researches in European Russia and the Caucasus in 1859–1919 (from documents in the Research Archive of the Russian Academy of Sciences Institute for the History of Material Culture)]. Saint Petersburg: LEMA.

Dluzhnevskaia, Galina V. and Kircho, Liubov' B. (2009). "Imperatorskaia Arkheologicheskaia komissiia i izuchenie drevnostei Srednei Azii" [The Imperial Archaeological Commission and the Study of the Antiquities of Central Asia]. In: *Imperatorskaia Arkheologicheskaia komissiia (1859–1917 gg.) K 150-letiiu ee osnovaniia. U istokov otechestvennoi arkheologii i okhrany kul'turnogo naslediia* [The Imperial Archaeological Commission (1859–1917). To mark the 150th anniversary of its foundation. At the Beginnings of archaeology and protection of cultural heritage in this country], ed. Aleksandr E. Musin and Evgenii N. Nosov. Saint Petersburg: Dmitrii Bulanin. pp. 783–812.

Iadryshnikov, Vladimir A. (2000). *Spaso-Nereditskii monastyr': istoriia stroitel'stva i restavratsii* [The Saviour Monastery on Nereditsa: A History of the Construction and Restoration]. *Novgorodskii istoricheskii sbornik* [Novgorodian Historical Anthology]. Vol. 8, No. 18. Saint Petersburg: Dmitrii Bulanin.

Jolshin, Denis D. (2009). "Imperatorskaia Arkheologicheskaia Komissiia i raskopki v Kieve 1908–1914 gg." [The Imperial Archaeological Commission and Excavations in Kiev 1908–14]. In: *Imperatorskaia Arkheologicheskaia komissiia (1859–1917 gg.) K 150-letiiu ee osnovaniia. U istokov otechestvennoi arkheologii i okhrany kul'turnogo naslediia* [The Imperial Archaeological Commission (1859–1917): To mark the 150th anniversary of its foundation. At the Beginnings of archaeology and protection of cultural heritage in this country], ed. Aleksandr E. Musin and Evgenii N. Nosov. Saint Petersburg: Dmitrii Bulanin. pp. 909–937.

Jolshin, Denis D., Meliukh, Ekaterina A. and Khodakovsky, Evgeny V. (2015). *Dmitrii Vasil'evich Mileev (1878–1914). Arkhitekturnaia arkheologiia i restavratsiia v Rossii v nachale XX v.* [Dmitrii Vasil'evich Mileev (1878–1914). Architectural Archaeology and Restoration in Russia in the Early 20th Century]. Saint Petersburg: Dmitrii Bulanin.

Khodakovsky, Evgeny (2016). *Wooden Church Architecture of the Russian North: Regional Schools and Traditions.* London, New York: Routledge.

Khodakovsky, Evgeny and Meliukh, Ekaterina (2015). "Dmitrii Mileev and the Restoration of Wooden Architectural Monuments in Early Twentieth-Century Russia", *Russian Review*, Vol. 74, No. 2, pp. 247–271.

Lapshin, Vladimir A. (2002). "Bor'ba za okhranu pamiatnikov arkheologii v Rossii vo vtoroi polovine XIX– nachale XX v.'" [The Struggle for the Preservation of Archaeological Sites in Russia in the Second Half of the 19th Century and Early 20th], *Kul'turnoe nasledie Rossiiskogo gosudarstva* [Cultural Heritage of the Russian State], Issue III. Saint Petersburg: IPK Vesti. pp. 79–87.

Lisovskii, Vladimir G. (1971). *Akademik arkhitektury Vladimir Vasil'evich Suslov. Katalog vystavki* [Academician of Architecture Vladimir Vasil'evich Suslov. Exhibition Catalogue]. Leningrad: Iskusstvo.

Markina, Galina K. (2000). "Stroitel'stvo zheleznodorozhnoi magistrali Petrograd-Tsarskoe Selo-Novgorod i bor'ba za sokhranenie novgorodskikh pamiatnikov stariny" [The Construction of the Petrograd-Tsarskoye Selo-Novgorod Mainline Railway and the Struggle for the Preservation of Novgorodian Ancient Monuments], *Novgorodskii istoricheskii sbornik* [Novgorodian Historical Anthology]. Vol. 8, No. 18. Saint Petersburg: Dmitrii Bulanin. pp. 331–363.

Materialy po voprosu o sokhranenii drevnikh pamiatnikov, sobrannye Moskovskim Arkheologicheskim Obshchestvom [Materials on the Question of the Preservation of Ancient Monuments Gathered by the Moscow Archaeological Society] (1911). Moscow: MAO [Moscow Archaeological Society].

Mednikova, Elena Iu. (1995). "Deiatel'nost' akademika arkhitektury P.P. Pokryshkina v Imperatorskoi Arkheologicheskoi Komissii (po materialam rukopisnogo arkhiva IIMK RAN)" [The Activities of Academician of Architecture P.P. Pokryshkin in the Imperial Archaeological Commission (on the basis of materials in the manuscript archive of the RAS Institute for the History of Material Culture], *Arkheologicheskie Vesti* [*Archaeological News*]. No 4. Saint Petersburg: Petro-RIF. pp. 303–311

Medvedeva, Mariia V. (2004). "Pëtr Petrovich Pokryshkin i problemy okhrany pamiatnikov (po materialam arkhivov IIMK RAN)" [Pëtr Petrovich Pokryshkin and Problems of Protecting Monuments (on the basis of materials in the archives of the RAS Institute for the History of Material Culture], *Arkheologicheskie Vesti* [*Archaeological News*]. No 11. Saint Petersburg: Dmitrii Bulanin. pp. 379–387.

Medvedeva, Mariia V. (2005). "Deiatel'nost' arkhitektora K.K. Romanova v oblasti izucheniia i okhrany pamiatnikov monumental'nogo zodchestva po dokumentam iz sobraniia Nauchnogo arkhiva IIMK RAN" [The Activities of the Architect K.K. Romanov in the field of the study and preservation of architectural monuments on the basis of materials in the Research Archive of the RAS Institute for the History of Material Culture]. *Arkheologicheskie Vesti* [*Archaeological News*]. No 12. Saint Petersburg: Dmitrii Bulanin. pp 291–301.

Medvedeva, Mariia V. (2010). Imperatorskaia Arkheologicheskaia Komissiia i problemy sokhraneniia drevnikh sten Pskova v kontse XIX-nachale XX v." [The Imperial Archaeological Commission and Problems of the Conservation of the Ancient Walls of Pskov in the Later 19th and Early 20th Centuries]. In: *Dialog kul'tur narodov srednevekovoi Evropy. K 60-letiiu so dnia rozhdeniia E.N. Nosova* [The Dialogue of Cultures of the Peoples of Medieval Europe. Festschrift for E.N. Nosov's 60th Birthday], ed. Aleksandr E Musin and Natal'ia V. Khvoschinskaya. Saint Petersburg: Dmitrii Bulanin. pp. 474–483.

Medvedeva, Mariia V. (2013). Arkheologicheskii nadzor pri stroitel'stve zheleznodorozhnoi nasypi k iugu ot Novgoroda v 1916–1917 gg. Khronika sobytii. Vzgliad so storony Imperatorskoi Arkheologicheskoi Komissii [Archaeological Supervision During the Construction of the Railway Embankment to the South of Novgorod in 1916–17. A Chronicle of Events. The Imperial Archaeological Commission's View], *Materialy konferentsii 'Novgorod i Novgorodskaia zemlia. Istoriia i arkheologiia'* [Materials of the Conference "Novgorod and the Novgorodian Land. History and Archaeology"]. Issue 27. Novgorod: OOO "Pervyi izdatel'sko-poligraficheskii kholding". pp. 342–349.

Medvedeva, Mariia V. (2014). "Steny i bashni Novgorodskogo Kremlia v rukopisnykh i fotodokumentakh Nauchnogo arkhiva IIMK RAN" [The Walls and Towers of the Novgorod Kremlin in Manuscript and Photographic Documents in the Research Archive of the RAS Institute for the History of Material Culture], *Materialy konferentsii 'Novgorod i Novgorodskaia zemlia: Istoriia i arkheologiia'* [Materials of the Conference

"Novgorod and the Novgorodian Land. History and Archaeology"]. Issue 28. Novgorod: Novgorod State Museum Preserve, ed. Valentin L. Yanin. pp. 336–345.

Medvedeva, Mariia V. and Musin, Aleksandr E. (2009). "Imperatorskaia Arkheologicheskaia komissiia: restavratsiia i okhrana pamiatnikov kul'tury" [The Imperial Archaeological Commission: Restoration and Protection of Cultural Monuments]. In: [*The Imperial Archaeological Commission (1859–1917). To mark the 150th anniversary of its foundation. At the Beginnings of archaeology and protection of cultural heritage in this country*], ed. Aleksandr E. Musin and Evgenii N. Nosov. Saint Petersburg: Dmitrii Bulanin. pp. 938–1064.

Medvedeva, Mariia V., Musin, Aleksandr E., Vseviov, Lev M. and Tikhonov, Igor' L. (2009). "Ocherk istorii deiatel'nosti Imperatorskoi Arkheologicheskoi komissii v 1859–1917 gg." [An Outline of the History of the Activities of the Imperial Archaeological Commission in 1859–1917]. In: [*The Imperial Archaeological Commission (1859–1917). To mark the 150th anniversary of its foundation. At the Beginnings of archaeology and protection of cultural heritage in this country*]. Saint Petersburg: Dmitrii Bulanin. pp. 21–247.

Mikhailovskii Evgenii V. (1971). *Restavratsiia pamiatnikov arkhitektury (razvitie teoreticheskikh kontseptsii)*. Moscow: Izdatel'stvo literatury po stroitel'stvu.

Peskarëva, Klavdiia M. and Riabinin, Evgenii A. (1984). *Pervoe gosudarstvennoe uchrezhdenie otechestvennoi arkheologii (k 125-letiiu sozdaniia Arkheologicheskoi Komissii* [The First State Institution of Archaeology in This Country (Marking the 125th Anniversary of the Archaeological Commission)], *Sovetskaia Arkheologiia* [*Soviet Archaeology*]. No 4. Moscow: Nauka. pp. 299–307.

Platonova, Nadezhda I. (2015). "Arkhitektor-arkheolog P. P. Pokryshkin: stranitsy biografii" [The Architect-Archaeologist P.P. Pokryshkin: Pages of a Biography"], *Kratkie soobshcheniia Instituta arkheologii* [Brief Communications of the Institute of Archaeology]. No 241. Moscow: IA RAN. pp. 422–437.

Platonova, Nadezhda I. and Musin, Aleksandr E. (2009). "Imperatorskaia Arkheologicheskaia komissiia i ee preobrazovanie v 1917–1919 gg." [The Imperial Archaeological Commission and Its Transformation in the Years 1917–19]. In: [*The Imperial Archaeological Commission (1859–1917). To mark the 150th anniversary of its foundation. At the Beginnings of archaeology and protection of cultural heritage in this country*], ed. Aleksandr E. Musin and Evgenii N. Nosov. Saint Petersburg: Dmitrii Bulanin. pp. 1065–1115.

Pod"iapol'skii, Sergei S., Bessonov, German B., Beliaev, Leonid A., Korkin, Vladimir D., Postnikova, Tamara M. and Tabunshchikov, Iurii A. (2000). *Restavratsiia pamiatnikov arkhitektury* [The Restoration of Architectural Monuments]. Moscow: Stroiizdat.

Pokryshkin, Pëtr P. (1905). "Kratkie sovety dlia proizvodstva tochnykh obmerov v drevnikh zdaniiakh" [Brief Advice on Making Precise Measurements in Ancient Buildings]. *Izvestiia IAK* [Proceedings of the IAC]. Issue 16. Saint Petersburg: Printworks of the Main Administration of Appanages. pp. 120–123.

Pokryshkin, Pëtr P. (1906). "Otchet o kapital'nom remonte Spaso-Nereditskoi tserkvi v 1903–1904 gg." [Report on the Major Repairs to the Church of the Saviour on Nereditsa], Materialy po arkheologii Rossii [Materials on the Archaeology of Russia]. No 30. Saint Petersburg: Printworks of the Main Administration of Appanages.

Pokryshkin, Pëtr P. (1910). "Provetrivanie zdanii, osobenno kholodnykh" [The Ventilation of Buildings, Especially Unheated Ones]. *Izvestiia IAK* [Proceedings of the IAC]. Issue 34. *Voprosy restavratsii* [Questions of Restoration]. Issue 5. Saint Petersburg: Printworks of the Main Administration of Appanages. pp. 85–87.

Pokryshkin, Pëtr P. (1915). Kratkie sovety po voprosam remonta pamiatnikov stariny i iskusstva [Brief Advice on Questions of Restoring Ancient Monuments and Works of Art]// *Izvestiia IAK* [Proceedings of the IAC]. Issue 57. *Voprosy restavratsii* [Questions of

Restoration]. Issue 15. Petrograd: Printworks of the Main Administration of Appanages. pp. 178–190.

Poliakova, Marta A. (2005). *Okhrana kul'turnogo naslediia Rossii* [The Preservation of Russia's Cultural Heritage]. Moscow: Drofa.

Razgon, Avram M. (1957). "Okhrana istoricheskikh pamiatnikov v dorevoliutsionnoi Rossii (1861–1917)" [The Preservation of Historical Monuments in Pre-Revolutionary Russia (1861–1917)], *Istoriia muzeinogo dela v SSSR* [The History of Museum Work in the USSR]. Vol. 1. Moscow. pp. 73–129.

Savel'ev, Iurii R. (2009). *Nikolai Vladimirovich Sultanov. Portret arkhitektora epokhi istorizma* [Nikolai Vladimirovich Sultanov. Portrait of an Architect of the Era of Historicism]. Saint Petersburg: Liki Rossii.

Shchenkov, Aleksei. S. ed. (2002). *Pamiatniki arkhitektury v dorevoliutsionnoi Rossii. Ocherki istorii arkhitekturnoi restavratsii* [Architectural Monuments in Pre-Revolutionary Russia. Outlines of the History of Architectural Restoration]. Moscow: Terra.

Smolin, Viktor F. (1917). "Kratkii ocherk zakonodatel'nykh mer po okhrane pamiatnikov stariny v Rossii" [A Brief Outline of Legislative Measures for the Preservation of Ancient Monuments in Russia], *Izvestiia IAK* [Proceedings of the IAC]. Issue 63. Saint Petersburg: Printworks of the Main Administration of Appanages. pp. 121–148

Suslova, Anna V. (1959). "Nekotorye dannye k kharakteristike deiatel'nosti akademika arkhitektury V.V. Suslova v oblasti restavratsii i okhrany novgorodskikh pamiatnikov" [Some Data for a Description of the Activities of Academician of Architecture V.V. Suslov in the Field of the Restoration and Preservation of Novgorodian Monuments]. *Novgorodskii istoricheskii sbornik* [Novgorodian Historical Anthology]. Issue 9. Novgorod: Borovichi Municipal Printworks. pp. 191–219.

Suslova, Anna V. (1993). "Issledovanie i podgotovka k restavratsii Spaso-Nereditskoi tserkvi akademikom arkhitektury V.V. Suslovym v 1896–1898 gg" [The Study and Preparation for Restoration of the Church of the Saviour on Nereditsa by Academician of Architecture V.V. Suslov in 1896–98]. *Novgorodskii istoricheskii sbornik* [Novgorodian Historical Anthology]. Issue 4(14). Saint Petersburg – Novgorod: Novgorod Printworks. pp. 208–215.

Suslova, Anna V. and Slavina Tat'iana, A. (1978). *Vladimir Suslov*. Leningrad: Stroiizdat.

Archival sources

All archival sources are in Russian and are kept in the Manuscript Section of the Research Archive of the Russian Academy of Sciences Institute for the History of Material Culture in Saint Petersburg. For brevity, the documents are cited in the text as "IHMC Archive" plus the year.

——— (1859). Fund 1, Schedule1, File 1. On the foundation of the Imperial Archaeological Commission.

——— (1862(a)). Fund 1, Schedule1, File 26. On the Engineering Department and Administration of Transport Routes being asked to assist the Archaeological Commission in the preservation of antiquities when ancient works of architecture are demolished, roads laid out and so on.

——— (1862(b)). Fund 1, Schedule1, File 27. On the provincial statistics committees being asked to take part in the study and preservation of the nation's antiquities.

——— (1882). Fund 1, Schedule1, File 31. On changes to the Commission's statutes and staff rosters.

——— (1886). Fund 1, Schedule1, File 50. On relations with the Ministry for Internal Affairs regarding the prevention of excavations on state, church and public lands.

——— (1887). Fund 1, Schedule1, File 69. On establishing order in the collection and preservation of artefacts from burial mounds.

——— (1900). Fund 1, Schedule1, File 174. On the presentation to the Chancellery of the Ministry of the Imperial Court of "Outlines of the Commission's Activities during the Reign of Emperor Alexander III".

——— (1903). Fund 1, Schedule1, File 50. On participation in the review of a new "Building Statute" that was being drafted.

4 Cultural heritage in Norway and the international exchange of ideas

A scholarly description and a personal narrative

Dag Myklebust

The scholarly description

The intellectual platform for Norwegian cultural heritage protection was laid out by our first famous painter, Johan Christian Dahl (1788–1857). He was born in Bergen, the second-largest city in the country, situated on the west coast of southern Norway. Bergen had a rich cultural life with a wide international perspective as it was a trading port exporting dried fish to Europe and was a member of the German Hanseatic League only.

Dahl started out as an apprentice to a house painter, but very soon his artistic talent was discovered by influential members of the cultural elite in Bergen. They collected money to send him to study at the Academy of Fine Arts in Copenhagen. Dahl moved on to the Academy of Arts in the German city of Dresden, where he became a professor in 1826.

Inspired by Dahl, one of his students in Dresden, Joachim Frich (1810–1858), also a native of Bergen, established the Norwegian Society for the Preservation of Ancient Monuments in 1844 together with a group of other painters, architects and intellectuals. When in 1855 its board of directors evaluated the results of the society's work in its first ten years, the conclusion was that the government ought to appoint someone to be officially responsible for the work needed to protect cultural heritage in Norway. It was considered appropriate for that inspector to work directly under the Ministry for Church Affairs and Education.

The Norwegian Parliament declined to establish such a post. Instead, an annual grant was given to the society in 1860 to engage someone to look after the relics of the past. This decision effectively created an inspector, but without the power of a governmental appointment and legislation to support his work. The man engaged for this position – in what was a private, non-governmental organization – was the lawyer and bureaucrat Nicolay Nicolaysen (1817–1911), born and raised in Bergen. He was *de facto* the Inspector for Ancient Monuments in Norway until 1899. During this period, he was also chairman of the society, with a small board of directors to assist him. They were a politically conservative group, opposed to any idea of legislation to protect cultural heritage, since that would mean limiting the right to ownership of private property. Apart from some

random clauses relating to heritage in different specialized laws and regulations, among them the Church Act of 1897, there was no proper heritage legislation in Norway. This meant that we had no real legislation in this field until 1905, when the first act on cultural heritage was passed. However, even that act provided adequate means of protection for prehistoric and medieval objects.

In 1909, a major reorganization of the Society for the Preservation of Ancient Monuments took place, making the board answerable to a representative assembly elected by the different regional branches of the society. The chairman of the reorganization committee was the politician Carl Berner (1841–1918), who had a very high public standing, having been president of the Norwegian Parliament during the dissolution of the union with neighbouring Sweden in June 1905. The article of the society's new statute dealing with the board of directors stated that in the event of a government Inspectorate for Cultural Heritage being established, the inspector should be included as a non-voting member. This was the start of a campaign to have the Parliament establish such a post. Finally, the Ministry of Church and Education officially proposed this measure in 1912, and it was approved by Parliament on 29 March that same year.

The architect Herman Major Schirmer (1845–1913), whose greatest merit was being a successful teacher of architecture students at the Art and Crafts School in the Norwegian capital Kristiania (later Oslo), was appointed by the government as the first State Inspector of Cultural Heritage (*Riksantikvar*) on 15 November 1912. Schirmer was a controversial figure, having had to step down as chairman of the Society for the Preservation of Ancient Monuments after a conflict with the rest of the board of directors. The board did not approve of the way he had sought to manipulate himself into the position of State Inspector behind their backs. In any case, he died in April 1913, after only five months in office, without having dealt with any preservation issues. This opened the field for a new man to take up the governmental work of preserving Norwegian heritage.

The man in question was the young art historian Harry Fett (1875–1962). He was the son of a German immigrant industrialist, but, instead of following his predestined role of becoming a businessman, he chose to travel to Germany and Italy to study the humanities. On his return to Kristiania, he was recruited both as a secretary for the Society for the Preservation of Ancient Monuments and as conservator at the newly founded Norwegian Folk Art Museum. He was a very productive writer, publishing a great number of studies in the spheres of architecture, painting, crafts and folk art. In 1908 he obtained his doctorate with a study of medieval Norwegian sculpture. On his father's death in 1911, fate made him a businessman after all, since he then had to take over as head of the family business – a factory producing pulp and paper products.

Fett took up his post as state inspector in December 1913, but he had no office, no staff and no budget apart from his salary and a small allowance to cover travel costs. In 1917 he was able to hire a secretary and started sharing an office with the Society for the Preservation of Ancient Monuments. He wrote a couple of programmatic articles in the society's yearbook, describing what he felt were the most important tasks in working out government policy for the protection of

cultural heritage. At the top of the list was what he termed "an account of the heritage", an inventory of the cultural capital that valuable historic buildings represented. In 1918 he was provided with professional help to carry out that work, when the theologian Anders Bugge (1889–1955), later a professor of art history, joined the office. More staff were recruited in the following years, and in 1923 they moved into well-functioning offices in what was known as the new Government Building. They shared the building not only with the Ministry of Finance but also with some other government institutions, which created a stimulating working environment.

Another major step forward was taken in 1920, when the Norwegian Parliament, influenced by the *Riksantikvar*, passed a special law: the Law on the Protection of Historic Buildings. This law, based on a similar Danish one from 1918, provided for a special commission to draw up a list of protected buildings, which was done during the 1920s. Eventually, a reasonable working budget was granted, despite the difficulties in the Norwegian economy. Through the 1930s, the inspectorate developed into a functional institution adequate for its purposes.

The difficult times also provided an opportunity. Financed by a grant from the Ministry of Social Affairs, young unemployed men were hired to restore medieval ruins under the guidance of highly competent leaders. Some of those young people acquired sufficient skills to in turn become leaders of their own restoration teams.

Another activity that evolved was the restoration of church interiors and art, and several specially trained and skilled painters were financed by the Ministry of Church Affairs. The leading figure in this field was Domenico Erdman (1879–1940), who had been on the *Riksantikvar*'s staff since 1918.

The German occupation of Norway in 1940 meant new challenges for the *Riksantikvar*. One was to protect culturally significant buildings from being destroyed by fortification projects. Another important task was to protect valuable metal objects like church bells from being commandeered and melted down for military purposes. A third challenge was to keep the ordinary work of the *Riksantikvar* going without becoming compromised by too close contact with either the German occupation administration or the Norwegian Nazi puppet government. The general view is that the *Riksantikvar*'s office under Fett's leadership succeeded in this.

On Hitler's birthday, 20 April 1944, a ship filled with dynamite exploded in the harbour of Bergen, a city with a rich heritage from medieval times and later. Bergen was the capital of Norway till around 1300 and for a long period the largest city in the country. Many important edifices were damaged by the explosion, and a lot of the resources available for heritage protection had to be re-allocated. The Bergenhus fortress complex – including Haakon's Hall, a medieval royal festival hall, and a Renaissance tower with a medieval fortification tower concealed within it – was successfully restored with better functionality and didactic quality than before the catastrophe. The same is true of some important Baroque buildings that were also damaged. In fact, the explosion created new opportunities for architectural archaeology.

The state inspector who had to tackle these demanding tasks was Arne Nygård-Nilssen (1899–1958), an art historian who had joined the *Riksantikvar* service as a student in 1922 and grown to become Fett's obvious successor. He took over in 1946, as Fett had been given the honour of remaining state inspector through the celebrations for the hundredth anniversary of the Society for the Protection of Ancient Monuments, postponed due to the war until the spring of 1946. In view of the colossal challenges faced in Bergen, it was no handicap that this was Nygård-Nilssen's native town.

Another part of Bergen's most important architectural heritage that was partially damaged in 1944 was Bryggen (The Wharf), a row of wooden buildings put up after a fire in 1702. These edifices were rebuilt on their original medieval plots, repeating an ensemble with a 500- to 700-year-old structure. Thankfully, all the buildings proved to be repairable after the war. A large fire in 1955, however, destroyed a large number of the warehouses, and another in 1958 damaged a few more. This again created a great opportunity for archaeologists, with excavations going on for almost 15 years. This probably saved the remains of Bryggen, since there was considerable popular sentiment in the 1950s in favour of its demolition to provide more room for the city's development. The *Riksantikvar*'s office was successful in preserving it, however, partly by finding a good way of harmonizing the design of a new hotel complex on the site of the excavations with the existing buildings. In 1980, Bryggen was included in UNESCO's World Heritage List.

Among Nygård-Nilssen's achievements, two more should be mentioned. The first is that he succeeded in increasing the *Riksantikvar*'s resources considerably in terms of both personnel and budget. The second was that he was among the first who understood the importance of city planning as a tool for cultural heritage protection.

I have personally had the privilege of accessing Nygård-Nilssen's private archives, where I found a draft for an introduction to a never-completed unpublished book on general heritage conservation in Norway that was probably written in 1944 or 1945. He starts with an analysis of a text that today is very well known in the world of building conservationists, namely the essay "Der moderne Denkmalkultus und seine Entstehung" written by the Austrian art historian and *Generalkonservator* Alois Riegl (1858–1905) as an introduction to a proposal for a law on heritage protection (Riegl 1903). In it, Riegl puts forward a methodical way of analyzing what values can be ascribed to heritage, which in turn provides a platform for understanding how to preserve it.

At that time, this essay was not known outside the German-speaking world, and it was only around 1980 that Riegl's way of thinking was introduced to Norway. Some years later, Riegl's essay was translated into English and French and subsequently included in textbooks and theses on heritage preservation. Had Nygård-Nilssen had the opportunity to finish his book, he would have stood out as a great pioneer in the promotion of systematic heritage-oriented thinking in Europe. Unfortunately, due to the many practical challenges he faced in postwar Norway and his unexpected death in 1958, this never came about (see also Myklebust 2014).

The personal narrative

After graduating with a Master's Degree in Art History from the University of Oslo and a three-year period as a research fellow studying the history of restoration in Norway, I was invited in 1984 to work at the *Riksantikvar*'s office by Dr Stephan Tschudi-Madsen (1923–2007), a great pioneer in the study of European Art Nouveau/Jugendstil Architecture. He was then the director general and far more interested in international cooperation than his predecessor. He was the founder of the Norwegian national committee of ICOMOS and led the work of getting the first Norwegian monuments onto UNESCO's World Heritage List, ahead of any other Nordic country.

As a student, I had worked for two years in the *Riksantikvar* archives with the task of revising the list of protected monuments. I was at the same time working, at Tschudi-Madsen's request, on inventorying Norwegian Art Nouveau/Jugendstil architecture. This background explains why I was chosen to represent Norway on UNESCO's project for the study of and preservation of Jugendstil architecture when the invitation to participate came in 1986, the year after the General Assembly of UNESCO decided to establish such a project. This was a political initiative taken by the West German national committee of UNESCO, supported by its East German counterpart. The idea was to find a topic that was equally relevant on both sides of the Iron Curtain.

The first meeting was held in Frankfurt am Main in 1986. The participants came from several countries, both Western and Eastern European, and for many of us this meeting was an opportunity to get to know Art Nouveau/Jugendstil architecture in countries that we had little or no access to before.

The meeting elected a standing committee of six representatives from the following countries: East Germany, West Germany, Hungary, the Soviet Union, Greece and Norway. This committee had the task of securing the progress of the project, and its first meeting was held in the Norwegian town of Ålesund in April 1987.

This town, a coastal fishing harbour exporting dried codfish to many European countries and consisting mainly of two-storey wooden buildings, burnt down almost completely during the night of 23 January 1904. Thanks to good insurance procedures, the town was quickly reconstructed, this time of course with brick and stone buildings. By 1907 the town's renewal was complete, with approximately 350 new buildings of high quality. The process benefited from a lull in the construction in Norway's two largest cities, the capital Oslo and Bergen, which made many of the best architects and craftsmen available to move to Ålesund for work.

In 1987 we had no idea of the great changes that would come over Europe only two and four years later, with the fall of the Berlin Wall in 1989 and the dissolution of the Soviet Union in 1991. It was a great privilege for me to follow those political developments together with a group of people who met two or three times a year and grew to know each other very well, with enough mutual trust to speak openly about those transformations. But that was a personal benefit.

We may have had a little forewarning, though. The Ålesund meeting ended with a dinner for the participants given at my home in Oslo. During this dinner, the representative from the Soviet Union declared that he was a Russian. The participant from East Germany discretely told me that if the man from the Soviet Union had expressed a similar sentiment back in his own country it would immediately earn him a one-way ticket to Siberia.

The professional benefit was that our meetings included professional excursions that provided a broad knowledge of the richness of Art Nouveau/Jugendstil architecture in Europe, which we could pass on to our colleagues through lectures, articles and exhibitions. A clear example of this dissemination of knowledge about the style came in a television programme on Art Nouveau architecture broadcasted by the main channel of Norwegian National Television in 1998, with Dr Tschudi-Madsen acting as presenter. He took the audience to places that he himself had no knowledge of when he wrote his doctoral thesis, *Sources of the Art Nouveau*, in 1956. Two examples are the very sophisticated architecture in the Latvian capital Riga (a city unknown to most Europeans) and the homogeneous centre in the small town of Greiz in what used to be East Germany.

That little town in Thuringia turned out to have an almost identical history to Ålesund. The centre of Greiz burned down completely in 1902 but was reconstructed by 1904 with masonry buildings entirely in the Jugendstil.

We met in more countries than there would be any sense in listing here, but one event that made an especially strong impression was the steering committee meeting in Moscow and St Petersburg in 1991. This meeting was organized by the architect Maria Nashchokina, who had taken over as what soon would be the Russian representative in the project. The encounter with the high-quality Russian Art Nouveau/Jugendstil architecture gave me a knowledge base that it was a privilege to possess and enjoy later in my international work.

The geopolitical changes happening in Europe around 1990 also altered the situation for the Council of Europe. Founded in 1949 by ten Western European countries, this organization was the most important inter-governmental institution in this region of the world.

As it developed, though, the European Union slowly took over as a more important arena, and the Council of Europe assumed the role of a training ground for beginners in international cooperation.

Now, suddenly, the organization acquired a new and very important role.

The three founding principles for the Council of Europe (CoE) were the member states' commitment to the principles of pluralistic democracy, human rights and the rule of law. The pledge to respect human rights also meant that all member states had to abolish capital punishment through legislation.

The human rights were defined in the European Convention of Human Rights which was adopted by the CoE in 1950 and came into effect on 3 September 1953, when it was ratified by the necessary number of participating states. There is a corresponding Court of Human Rights for examining possible violations of the convention by the states that have ratified it.

After 1991 an increasing number of the new post-Communist independent states applied for membership in the CoE. This membership would mean an official certification that the country in question really was a pluralistic democratic country, respecting human rights and the rule of law.

In 1991 the Environment Ministry appointed me to represent Norway on the Cultural Heritage Committee of the CoE. By that time, the CoE had developed a wide range of responsible steering committees in different professional fields, creating specific projects. An important aspect of these committees was that they established professional networks across a multitude of European countries. I had the great pleasure of meeting a stream of colleagues previously unknown to me, opening new perspectives in heritage management.

Sadly, the importance of these networks has been grossly underestimated by the administration of the CoE. In fact, they used to be one of the main assets of the organization. These networks made it possible to create cooperation between countries with projects also outside the working programme of CoE.

I will give an example. In 1994, I was called to the office of the deputy director of the *Riksantikvar*, which in 1988 had been transformed into the Directorate for Cultural Heritage under the Environment Ministry. She told me that the ministry had asked the directorate to look into the possibility of establishing a Russian-Norwegian cooperation on cultural heritage protection. This would be under the umbrella of the Russian-Norwegian governmental agreement on environmental protection.

This was an agreement concluded in 1988 between the governments of the Soviet Union and Norway. It was later renewed between the governments of the Russian Federation and Norway. There was, however, an asymmetry in the ministerial structures of the two countries. In Russia, cultural heritage protection was the responsibility of the Ministry of Culture. In Norway, cultural heritage matters concerning buildings and archaeology had been the responsibility of the Environment Ministry since its establishment as the first of its kind in Europe in 1973.

The Directorate for Cultural Heritage decided to send a fact-finding mission to Russia to learn about the heritage protection system in the Russian Federation and make contacts with individuals and institutions with whom we could establish cooperation in our field.

Since I represented Norway on the Cultural Heritage Committee of the CoE, I used its plenary meeting to approach the Russian delegate asking for help in making contacts. That delegate, Alexei Komech, director of the Moscow Art Institute, put me in touch with the director of the newly founded Russian Institute for Natural and Cultural Heritage Research, one of the few new government institutions that had been established after the dissolution of the Soviet Union.

This director, Professor Yury Vedenin, invited the Directorate for Cultural Heritage to come to his institute to discuss the matter, and he also arranged for his colleagues to organize excursions to Petrozavodsk (the capital of the Republic of Karelia) and Arkhangelsk (the capital of the north-western *oblast* of the same name). I chose Nils Marstein as my travelling partner, both because of his competence as chairman of the ICOMOS International Wood Committee and

because I was very well aware that later that year he would take over as head of the Directorate for Cultural Heritage.

Both excursion destinations had long-standing cultural and commercial connections with Norway. The border between Norway and Russia was defined in 1826, and it has been a peaceful border, since our two countries never have been at war with each other. Before 1917 there was a rich trade between the northwestern part of Russia and Northern Norway. Norway exported fish and imported grain and birchbark which was used in buildings. There were a lot of common features between the building traditions of the two countries, and a sort of pidgin Russian-Norwegian language developed.

The commerce was called the "Pomor trade", after the Russian name of the people living on the coast of the White Sea, especially on the southern coast of Murmansk – *po moriu* means "by/along the sea".

The Russian-Norwegian environmental agreement is supervised by a commission. Delegations from both countries hold annual meetings that are normally chaired by people of deputy minister / state secretary level.

At its meeting, late in 1994, the commission agreed that cultural heritage protection should be included in its working programme. After our fact-finding mission in June 1995, the Russian side invited us Norwegians to a first working group meeting in Sortavala in the east of Russian Karelia, close to the border with Finland.

This was unknown territory for most of our Russian colleagues as well, since people who did not live there had very limited access to this border area in Soviet times.

To my great delight, Professor Vedenin was appointed chairman of the Russian part of the group, while I became the Norwegian chairman. Having had a pleasant meeting in Moscow with good personal rapport from the outset, some six months before, made it easy for us to establish a good working atmosphere. The two sides had different proposals regarding what should be included in our working programme, but we had no problems in setting up a plan of action that respected both sets of priorities.

That programme belongs to the second part of this book and will be dealt with in another chapter going into some of the concrete projects (see Chapter 9).

Professor Vedenin's institute was a very important place in our work. Conveniently situated in Moscow near the VDNKh metro station, the building contained not only his institute's premises but also a hotel where we, the Norwegian guests, could live comfortably at a reasonable price. The institute had lecture rooms and functional meeting facilities. It even had an exhibition hall where you could display art.

This last feature came to my mind once when I was sitting on a plane returning to Oslo from Moscow. I was reflecting on my relationship with Yury Vedenin. From the very beginning of our work together, we were good friends. That friendship became ever stronger. Although he was almost ten years older than me, his mind was perhaps even younger than mine. We had a trust in each other that was absolute. There was also something shared in our family backgrounds. We were

both the sons of practicing architects who had one thing in common: when they retired from that profession, Alexander Vedenin and Einar Myklebust both took up new careers as artists, as painters. On the plane the idea came to me: we have these two fathers with a similar development in their lives; Yury has his gallery; what if we held a joint exhibition of our fathers' paintings!

Back in Oslo, I immediately contacted Yury, who unhesitatingly agreed to my idea. A year later we managed to make it a reality. My father, I and our wives took my father's contribution to Moscow, a cycle of allegorical paintings symbolizing human vices and virtues made specially for this exhibition. Yury's father brought paintings from different stages in his oeuvre, mostly landscape paintings. Despite the different modes of expression, the exhibition worked very well. There was a big opening ceremony, with the cultural attaché of the Norwegian Embassy stating in his speech that this was the first Russian-Norwegian cultural event to be organized without any government sponsorship!

I have taken the liberty of telling this personal story to illustrate one very important aspect of international cooperation: it functions at the highest level of quality only when it is based on good personal relations. I am happy to say that I have such relations, not only with Yury, but with many people whom I have learned to appreciate throughout the 15 years when I was responsible on the Norwegian side for the bilateral Russian-Norwegian governmental cooperation on cultural heritage protection issues.

References

Myklebust, Dag. (2014). *Med vilje og viten. Om kulturminnevern i Norge*. Oslo: Pax. (Summary in English)

Riegl, Alois. (1903). *Der moderne Denkmalkultus und seine Entstehung*. Wien und Leipzig: W. Braumüller.

Part II

Contemporary preservation of historic monuments

Former preservations as heritage and obstacle

5 Facing the vulnerabilities of a medieval cathedral

Per Schjelderup

Introduction

The Cathedral of Stavanger and the city that has grown around it will celebrate their nine-hundredth anniversary in 2025. This approaching jubilee has generated renewed attention to the cathedral's importance as a piece of our cultural heritage and to the state of the building. Schjelderup & Gram architects, represented by Live Gram and myself, were commissioned to draw up a comprehensive restoration plan for the cathedral and the Bishop's Chapel (Gram and Schjelderup 2013). This in turn led to the launch of extensive restoration work to be finished by the jubilee.

When it comes to size and splendour, Stavanger Cathedral falls short of the Nidaros cathedral in Trondheim, and still more compared to its close English relatives. Yet this building has been used uninterruptedly down through the centuries; it was never a ruin and is today held to be Norway's most authentic medieval cathedral. It has passed the test of endurance and has withstood the pressure from the ever-growing city surrounding it. Still, it is vulnerable in so many ways.

Which are the factors making a medieval stone cathedral vulnerable?

Obviously, it was made for a society and in a context that no longer exist, either culturally or in terms of technical and material factors. Even the climate has changed substantially.

This chapter will present the complex challenges to be dealt with ahead of the comprehensive restoration of a medieval cathedral due to take many years. Restoring this cathedral is about far more than the mere physical building. We emphasize the importance of restoring the knowledge and craftsmanship needed and also of reviving public interest. Planning and conducting this restoration hence entails historical, technical, and educational expertise, aims, and ambitions.

A brief history of the cathedral and previous restorations

The known history of Stavanger Cathedral goes back to 1125, when King Sigurd Jorsalfare appointed Reynald from Winchester as bishop of the new diocese of Stavanger. As the patron saint for his cathedral, Reynald chose St Swithun, a ninth-century bishop of Winchester (Bruland 1999: 25).

Most likely the surrounding town then was just a small cluster of houses located between the sheltered harbour and the Breiavatnet lake. The cathedral was built on a hilltop close to the lake, probably replacing an earlier wooden church, suggested by the four post holes found under the crypt and the remains of Christian burials several generations older than the cathedral itself. The city of Stavanger grew up around this cathedral, its fortunes following the rises and falls of the ecclesiastical and economical power of the diocese.

As early as 1272, a fire in the city affected the church and caused severe damage. We do not know how severe, but a short note in Icelandic annals cites Archbishop Jon Raude as saying:

> The Holy Swithun church, Stavanger cathedral, is recently burned. Forty days indulgence given to whosoever wants that same church to be comforted by larger devotional meetings and beneficial gifts. . .
>
> (Bruland 1999: 45)

After the fire, the chancel was demolished and rebuilt in the new Gothic style and manner, twice the size of the old one and with a tower on each side of the east façade. The fire fortunately did not damage the Romanesque nave and side aisles. What is believed to have been a Romanesque western tower was taken down and rebuilt, receiving a Gothic soapstone portal. The wooden roof structure was undoubtedly completely destroyed and rebuilt as a result of the fire in 1272. The cathedral acquired the modest shape we still see today – one continuous gabled roof over both nave and chancel flanked at the east end by two towers (Fig. 5.1).

We have limited knowledge about the alterations carried out after this, before extensive restorations started in the second half of the nineteenth century.

After the liberation from Denmark in 1814, there was an awakening of national romanticism among the Norwegian cultural elite. This was closely connected to similar tendencies in continental Europe, where an interest in the Middle Ages was growing, particularly in Gothic architecture. Most of the Norwegian architects had obtained their education in Germany, and the views on historical architecture prevailing there were evidently brought home and applied to a Norwegian context (Lidén 1991: 23–30). Our many stave churches and our rather few stone cathedrals were rediscovered as important symbols of national heritage and identity. This trend was not as much about preserving the buildings as they were, as it was about restoring their presumed former splendour.

Wilhelm von Hanno (1826–1882) and Heinrich E. Schirmer (1814–1887) produced the first comprehensive restoration plan for the Stavanger Cathedral in 1856. The drawings proposed an "upgraded" cathedral in accordance with the prevailing Neo-Gothic ideals, with a new soapstone cornice on the western gable and height added to the two towers. Neither of these alterations had any basis in the cathedral's history. When Conrad Fredric von der Lippe (1833–1901) was commissioned to actually carry out the restoration in 1867, the towers were left as they were, but the gable cornice was added and the traditional roof tiles were replaced with slates. He also altered the pitch of the roofs above the side aisles so

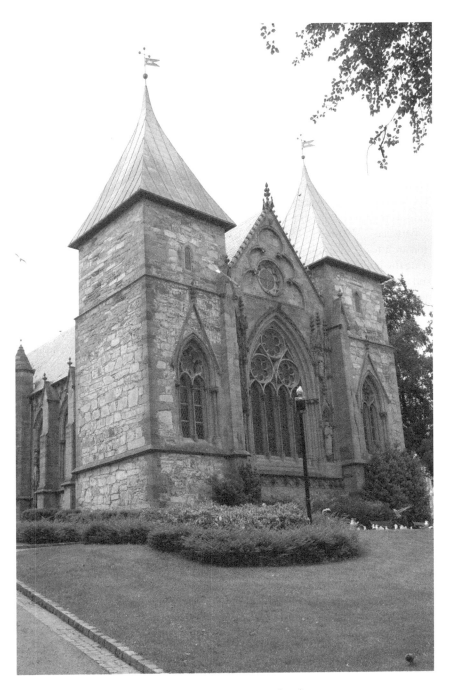

Figure 5.1 St Swithun Cathedral in Stavanger. Eastern façade.

as to replace the rectangular Baroque windows with rounded ones in the Romanesque style. Inside, all the Baroque and Renaissance furnishings and fixtures were removed and replaced with new ones in the Neo-Gothic style. Only the Baroque epitaphs and pulpit were spared. The medieval arch between nave and chancel was drastically expanded. The wooden roof construction, presumably dating from 1300, was taken down and replaced with an open construction quite similar to the one in the Værnes church, in keeping with the trend among prominent Norwegian conservators. Von der Lippe did not totally agree with this, but in the end he had to compromise. Additionally, new technology and materials were introduced. The extensive use of iron bars, covered only by a thin layer of cement plaster, testifies in equal measure to a great faith in the new mortar and a limited understanding of the climatic dynamics within the medieval walls. All in all, the authenticity of the cathedral was severely threatened during the late 1800s. Even if only a few changes were made to the medieval stone structure, the Romanesque walls were indeed scarred by this romantic restoration.

Between 1939 and 1942, the cathedral again became the subject of a restoration architect's ambitions. Gerhard Fischer (1890–1977) concentrated on uncovering the building's constructional history, mainly through archaeological surveys and documentation. The outbreak of the Second World War made it even more necessary to document the edifice as precisely and fast as possible (Fischer 1964: 15). Subsequently, Fischer's drawings remained the most accurate documentation available until today's digital surveys. He also had all the exterior plaster removed and the masonry repointed with cement-based mortar. He wanted every single stone to display its characteristics and to take part in telling the history. The first chapter of his own restoration report was titled "Muren Taler" (The Wall Is Speaking). This ambition has proved to be too much for these medieval walls to bear, leaving them less protected from the wet and windy climate.

The restoration plan and its implications

Since 1856, no one had drafted a comprehensive restoration plan for Stavanger Cathedral. Even so, both the cathedral and the Bishop's Chapel have undergone several repairs, modifications and restorations over the intervening more than 150 years. Some of these have been well argued, described and documented; others just happened, often as a secondary consequence of other interventions. These modifications have seldom been subject to the monitoring and management appropriate to a listed cathedral.

When local politicians realized that Stavanger's nine-hundredth anniversary was approaching, one of the goals set out was that the cathedral should be fully restored and "shining" for the jubilee. Due to a growing understanding of the complexity and the potentially high cost of the problems cropping up, calls for an all-embracing approach increased, and in 2013 we were commissioned to draw up a new comprehensive restoration plan for Stavanger Cathedral and the Bishop's Chapel. The main objective in making the plan was therefore to establish a solid basis for priorities, management and cost calculations of the various restoration

works needed, thereby giving detailed definition to the bold political ambitions. To achieve this, we had to describe the condition of everything – from heavy medieval walls to the clock mechanism, from plumbing to liturgical silverware, from wooden roof constructions to Baroque woodcarvings. We had to ask ourselves what factors were making these structures, materials and objects – and, consequently, the cultural monument as a whole – vulnerable. Twenty different technical specialists contributed their survey reports on condition and problems, together with their suggestions for action. But cultural factors of vulnerability also need to be taken into consideration when a medieval cathedral is expected to meet the demands of a modern society.

Estimated cost calculations were made, and the total came to more than 300 million Norwegian kroner, equivalent to about 32 million euros (July 2017). Consequently, decisions about financial priorities and strategies for funding had to be made quickly for the plan to be implemented in keeping with the political ambitions.

Not just the building itself

Besides the obvious objective of restoring the building's structure, our plan makes a major point of having two more restoration goals that we consider almost as important. We need to revive the craftsmanship required to refurbish a medieval building, and we need to revive public interest.

After decades of accelerating development in materials, building technologies and the way building projects are managed, traditional skills, practices and procedures have been neglected and gradually forgotten (Jokilehto 1999: 15). Whatever remains of traditional skills and knowledge has lost its commercial value on today's market. The lack of relevant experience is evident in all crafts and in every area of commercial building expertise. One obvious solution to this is to employ a permanent staff of restoration artisans, like the Nidaros Cathedral Restoration Workshop – NDR. The NDR is funded from the central state budget and was established as early as 1869 to rebuild Norway's national sanctuary. Due to the differences in the size and significance, it seems rather unrealistic for Stavanger to achieve anything of that kind. In our project, we are restricted by the standard procedures laid down in law for engaging commercial companies by tender, a system that tends to favour legal compliance and cost effectiveness over competence and continuity. We aim to find ways of engaging craftspeople that are motivated to meet extraordinary expectations and to take the effort and time needed for learning processes and for long-term collaboration between specialists in different fields.

No less important is reviving public interest in the cathedral. This might seem a bit outside the normal remit of a restoration project. Still, when drawing up a plan for the future existence of a medieval building, we must never ignore the fact that a disregarded building will soon become a neglected one. Even prioritizing maintenance and necessary restoration will, in the end, depend on the local people's attachment to the building. In that respect, restoring interest is critical

to restoring the cathedral. Therefore, the restoration plan includes educational efforts, research programmes and close interaction between craftspeople and the public.

If we conduct our restoration in a way that makes the building and its history visible, audible, tangible and accessible to the general public, it will provide opportunities to experience history with the senses and engage people's interest in the building *being* restored as a communal monument of cultural heritage. The grim alternative is public, political and financial neglect.

The vulnerabilities of a medieval cathedral

The idea of describing a 900-year-old stone cathedral as vulnerable might seem strange or surprising to most people, for whom such a building would appear more or less everlasting and indestructible, in contrast to the general acceptance of rapid decay and frequent replacement of modern buildings and materials. As curators and restoration architects, too, we share high expectations of giving the old building a long and healthy future. Our overarching goal is to facilitate another 900 years of the cathedral's existence with minimal loss of authenticity. That entails recognizing that any building and material is actually falling apart. It also entails thinking ahead, trying to understand and foresee what will happen in ten, fifty and a hundred years' time and doing whatever possible to arrest or delay processes of decay.

In his book *Restoration of Historic Buildings*, Bernard M. Feilden presents a variety of causes for decay in materials and structures in historic buildings. Several of them are in the category of natural causes intrinsic to the ageing processes that will occur in any material structure or surface due to internal chemistry and exposure to normal environmental factors like the presence of air, visible and ultraviolet light, radiation, humidity and temperature. Changes in static stress, temperature and humidity levels will accelerate these effects as the expansion and contraction of metal and wood will put a strain on nearby materials.

We also see a number of human-made causes. Vibrations produced by machines and traffic, groundwater abstraction and atmospheric pollution add to the daily wear and tear on historic buildings and monuments. Other human-made factors are closely related to the internal environment and the use of the building (Feilden 1998:169–181). Modern demands regarding functionality, flexibility and comfort also place considerable strain on historical buildings.

Distinguishing between natural and human-made factors is useful for the taxonomy of causes, even if we are today increasingly aware of human impact on global climatic and environmental changes.

Our restoration plan identifies and addresses a number of factors, both natural and human-made, applicable to Stavanger Cathedral. Some of them we can reduce dramatically or totally eliminate by changing or removing the underlying causes. Others we have to cope with by minimizing their consequences, while the underlying causes of decay are out of our hands. We have called these factors collectively "the vulnerabilities of a medieval cathedral", quoting a chapter

title from the restoration plan for the Nidaros Cathedral (Storemyr & Lunde 1998:13). Some of these vulnerabilities and the measures taken to deal with them will be commented on below.

Climate-related stress factors

Coastal western Norway is known for its wet and windy weather. Statistics show that the average precipitation in Stavanger is about 1,200 mm per year and that we have 253 days a year with rainfall (or snowfall) (SSB 2013). Combined with the windy conditions, this constitutes a stressful climatic environment for a medieval stone cathedral. The masonry's ability to withstand these conditions over time has proven to vary widely due to differences in materials, composition and application, but also due to inadequate maintenance.

Despite the fact that this building has been in uninterrupted use as a church through its entire 900-year history, it will inevitably have undergone long periods of neglect and unrepaired damage. Consequently, water has penetrated the walls, possibly causing both washout of the lime binder and hygroscopic activation of salts. Once the salts are activated by humidity, they can cause continuing surface damage for hundreds of years.

The soapstone ashlar and ornaments are particularly vulnerable to climatic conditions. Different kinds of soapstone with varying porosity, structure and mineral composition will cope very differently with the humidity and with a long-term chemical coexistence with the neighbouring stones, joints and mortars. Thus, we find some original medieval soapstone parts still intact and other stones that have been replaced and repaired several times yet are once more showing obvious signs of deterioration. Problems with uneven and poor stone quality have also been a major challenge for the Nidaros Cathedral Restoration Workshop in Trondheim (Storemyr 2010: 172–178). The NDR's documentation on these problems and its way of solving them represents an important resource for the surveys and work on soapstone to be carried out at Stavanger Cathedral. Our own team of stone restoration technicians from the Archaeological Museum of Stavanger / University of Stavanger is expected to perform close to 30 full-time equivalents of soapstone restoration work during the decade to come.

Due to on-going climate changes, the weather is generally expected to become increasingly mild, wet and windy. Consequently, the problems described above will grow. This calls for more surveillance and enhanced maintenance for the medieval walls.

Contaminated air and rainwater

Being vulnerable to the effects of water intrusion, the medieval masonry will also suffer from contamination brought by the rain. For several decades, the main source of harmful contamination has been European industry's emissions of sulphur dioxide and nitrogen oxide, causing so-called acid rain. Due to the reaction between sulphuric acid and calcium carbonate in the stone, we see the

extensive formation of gypsum crusts on the stone surfaces. These "black crusts" trap moisture and produce masked areas of on-going salt weathering and other decay mechanisms.

Even though sulphur contamination has dropped more than 65 per cent since 1980 (Brunvoll & Hass 2006), due to decreased emissions from industry, this still constitutes a potential cause for stone decay on Stavanger Cathedral.

Lack of new soapstone

The on-going extensive repair and replacement of soapstone generates a need for reliable supplies of new stone. All the known quarries used in historical times have been destroyed or exhausted, or else they are listed as cultural or industrial heritage sites (Storemyr, Lundberg, Østerås and Heldal 2010: 261). Currently, it is in fact a challenge to procure soapstone of good, consistent quality that is suitable for carving and with presumed high durability. This problem is much greater at the Nidaros Cathedral, which is much larger and mainly built of soapstone. Action has been taken there to open a Norwegian quarry capable of delivering sufficient quantities of suitable stone over time. The Stavanger project is very interested in its success.

Fire

The fire in 1272 is thankfully the only one known to have marred the history of this cathedral. The greatest fire risks today come from old or damaged electrical installations, the extensive use of candles and the danger of arson. Extinguishing systems based on water mist and Inergen gas (for the crypt) have been installed and are believed to provide good indoor protection.

The use of cement-based mortars in earlier repairs and restorations

The optimistic use of cement-based mortars throughout the twentieth century has led to additional salt problems. Even worse is the fact that these mortars are far too strong and hard to coexist successfully with the historic masonry. The flexibility of a traditional lime mortar has saved many joints and even soapstone from breakage. Rigid cement-based joints tend to crack eventually and also to damage the weaker adjoining stones. After Fischer removed all external plaster and repointed the rubble masonry walls with these hard joints, the masonry is continually developing small cracks that let in water from driving rain. Due to its impermeability, cement also forms a vapour barrier, keeping moisture inside the walls, causing frost damage and slowly evolving deterioration of the underlying mortars.

Several old photographs and paintings show that the walls were whitewashed before the restorations of the 1860s and 1870s, when the whitewash was replaced with a cement-based plaster that in its turn was removed by Fischer in the 1940s. The traditional application of lime-based slurry plaster and whitewashes gives the

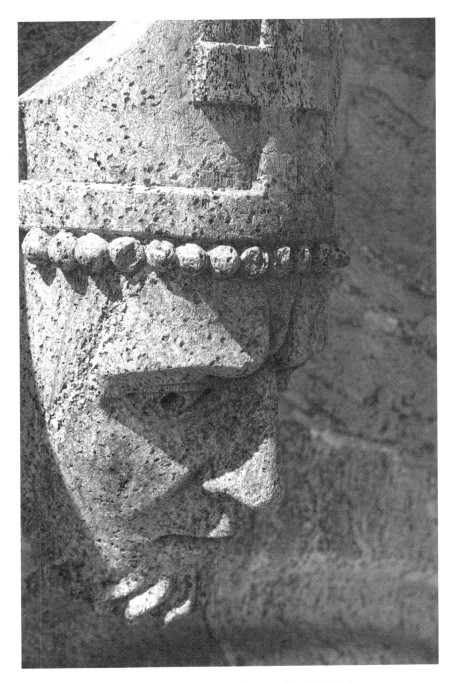

Figure 5.2 St Swithun Cathedral in Stavanger. A carved head of a bishop.

walls a protective layer with some crucial functions. First, it provides a smoother surface for the water to run down instead of accumulating in imperfections and crevices. Second, it provides a breathable skin through which internal humidity can evaporate. Third, this is meant to be a sacrificial layer that will degrade and crumble from the effects of the weather and thus contribute to the durability of the underlying joints and stone masonry. The strength of these massive walls is in fact dependent on the weakness of the surface, providing it is renewed regularly.

In view of this, we are now considering whether a traditional lime render should be applied again over the entire church walls or just on the most weather-beaten eastern towers (Fig. 5.3).

Cultural vulnerability factors

Besides the many dangers already mentioned, there are several aspects of modern society that make an old cathedral vulnerable and threaten its authenticity. The old building struggles to serve as a contemporary place of worship and to meet new demands regarding comfort, general accessibility, toilets for disabled, room for safe storage and staff facilities. Stavanger Cathedral is even expected to serve as a concert hall and a much-visited tourist attraction. Requirements for modern technical amenities, power supplies, cloakrooms, ticket sales area and so on add to the demands coming from the congregation.

The refurbishment and replacement of the organ seems to have been a typical trigger for major renewals and alterations to churches, and this was also the case for Stavanger Cathedral. The first organ was installed in 1623. It was then replaced with a new one in 1869, 1948 and 1992. Those years correspond quite neatly to most recent major changes made to the church's interior. Even substantial structural changes were made to adapt the old building to accommodate the new organ. This is, unfortunately, a relevant issue even today. As part of installation and later modifications of the 1992 grandiose "Baroque" organ, several changes were made to the surrounding structures. Organ considerations seem to trump almost anything when it comes to priorities. As in the case of the ever-growing organ, compliance with any modern demand will inevitably change the church itself unless it is also carefully considered as being subordinate to the protection of the building.

I have already mentioned the danger of being neglected in our modern political and economical society and how this correlates with the danger of insufficient maintenance.

The need for further clarification and surveys

Any restoration plan will raise topics and problems that demand further investigation and clarification. In some areas we simply need more information; in others we need to refine our own views on guidelines to be followed and actions to be taken. The needs and rights of users and employees must be taken into consideration at all stages of planning and implementation. There will be a continuous

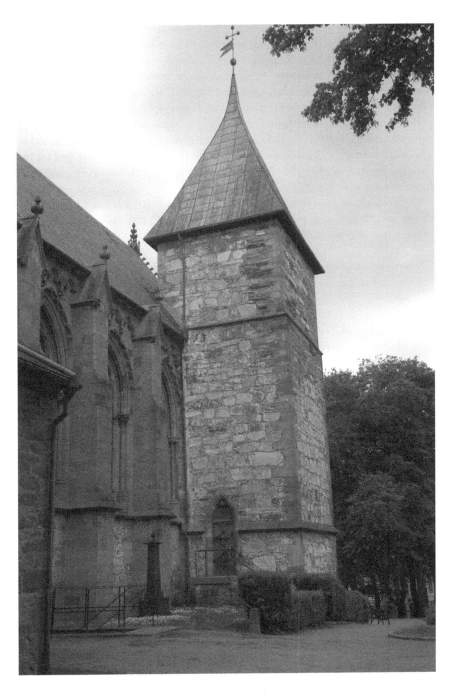

Figure 5.3 St Swithun Cathedral in Stavanger. South-eastern tower.

process of amending and supplementing the chronological overview we compiled in 2008 enumerating all known changes and modifications made during the cathedral's history (Schjelderup, Gram and Riese 2008). The on-going surveys regarding the state of the medieval masonry will be extended with supplementary means and methods, as will researches and experiments aimed at producing an appropriate restoration mortar. A lot more could be said about the points mentioned, but, due to the limitations of this chapter, I will focus here on the premises and guidelines for further restoration and our emphasis on documentation.

Restoring a medieval cathedral obviously involves working in compliance with cultural heritage legislation, or rather under the stringent restrictions that follow a heritage listing. Still it is important both for the project internally and for the national heritage authorities that we elaborate and clarify our understanding of those constraints.

Our restoration plan (Gram and Schjelderup 2013: 26) sets out a list of priorities in compliance with principles of the ICOMOS "Venice Charter". Article 9 of the Charter states that the aim of restoration

> is to preserve and reveal the aesthetic and historic value of the monument and is based on respect for original material and authentic documents.
>
> (ICOMOS 1964: 2)

This implies quite a conservative approach and a general principle of doing only what is necessary to preserve the building as a "living witness" for the future. In its preamble, the charter also states about our historical monuments: "It is our duty to hand them on in the full richness of their authenticity" (ICOMOS 1964: 1). These are overarching guidelines for our restoration, but there are clarifications left to be made, especially regarding our understanding of what is "necessary" and what is "authentic".

In his article on restoration and authenticity, Jon Bojer Godal (Godal 2004: 31) describes "material authenticity" as being based on the material that was installed when the building was new. Stavanger Cathedral's high degree of material authenticity makes it more or less unique among medieval buildings in Norway. But, as Godal explains further, this is only one of many aspects of authenticity. So, what are the grounds for claiming authenticity on the cathedral's behalf? The building's underlying structure may have remained uniquely intact and unaltered throughout its history, but both the exterior and the interior of the cathedral have undergone substantial changes in appearance, to a degree that today's cathedral would be more or less unrecognizable to the people who visited it hundreds of years ago. Light, colours, smells and sounds have all changed dramatically along with the cultural, technological and environmental context. The Lutheran Reformation and the growth of a modern city around the building are just two of many factors contributing to the lack of what I would tentatively call "contextual authenticity", an authenticity that it is neither possible nor desirable to recover. Still, this raises the question of whether an architectural monument will ever be able to communicate "the full richness of its authenticity".

According to the architectural historian Knut Einar Larsen, "the authenticity of a cultural monument or building is partly associated with form, partly with substance" (Larsen 2004: 19). A focus on form and visual appearance must be balanced against, and if necessary overruled by, the authenticity and functionality of materials, craftsmanship and procedures. Many of our historical monuments suffer from a bias towards visual appearance in the understanding of authenticity. Stavanger Cathedral is no exception, considering the restorations done since the 1860s.

Article 10 of the Venice Charter comments on the possibility of using modern materials if the traditional technique proves inadequate. This is something we frequently have to consider. Especially when it comes to coping with present and future climate changes and to the adaption of an old building to modern use, traditional solutions will prove inadequate. We know that repairs to soapstone have been made with modern glue and that epoxy-based fillers are being used in other restoration projects. The point is to communicate openly the deliberations behind these choices.

The romanticism that motivated nineteenth-century architects and conservators to restore cathedrals, stave churches and medieval farmhouses fostered conceptions of authenticity that differ dramatically from current discourses on cultural heritage. An idealized conception of medieval appearance was applied with liberal use of modern materials and methods. As a result, neither in form nor in substance do we have what was built in the Middle Ages. The cathedral is listed with all its historical supplements and alterations. Article 11 of the Venice Charter states that all periods in the building of the monument must be respected, but at the same time it leaves open for consideration the historical, archaeological and aesthetic value of what to keep and what to modify or remove. Such considerations cannot be left to one person alone. In the case of Stavanger Cathedral, we are constantly in dialogue with archaeological experts, skilled conservation technicians and, of course, the Directorate for Cultural Heritage. In some cases, we have arranged seminars, gathering national and international experts, to discuss and seek consensus on a matter of this sort. We are soon to arrange a national seminar to deliberate on points relating to the restoration of stone portals.

About the need for a science-based restoration

The current restoration of Stavanger Cathedral is largely about reducing damage caused by previous restorations. Rusting iron rods and hard cement mortars were meant to preserve the building, but they have in time become its enemies. This raises the concept of procedural authenticity, implying that restorations and repairs should be carried out with materials and methods similar to the original. The fact that a building is still standing after 900 years indicates that something has been done right and with the appropriate materials, procedures and details. The challenge is to find out what those are and how to repeat them successfully. However, implementing this brings up at least two major problems. One problem

is the high economic costs of following old procedures and using authentic materials. Many of the medieval procedures were very labour-intensive and required several very specialized teams of workers. Lack of appropriate skills and the generally high salaries in a modern Western economy make it very challenging to find and finance the labour required. Furthermore, the chosen procedures will have to be repeated in the future, or else the choice of a traditional approach may prove harmful in the long run.

The other problem is whether the traditional solutions can cope with future climate. We have seen how acid rain has already affected the structures and surfaces of historical buildings, and we know that some of our traditionally built structures will not stand up to the trials of predicted climate changes. Thus, our desires for procedural authenticity will potentially harm the building if we do not take these issues and others into consideration.

Emphasis on documentation

A lot of the earlier work on the cathedral, even that done quite recently, was recorded and documented rather poorly, or not at all, making it difficult for us to determine, interpret and assess the measures taken. We aim at complying with high standards for recording and documentation in keeping with the ICOMOS principles ratified by the Sofia assembly in 1996 (ICOMOS 1996). We expect every consultant and every craftsperson to document their work through written descriptions and reports, drawings, photographs or film, complying to a standard set for all. This implies that we will require some degree of documentation competence from everyone involved but also that we have to include instruction and training as an implicit element of the assignment.

Records of actions taken and the reasoning behind them will give the necessary insight for future assessment or repetition of what has been done. All documents relevant to current operations and to future maintenance and restorations are therefore being placed in a web-accessible database system.

For the planning and documentation of a major restoration, we need precise and reliable graphic documentation of the structures to be restored. In the case of Stavanger Cathedral, the most-informative drawings were the ones made by restoring architects in the nineteenth and twentieth centuries, especially the ones made by Gerhard Fischer between 1939 and 1950. Fischer's drawings are accurate and informative but also quite influenced by his particular interests and viewpoints.

Digital three-dimensional scanning has already been done, and photogrammetric registration is underway to complement the point cloud so as to support the making of architectural drawings and a three-dimensional model. This again will be useful as a basis for developing a GIS-based documentation tool and technical and architectural planning, as well as for making good visual aids for public presentations.

Despite all the factors of vulnerability and decay and despite the obvious complexity of restoring the Stavanger Cathedral, we truly believe that the on-going

project will fulfil its intentions: to "preserve and reveal the aesthetic and historic value of the monument" and, to the best possible extent, hand it on in the full richness of its authenticity.

References

Bruland, Inge (1999). *Stavanger Cathedral, a Unique National Religious Monument*. Stavanger: Stavanger næringsforening.

Brunvoll, Frode and Hass, Julie (2006). *Indicators for sustainable development*.

Gram, Live and Schjelderup, Per (2013). *Restaureringsplan for Stavanger Domkirke og Bispekapellet 2013–2025*. Stavanger: Kirkevergen i Stavanger.

Feilden, Bernard (1998). *Conservation of Historic Buildings*. Oxford: Reed Educational and Professional Publishing Ltd.

Fischer, Gerhard (1964). *Domkirken i Stavanger, Kirkebygget i middelalderen*. Oslo: Dreyers forlag.

Godal, Jon Bojer (2004). "Restaurering og autentisitet". In: *Årbok til Foreningen til norske Fortidsminnemerkers Bevaring*, 158. Oslo: Fortidsminneforeningen. pp. 27–34.

ICOMOS (1964). *International Charter for the Conservation and Restoration of Monuments and Sites*. Available at: www.icomos.org/charters/venice_e.pdf (Accessed 20 October 2016).

ICOMOS (1996). *Principles for Recording of Monuments, Groups of Buildings and Sites*. Paris: International Council of Monuments and Sites.

Jokilehto, Jukka (1999). "A Century of Heritage Conservation", *Journal of Architectural Conservation*, Vol. 5, No. 3, pp. 14–33. London: Taylor & Francis.

Larsen, Knut Einar (2004). ". . . hele deres rikdom av autentisitet". In: *Årbok til Foreningen til norske Fortidsminnemerkers Bevaring*, 158. Oslo: Fortidsminneforeningen. pp. 15–26.

Lidén, Hans-Emil (1991). *Fra antikvitet til kulturminne*. Oslo: Universitetsforlaget.

Schjelderup, Helge, Gram, Live and Riese, Lars. (2008). *Stavanger Domkirke og Bispekapellet – en oversikt over bygningsmessige arbeider i perioden 1125–2008*. Stavanger: Kirkevergen i Stavanger.

SSB (2013). *Statistisk sentralbyrå, årbok 2013*. Available at: www.ssb.no/a/aarbok/tab/tab-026.html (Accessed 20 October 2016).

Storemyr, Per and Lunde, Øivind (1998). *Restaureringsplan for Nidarosdomen 1999–2019*. *NDR rapport 9801*. Trondheim: Nidaros Domkirkes Restaureringsarbeiders forlag.

Storemyr, Per (2010) "Fra 'Luftangrep' til klimaendring: Forvitring på Nidarosdomen i historisk og politisk kontekst". In: *Nidarosdomen – ny forskning på gammel kirke*, eds. Knut Bjørlykke, Øystein Ekroll, and Birgitta Syrstad Gran. Trondheim: Nidaros Domkirkes Restaureringsarbeiders forlag.

Storemyr, Per, Lundberg, Nina., Østerås, Bodil. and Heldal, Tom. (2010). "Arkeologien til Nidarosdomens middelaldersteinsbrudd". In: *Nidarosdomen – ny forskning på gammel kirke*, eds. Knut Bjørlykke, Øystein Ekroll, and Birgitta Syrstad Gran. Trondheim: Nidaros Domkirkes Restaureringsarbeiders forlag.

6 The Faceted Palace in Novgorod the Great

The main problems of restoration

Ilya Antipov and Dmitriy Yakovlev

The scientific restoration of Early Russian architectural monuments began in the late nineteenth and early twentieth centuries. Above all, mention should be made of the work carried out in that period by Vladimir Suslov, Pëtr Pokryshkin and Dmitrii Mileev (Suslova and Slavina 1978: 30–60; Mednikova 1995: 303–311; Khodakovsky and Meliukh 2015: 247–271). The 1930s were a severe trial for the nation's culture: many ancient monuments were remorselessly demolished, in some cases after a restoration had been carried out. Fortunately, those events barely touched the works of the Novgorodian school of architecture. More than other old Russian cities, Novgorod the Great retained its works of masonry architecture from the eleventh to fifteenth centuries, and it is with Novgorod that one of the brightest chapters in the history of restoration in this country in the twentieth century is associated. The damage caused by the Second World War produced a need for the study and reconstruction of many medieval church buildings. In the 1950s and 1960s, the majority of Novgorod's churches were studied and rebuilt thanks to the efforts of architect-restorers belonging to the Novgorod Restoration Workshop: Grigorii Shtender, Leonid Krasnorech'ev, Liubov' Shuliak, Tamara Gladenko and others (Gladenko et al. 1964: 183–263). This work was continued in the 1970s through 1990s.

Meanwhile, the sole surviving secular building from the time of Novgorod's independence – the Archbishop's or Faceted Palace – still remained unstudied for many years. It is only in the past couple of decades that specialists have managed not only to investigate this unique edifice but also to carry out a restoration. The main aim of this chapter is to describe the method employed in the restoration of the building and to describe the problems and difficulties that arose during work on it (Fig. 6.1).

The remnant of the residence of the Archbishop of Novgorod – which, by analogy with its namesake in the Moscow Kremlin, local historians in the early nineteenth century took to calling the *Granovitaia palata* (Chamber or Palace of Facets) – is located inside Novgorod's citadel, the Detinets, to the north-west of the eleventh-century St Sophia's Cathedral.

The palace is part of the complex of buildings that made up the Novgorodian Archbishop's Court, where, the chronicles tell us, masonry construction began in the middle of the fourteenth century (Antipov 2013: 3). The building

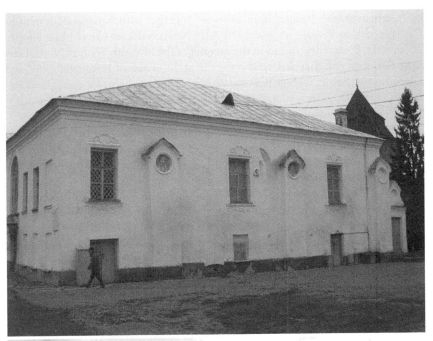

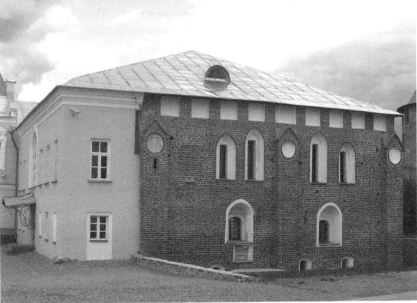

Figure 6.1 The Archbishop's (Faceted) Palace in Novgorod the Great. View of the building from the south-east in 2006 before the start of the restoration (above) and in 2013 after its completion (below). Photographs by D. Yakovlev.

of the Archbishop's Palace was constructed on the orders of Archbishop Evfimii (or Euphemius) II in 1433. According to the chronicle accounts, it was erected by "German master builders from overseas" together with Novgorodian masons (Novgorodskaia Pervaia letopis' 1950: 416; Novgorodskaia Chetvertaia letopis' 2000: 607). It was constructed in the manner of the fifteenth-century North German *Backsteingotik* that was typical for the architecture of Hanseatic cities and towns on the Baltic, such as Rostock and Stralsund, and also for castles and fortresses of the Teutonic Order, such as Marienburg (Antipov and Yakovlev 2015: 107–115). Most probably the builders came to Novgorod the Great from Riga.

The Archbishop's Palace was made up of three parts. The building had an L-shaped ground plan. Its eastern section had two storeys and a cellar; the north-western, two storeys; the (now lost) south-western, two-storeys and a cellar. All three parts were connected at second-storey level by galleries.

Evidently, the eastern part of the building was the main one: all three of its floors, and also the attic space beneath the roof, were linked by internal staircases. The lowest, cellar level of the eastern third would seem to have had purely service functions. The ground floor took the form of a hall with a square pillar in the middle. It is not impossible that this space had not only practical service functions but public ones as well. Finally, the upper floor contains the best-known room in the Archbishop's Palace: the large grand hall with a round pillar in the middle and soaring stellar vaults, whose ribs rest on shaped stone consoles emerging from the walls.

The ground floor of the north-western, two-storey third of the building had a purely practical purpose, evidently being used for storage. Above it, there was a large chamber apparently serving as a sacristy, two small rooms (most probably cells – residential rooms – of Archbishop Evfimii II), and also a corridor linking those rooms to the southern gallery that connected all three parts of the palace.

Reconstructing the functions of the lost south-western section of the building presents the most difficulty. All that is clear is that the cellar level was again used for service purposes, while the top-floor hall, which was covered by a stellar vault similar in construction to those in the hall with a central pillar, was heated by a stove located on the ground floor. This hall may have been intended as the setting for some formal receptions and banquets.[1]

Following the construction of the palace, Evfimii II's reign in the 1430s–1450s also saw the construction in the Archbishop's Court of a whole succession of ceremonial, residential and service buildings in masonry, as well as gateway and domestic churches (Antipov 2009: 131–134). For a period of almost three centuries, the palace, as the centre of the large Archbishop's Court complex, was not only the residence of the local head of the Church (archbishop and then metropolitan) but also the venue for various church services and ceremonies, especially on major ecclesiastical feasts, when the halls and galleries of the Archbishop's Palace became part of a single liturgical space with St Sophia's Cathedral.

Considering the substantial (and, in Evfimii's time, leading) role played by the archbishop in the administration of the Novgorodian *veche* republic, the grand chambers of the palace would have also been used for the most important public

acts of state, such as sessions of the Council of Lords (*Sovet gospod*), festive banquets, and the reception of honoured guests and envoys. The chronicles indicate that it was "at the Archbishop's Palace" (*u vladyki v palate*) in 1478 that Grand Prince Ivan III Vasil'evich of Moscow's decree on the abolition of the boyar republic and the annexation of the Novgorodian Land by Moscow was read out, an act which marked the start of the formation of a unified state that became the core of modern Russia (Iadryshnikov 2009: 96). It is certainly possible that this event took place in the palace built in 1433.

From the mid-sixteenth century onwards, the palace was gradually reconstructed. Between the late 1600s and the early 1800s, the modifications became especially large-scale, and by the end of the nineteenth century its original appearance was almost completely hidden beneath later accretions and alterations.

In the 1820s the largest hall in the palace, the single-pillared chamber with Gothic vaulting was converted into the Church of St Ioann (or John) of Novgorod. The old southern gallery was replaced by a new extension; a common brick cornice was built on, destroying most of the original elements at the tops of the façades that had hitherto survived. A wooden octagonal drum and small dome were constructed. New window and door openings were cut and old ones remodelled. As a result of nineteenth-century refurbishments, the lesenes on the eastern façade received ogival tops; inside the building a new grand staircase was created; a stairwell extension was added to the north-eastern corner of the building; the vaults and the central round pillar in the interior were plastered over with substantial changes to their profiles.

In the 1930s, the iconostasis in the single-pillar hall was dismantled, and the wooden drum above the palace was removed. Otherwise, no major changes were made to the structure of the building. Partitions were constructed in certain rooms, and window and door openings were redesigned.

The building was not badly affected by the Second World War, and soon after the liberation of Novgorod it was again being used to house various municipal administrative bodies, before later being handed over to the Novgorod Museum. A considerable proportion of the rooms were occupied by the museum's reserve stocks, while the one-pillar hall housed a display of decorative and applied art, mainly from the former sacristy of St Sophia's Cathedral. It was at this moment, in 1948–1949, that measurements and localized studies of the building were made: the Gothic portal in the southern façade was discovered; a fragment of an old window on the eastern façade was revealed and left in the form of a trial trench (Davidov 1950: 64).

Twenty years later, in 1967–1972, in conjunction with the installation of hot-water central heating, partial studies were carried out as was a fragmentary restoration of individual architectural elements (Grigorii Shtender) and paintings (Vladimir Romashkevich). In the one-pillar hall, the character of the brickwork and the construction of the vaults and pillar were determined. Traces of the old windows were found in the interior, and decorative niches containing mural painting were uncovered. Based on the results of this work, several display trial trenches were created in the interior with fragmentary restoration of the

fifteenth-century masonry (Shtender 1981: 62). Besides, in the course of work associated with the dismantling of heating stoves of a later date, it proved possible to study and restore two original doorways in the north-western rooms on the upper floor.

In 1987, a new multidisciplinary study of the building began again under the direction of Grigorii Shtender, but it was soon halted. A lack of funding and the impossibility of closing one of the Novgorod Museum's main displays for the duration of the work prevented specialists from embarking on a full-blown programme of research and restoration of the edifice.

The paradoxical situation arose where the presence in the one-pillar Gothic hall of a permanent display of precious items from the collection of the Novgorod Museum (the "Golden Treasury"), one of the most visited parts of the museum, was preventing the study and restoration of the building.

The remaining parts of the Archbishop's Palace continued to be used for all sorts of ancillary and service needs of the museum. The cellar beneath the one-pillar chamber was filled with rubbish, and there was no access at all to the northern half of it. Apart from the partially uncovered Gothic portal beneath the southern gallery, practically no serious investigation had been carried out in these rooms.

This situation persisted until the middle of the last decade, when the museum's director, Nikolai Grinev, made the difficult decision to close the display in the palace and move it to the main block of the museum for the restoration period. The museum's initial plans envisaged restricting the work to repairs in the main rooms of the upper floor with a simultaneous search for and uncovering and restoration of the monumental painting, isolated fragments of which have survived in the interior. However, Vladimir Sarab'ianov, the head of the team of artist-restorers who began work on the restoration of the monumental painting, pressed the need for a comprehensive restoration based on more intensive study.

In 2006, specialists from the Central Scientific Restoration Project Workshops began the multi-disciplinary researches necessary to draft project documentation. These included historical archival and bibliographical searches, architectural measurement and, above all, a full on-site study of the archbishop's palace that involved numerous trial trenches.[2] The carrying out of the trial trenches was usually preceded by test cleanings of the paint layers that were done as part of the work to uncover and reinforce the monumental painting.[3]

In parallel with the architectural researches and trial trenches, a study of the temperature and humidity conditions, an engineering survey of the technical state of the building's construction, and chemical and technological analysis of the building and finishing materials were completed. The company IGIT carried out geotechnical survey work.[4]

These researches were accompanied by large-scale archaeological work, which was being carried out for the first time on that immediate site.[5] Inside and outside the building, more than 30 excavation trenches of varying size were made. The purpose of these explorations was to obtain information about the original architecture and construction techniques used in the building, lost interior and

exterior elements, and also subsequent additions and alterations. Besides, pits were used to assess the technical state of the palace's underground structures.

The multidisciplinary study of the building provided data on its layout, three-dimensional composition and architectural details. New evidence made it possible to refine its constructional history and to obtain information not only for a pictorial reconstruction but also, in the majority of cases, for the re-creation of original elements of the building.

A very important result of the researches was the determination that fragments or traces of most of the original architectural elements have survived within the existing volume of the building, making it possible to carry out their uncovering from later accretions, restoration and reconstruction in a sufficiently well-grounded manner.

The plan for restoration envisaged the maximum possible identification and reconstruction of the palace's original layout and spatial structure and of its Gothic architecture, which is a rarity in European Russia, with the exception, of course, of Kaliningrad Region.

The restoration strategy was based on the results of the studies carried out on site, which revealed the fifteenth-century building to be to a considerable degree intact.

The main principle for the restoration of lost parts and details of architectural elements was reconstruction, provided there were traces at the location and surviving analogues within the palace itself, coupled with a detailed study of the constructional methods and technologies employed in the building. The scientific restoration of the building was made possible by the detailed study of the construction techniques and technologies employed in its making.[6]

In those instances where the original architectural forms had been completely lost or their remnants were concealed by later accretions that had their own independent artistic value and enriched our understanding of the edifice's complex constructional history, those later additions were preserved and restored in an analogous manner. Thus, on the whole, the strategy for this restoration can be described as analytical: the architect-restorers attempted to establish as completely as possible the original shapes of the building, without, however, destroying valuable architectural structures and elements that appeared in the course of the building's exploitation.[7]

A considerable portion of the total volume of work carried out on the Archbishop's Palace involved the reconstruction of the enlarged and otherwise damaged original window and door openings (Fig. 6.2).

The main method of restoring much-enlarged openings that had to a considerable extent lost their architectural features was the reconstruction of the aperture based on the presence of particular traces in the location. Surviving features of similar design were also used as archetypes for the precise re-creation of the dimensions of parts and details of the openings and their constructional characteristics. For the lost elements of an opening from each of the early construction periods (1400s, 1500s and 1600s) requiring reconstruction, analogues were selected only among the surviving elements of other features of the same age that can be found in the building of the Faceted Palace.

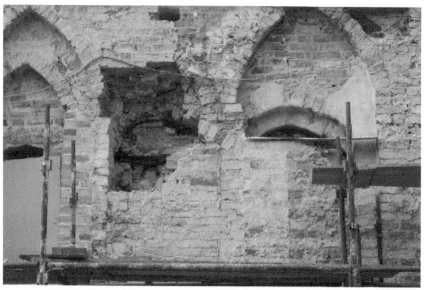

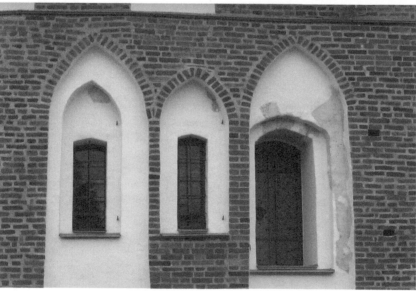

Figure 6.2 The Archbishop's (Faceted) Palace in Novgorod the Great. Part of the northern façade during the restoration work in 2007 (above) and after its completion (below). Photographs by D. Yakovlev.

In the eighteenth and nineteenth centuries, many of the old doorways were replaced by new, broader ones in a different position. After the widening process, one side (half) of the original opening usually survived beyond the in-filling, which made it possible, after the original width had been determined, to re-create

the symmetrically corresponding lost portion of the aperture. The original width was determined by a combination of factors: from traces and imprints in the masonry at the base of the opening (if they survived), by reconstruction from the surviving impost bricks of the discharging arch above the opening or the marks of these in the rubble filling, by calculating the spacing of the vertical rods of the window grilles, and so on.[8]

During the restoration of the original window and door openings of 1433, their distinctive constructional peculiarities were taken into account: every arris without exception was laid with headers and stretchers alternating in the vertical direction; only segmental arches or flat stone lintels[9] were used to head window openings; the inner parts of door and window openings displayed a precise difference in structure, depending on whether the room was heated or not; the niches on the façade side of the openings with a depth of half a brick were slightly increased in the horizontal direction by expansion of the vertical joints (while the average header width is around 13–13.5 cm, the façade niches have depths up to 17 cm); the specially shaped bricks used for framing architectural features differ in size, both from a regular brick and among themselves; and so on.

When restoring the brick and stone masonry both on the façades and inside the building, the restorers strove to reduce the replacement of authentic fifteenth-century masonry. For that reason, much use was made of the method of re-profiling the lost outer surface of the brick or stone using special restoration mortars made by the German firm Remmers. Re-profiling replaced the removal of a damaged brick, and in certain instances the thickness of the layers of the compound applied was as much as 70–80 mm.[10]

The strategy and sequence of operations for the conservation and restoration of the interiors and especially the finishing of the walls (materials, texture, colour, the display of fragments of murals of different dates and so on) were determined jointly with the restorers of monumental painting.

At all stages of the process, during the study of the building, the drafting of the restoration project and the carrying out of the work, a whole series of difficult questions arose. The issues that had to be tackled in the course of the restoration of the Archbishop's Palace can be divided into two main groups.

The **first group** comprises problems of a general kind that usually emerge during the restoration of the majority of Early Russian edifices, beginning at the research stage.

(A) *The highly complex constructional history of the Archbishop's Palace.* More often than not, medieval buildings, whether religious or secular in purpose, have undergone major reconstructions in the Modern Era, in the period between the mid-1700s and mid-1800s. As we can see in the present instance with the Faceted Palace in Novgorod, where a radical reconstruction took place in the 1820s, the original architectural shapes of the building were very heavily distorted as efforts were made to bring its outward appearance into line with the architectural tastes of that period. A large number of trial trenches through the eighteenth- and nineteenth-century masonry were required to determine the original architectural forms, and many of those could be carried out only

after probing by the mural restoration team to confirm the absence of old layers of paint and plaster in that particular area. Carrying out a large number of trial trenches was technically difficult and considerably delayed the work on producing a plan for the restoration of the building.

(B) *The grave technical state of the building's structures, which was nothing short of hazardous in places.* A survey of the condition of the masonry structures carried out in 2006 established the presence of a large number of cracks in the walls and vaults of the oldest part of the palace and deformation of individual sections of the walls. The main reasons for the appearance of cracks and deformations were the creation or sealing up of many different door and window openings without bonding into the adjoining masonry and several stove ducts being run through the walls with clay used as mortar. Another cause of the cracks and deformations was the later installation of vaults in rooms that previously had flat wooden ceilings.[11] In the meantime, the metal tie rods from the seventeenth to nineteenth centuries had become distorted, and their external anchors were found to be embedded in the weakened masonry of the walls.

Deformation in the walls and vaults was also stimulated by additional subsidence of part of the foundations, especially on the side of the western façade due to the upper level of ground water washing away the filling between boulders in the rubble foundation. The only slight projection of the roof and poor condition of the cornice overhang coupled with the considerable build-up of the cultural layer by the façades over the centuries and the absence of proper paving by the walls led to the exterior masonry becoming saturated and breaking down. The high level of ground water and the general superabundance of moisture in Novgorod's soils resulted in further high humidity within the building's structures, especially the foundations and the ground-floor parts of the palace. In combination with low temperatures in the winter months, this contributed to the formation of ice within the body of the walls and foundations, leading inevitably to the damage to the masonry. The generally unsatisfactory state of the roof produced numerous leaks inside the building.

All this required the working out of separate engineering projects and then time-consuming special operations to strengthen the damaged structures. These were carried out before, or at the same time as, the restoration of the brickwork of the walls and vaults.

Since the outward thrust of the "retrofitted" vaults and other factors were having a negative effect on the technical state of the building, to provide spatial rigidity two belts of metal ties were installed – at the level of the attic and below the floor of the upper storey (in the north-western part of the building). Metal rods with a round cross-section were inserted along the external and internal bearing walls. Most frequently, anchors running right through the wall were used. Where this was not possible, Y-anchors were employed, set in a special anchor mortar.

Due to the semi-rubble structure of the masonry, to ensure that the walls had sufficient density before putting tension on the anchors running through them, additional mortar was injected into the walls at the sites with preliminary repairs to failing sections and the jambs and lintels of the nearby openings. After tensioning of the ties, the anchor points on the façades were finished by repairing the brickwork.[12]

In all cases the injection strengthening of the masonry was combined with reinforcement using basalt plastic and fibreglass plastic rebars inserted into the holes used for injection of the compound.

(C) *The need to make changes to the approved restoration project.* In the course of on-site researches and the carrying out of the work, as is usual in such cases, there was amendment and refinement of the approaches set out in the project, with regard to both restoration and the plans for the adaptation and museumification of the building. Changes to the project were caused by the discovery of previously unknown aspects of layout, parts of the building and architectural details, and also by further specification of the assignment by the client – the Novgorod Museum.

The **second group** of problems comprises specific issues that arose in the course of work on this particular architectural monument – the Archbishop's Palace in Novgorod. The main distinctive problems that came up during the realization of the restoration project were the following:

(A) *Technological problems.* The restoration of original parts and details of the building (such as doors and windows) constructed in the Gothic building technique that is little known and unfamiliar to restorers in Russia required additional study of building technologies, especially the masonry and analogous examples of architectural forms in Backsteingotik buildings of the thirteenth to fifteenth centuries, including the direct examination of buildings in north-eastern Germany and Poland.

For example, research established that the façades of the palace were not originally whitewashed or rendered with plaster and for a long time the colour scheme of the façades was based on the contrast of red brick surfaces and plastered niches. In the restoration project it was decided to re-create the original appearance of the façades, which is typical for the Backsteingotik style. The implementation of this decision required not only the removal of dilapidated plaster of later date from the old parts of the building but also using special equipment to clean the surface from the remnants of mortars and soiling. For this purpose a Russian-made steam-blaster was used as well as a sand-blasting machine made by the German firm Remmers that has a precisely controllable vortex feed of special sand and delicately cleans the outside face of the masonry while preserving the "patina of time".

Another similar example is the technological problem involved in the restoration of architectural elements in which specially shaped bricks were used, such as the ribs of the vaults or the moulded frames around doors, windows and niches. As has already been noted, all the shaped bricks with different designs have their own dimensions that differ not only from the ordinary bricks but also between themselves. Ordering that quantity of individually patterned bricks for the restoration work was impossible for reasons of finance. So the decision was made to produce shaped bricks by casting special concrete with internal fibreglass plastic reinforcement. This was done using wooden moulds that gave the surface of the castings a texture similar to the originals. The castings were made with the (light grey) colour of concrete and tinted to the colour of brick in situ, after the restoration masonry work was finished.

Separate mention should be made of the tinting which was employed not only on the concrete castings but also on the other areas of masonry made from new restoration bricks. The factory-made bricks currently used for restoration work are lighter in colour than the old hand-formed bricks. It was therefore necessary to tint the new masonry to reduce the contrast between it and the original masonry that had been cleaned off so that people would perceive the façades and interiors of the building as an integral whole. For this purpose, use was mainly made of the colouring compounds for re-profiling mortars produced by Remmers with the matching being done on the spot.[13]

The joints in the restored areas of masonry were also tinted as the fifteenth-century mortar proved somewhat darker than the restoration version and had a warmer tone. Some of the tinting of the brickwork in the interiors was done by the restorers of monumental painting. The more regular shape of the modern bricks and the smoother texture of their outer surface means that the necessary distinction between new additions and original masonry can easily be made. After tinting, the masonry on the façades and in the interiors was impregnated with a water-repellent compound.[14]

(B) *The difficulties of adapting the building for museum displays.* The conversion of an architectural monument for this purpose with its specific requirements and the correlation of that adaptation with the revealing of elements of the original structure of the building, the re-creation of lost parts of the edifice and so on always present certain difficulties for a restorer. The installation of modern technological systems necessary for the proper functioning of a museum display – electric wiring, heating and ventilation, fire-alarms, security systems and the rest – in historical buildings is always fraught with a host of issues, and in this unique Backsteingotik edifice those problems were particularly pronounced. As a result, many aspects of the adaptation plan and of the designs for the utility networks had to be amended in the course of the restoration.

(C) *The problem of restoring the top of the Archbishop's Palace.* A separate problem was the question of re-creating the original three-dimensional composition of the building whose two surviving façades – the eastern and part of the

northern – may once have ended in stepped gables, while the building itself was covered by a tall roof. That element of the building seems to have survived until the Swedish occupation of Novgorod in the early seventeenth century.

The Novgorod Museum commissioned an additional project for the re-creation of the two gables and a corresponding tall roof with a pitch of around 50 degrees. The initial project envisaged retaining the roof in its existing form, without reconstruction of the wooden church drum and dome removed in the 1930s. Besides, the roof timbers over the greater part of the building were being destroyed by fungal infection, and the forced decision was taken to replace practically the entire frame.

The planners were of the opinion that, on the basis of the data obtained and using analogies, it would be possible to re-create, in a tentative generalized form, the original silhouette and three-dimensional composition and that taking that sort of approach would to a significant degree give the building back its lost role as the second (after St Sophia's) dominant feature in the north-western area of the Novgorod Detinets and the focus of the Archbishop's Court.

The plan for the re-creation of the top of the building was not, however, approved by the museum's academic board. It was also opposed by the majority of leading specialists in the field of restoration and protection of architectural monuments.

Therefore, in accordance with the decision of the Novgorod Museum's Academic and Methodological Board, a project version was implemented that entailed re-creation of only the bases of the gables at the level of the nineteenth-century cornice beneath the roof, with the retention of the existing size and shape of the roof that had become established in the 1930s.

(D) *The problem of reducing the ground level in the immediate area of the Archbishop's Palace.* Novgorod's medieval edifices are usually surrounded by a cultural layer that is often over a metre thick. Restorers in the 1960s–1990s managed to remove soil around some buildings, which improved conditions for the architectural monument and also resulted in a restoration of the historical appearance of churches (the Saviour on Nereditsa, St George's on the Market Place and others). Many buildings, though, remain as before surrounded by a massive accumulation of soil that causes damage to the masonry and also considerably alters the perceived proportions of the architecture (the Church of St Demetrius of Thessaloniki on Slavkova Street, the Church of the Prophet Elijah at Slavna, and more).

The proper existence of the Archbishop's Palace as a building under present-day conditions required work to literally rearrange the lay of the land and make improvements to the surrounding area. The full amount of work contemplated could not, unfortunately, be carried out due to funding difficulties. At the same time, it should be pointed out that the client had already chosen the variant

covering the least amount of territory from the three proposed by the planners. The failure to complete this work will lead to the gradual destruction of the retaining walls, protective capping masonry and the actual masonry of the sixteenth- and seventeenth-century extensions that have been uncovered by excavations and are now exposed following the lowering of the ground level.

Nonetheless, despite all the difficulties and problems enumerated above, the restoration work carried out in 2007–2012 did make it possible to re-create the majority of the original architectural elements and details both inside and on the façades of the building. At present, the interiors of the single-pillared hall with its ribbed Gothic vaults and certain other rooms – and also the eastern, northern and western façades belonging to the medieval core of the building (not counting the southern annexe from the 1820s and the Suffragans' Block from the late 1800s) – have been practically returned to their fifteenth-century state as far as the level of the upper cornices, with the exception of the roof of the building, whose present shape came into being in the nineteenth and twentieth centuries (Fig. 6.3). The ground next to the old façades has been taken back to the level of the fifteenth century.

Those elements from the 1500s and 1600s that did not disrupt the original compositions of the façades were retained and restored, as were certain altered windows in the western and eastern façades and doorways in the northern façade, in cases where the original openings had been lost altogether.

The completion of the restoration work and the inauguration of an expanded fully fledged museum display allowed visitors to see in all its fullness this one-of-a-kind building – the earliest of the almost completely extant masonry edifices in Russia that was simultaneously an ecclesiastical, civic and residential building, an architectural monument that catches attention with its North German Gothic features exceptional for Early Rus'.

The Archbishop's Palace is evidently the easternmost public building in the German Backsteingotik style, the only truly Gothic edifice to be constructed on the soil of medieval Rus', constructed moreover by German master builders to a special commission from a Russian Church hierarch. The building's structure and typology had a significant influence on subsequent ecclesiastical and secular architecture in the Muscovite state, including such an important building as the Faceted Palace in the Moscow Kremlin.

The completion of the restoration and the opening of the museum display in the building in time for the 1,150th anniversary of Russian statehood, which was celebrated in 2012, helped to emphasize the great significance of the Archbishop's Palace not only for the history of Russian architecture but also for the history of the Russian Orthodox Church and of the Russian state at the time of its construction.

The study of the Faceted Palace has considerably expanded our knowledge of medieval secular architecture. The experience acquired during the restoration of this edifice can be applied to the restoration of other medieval structures. A study of the main problems that arose during the work on this architectural monument

Figure 6.3 The Archbishop's Palace in Novgorod the Great. The interior of the single-pillared Gothic hall on the second storey in 2008 before the start of the restoration (above) and in 2013 after its completion (below). Photographs by D. Yakovlev and I. Antipov.

leads us to conclude that an analytical approach to restoration is required as it most fully accords with the goals of reconstructing medieval buildings that have undergone considerable reconstruction.

Notes

1 For more details of the architectural characteristics of the building, see Antipov and Yakovlev 2015: 107–115; Antipow and Jakowlew 2012: 74–81; Kalugina et al. 2009: 140–178; Yakovlev 2008: 160–174; Antipov 2009: 194–201.
2 Head of the team and chief architect of the project Irina Kalugina; architect-restorers Dmitriy Yakovlev, Ekaterina Ruzaeva, Georgii Evdokimov, Mariia Chistova, Elizaveta Skotnikova, Levon Arutiunian and Anastasiia Anuchina; chief project engineers Ivan Strel'bitskii and Ekaterina Borovikova; architect for the general plan and vertical layout Nadezhda Lorentsson; study of temperature and humidity conditions – industrial engineer Boris Sizov; head of the special engineering designs section Nina Krasnoshchekova; engineers for internal utilities and equipment Andrei Razuvaev, Andrei Ivkin, Natal'ia Mutovkina and Elena Egorova; building materials specialists Liudmila Pan'kina and Larisa Kulikova; archival and bibliographical researches Vladimir Skopin and Vladimir Iadryshnikov (of the Novgorod Museum). For details see (Kalugina et al. 2009: 140–178).
3 The restoration of the murals was carried out by specialists of the Interregional Agency for Scientific Restoration of Works of Art led by Vladimir Sarab'ianov; artist-restorers: Tat'iana Zolotinskaia, Tat'iana Romashkevich, Anna Valueva, Dmitriy Cheremisin, Agniia Karpova, Il'ia Seregin, Aleksandra Grebenshchikova, Varvara Sergienia, Ivan Sarab'ianov, Dar'ia Sladkova, Dmitriy Pimenov, Irina Nasluzova, Dar'ia Skoptsova, Anna Germanova and Tat'iana Fedorenko (Sarabianov 2009: 119–139).
4 The geotechnical survey work was carried out under the direction of Viktor Kuvshinnikov and Sergei Demkin.
5 This work was carried out by the Architectural-Archaeological Expedition of Saint Petersburg State University under the direction of Ilya Antipov, Valentin Bulkin and Aleksei Gervais.
6 The restoration work was carried out by the *Novrest* company (director: Vladimir Bakulin).
7 Regarding examples of analytical restoration in Novgorod, see Shtender 1981: 56–58.
8 New metal fittings (grilles and so on) were created for the restored window and door openings using traditional forging methods on the basis of surviving examples and mounted in place during the masonry work.
9 For the restoration of such lintels and other elements made of natural stone, the distinctive local schistose dolomitized limestone was used that is similar in colour and other properties to the old material.
10 For example, in the case when only the rear portion of a shaped brick remained, while the protruding part carrying the moulding had been cut away, it was re-created using re-profiling and not by replacement with a new piece.
11 The restoration plan called for the retention of the overwhelming majority of the later vaults. They were reinforced and restored.
12 It should be stressed that the engineering operations to install new ties were the start of the main phase of restoration work on the building.
13 When necessary the re-profiled bricks were also tinted additionally.
14 In those rooms of the palace where tinted brickwork is located alongside uncovered and restored fragments of the fifteenth-century murals (in the one-pillar hall, for example), this work was carried out exclusively by the restorers of monumental painting.

References

Antipov, Ilya (2009). *Novgorodskaia arkhitektura vremeni arkhiepiskopov Evfimiia II i Iony Otenskogo* [Novgorodian Architecture at the Time of Archbishops Evfimii II and Iona Otenskii]. Moscow: Indrik.

Antipov, Ilya (2013). "Ob atributsii i datirovke nekotorykh postroek novgorodskogo Vladychnogo dvora" [On the Attribution and Dating of Some Buildings of the Archbishop's Court in Novgorod], *Sofiia*, No 3, pp. 3–9.

Antipov, Ilya and Yakovlev, Dmitriy (2015). "The Faceted Palace in Novgorod the Great as the part of the Archbishop's Residence". In: *Castella Maris Baltici. XII. Castle as a Residence*, ed. Aleksander Andrzejewski. Łódź: University of Łódź. pp. 107–115.

Antipow, Ilja and Jakowlew, Dmitrij (2012). "Der Facettenpalast in Weliki-Nowgorod – Ein Denkmal der Zusammenarbeit Deutscher und Nowgoroder Meister". In: *Russen und Deutsche. 1000 Jahre Kunst, Geschichte und Kultur. Essays*, ed. Natalija Kargapolowa, Olga Teslenko, Comelia Skodock, and Bernhard S. Heeb. Petersberg: Michael Imhof Verlag. pp. 74–81.

Davidov, Sergei (1950). "Vosstanovlenie arkhitekturnykh pamiatnikov Novgoroda v 1945–1949 godakh" [The Restoration of Novgorodian Architectural Monuments in 1945–1949]. In: *Praktika restavratsionnykh rabot* [The Practice of Restoration Works], ed. L. Kal'ning-Mikhailovskaia. Issue 1. Moscow: Gosudarstvennoe izdatel'stvo literatury po stroitel'stvu, arkhitekture i stroitel'nym materialam.

Gladenko, Tamara, Krasnorech'ev, Leonid, Shtender, Grigorii and Shuliak, Liubov' (1964). "Arkhitektura Novgoroda v svete poslednikh issledovanii" [The Architecture of Novgorod in the Light of Recent Investigations]. In: *Novgorod. K 1100-letiiyu goroda [Novgorod. A Book of Essays Marking the 1100th Anniversary of the City]*. Moscow: Nauka. pp. 183–263.

Iadryshnikov, Vladimir (2009). "Problemy datirovki i funktsional'nogo naznacheniia novgorodskoi Granovitoi palaty" [Problems of the Dating and Functional Purpose of the Faceted Palace in Novgorod], *Novgorod i Novgorodskaia zemlia. Iskusstvo i restavratsiia* [Novgorod and the Novgorodian Land. Art and Restoration], Issue 3, Velikii Novgorod: Novgorodskii muzei-zapovednik. pp. 92–112.

Kalugina, Irina, Yakovlev, Dmitriy and Ruzaeva, Ekaterina (2009). "Arkhitektura Vladychnoi palaty novgorodskogo Kremlia po materialam issledovanii 2006–2008 godov" [The Architecture of the Archbishop's Palace in the Novgorod Kremlin Based on the Researches of 2006–08], *Novgorod i Novgorodskaia zemlia. Iskusstvo i restavratsiia* [Novgorod and the Novgorodian Land. Art and Restoration], Issue 3, Velikii Novgorod: Novgorodskii muzei-zapovednik. pp. 140–178.

Khodakovsky, Evgeny and Meliukh, Ekaterina (2015). "Dmitrii Mileev and the Restoration of Wooden Architectural Monuments in Early Twentieth-Century Russia", *Russian Review*, Vol. 74, Issue 2, pp. 247–271.

Mednikova, Elena (1995). "Deiatel'nost' akademika arkhitektury P.P. Pokryshkina v Imperatorskoi Arkheologicheskoi komissii (po materialam Rukopisnogo arkhiva IIMK RAN)" [The Activities of Architectural Academician Pëtr Pokryshkin in the Imperial Archaeological Commission (on the materials in the Manuscript Archive of the Institute for the History of Material Culture of the Russian Academy of Science], *Arkheologicheskie vesti [Archaeological News]*, No 4, pp. 303–311.

Novgorodskaia Pervaia letopis' Starshego i Mladshego izvodov [The First Novgorodian Chronicle] (1950). Moscow – Leningrad: Izdatel'stvo Akademii nauk SSSR.

Novgorodskaia Chetvertaia letopis'. Sokrashchennyi Novgorodskii letopisets (po spisku N. K. Nikol'skogo) [The Fourth Novgorodian Chronicle. The Short Novgorodian

Chronicle (after the copy from the collection of Nikolai Nikol'skii)] (2000). In: *Polnoe sobranie russkikh letopisei* [The Complete Collection of Russian Chronicles], ed. Fedor Pokrovskii. Vol. 4. Part 1. Moscow: Iazyki russkoi kul'tury. pp. 580–622.

Sarab'ianov, Vladimir (2009). "Rospisi Vladychnoi palaty Novgorodskogo kremlia: Kel'ia Ioanna. Predvaritel'nye zametki po rezul'tatam restavratsionnykh rabot v 2006–2007 godakh" [The murals of the Archbishop's Palace in the Novgorod Kremlin: Ioann's cell. A Preliminary Report on the Results of the Restoration Work of 2006–07], *Novgorod i Novgorodskaia zemlia. Iskusstvo i restavratsiia [Novgorod and the Novgorodian Land. Art and Restoration]*, Issue 3, Velikii Novgorod: Novgorodskii muzei-zapovednik. pp. 119–139.

Shtender, Grigorii (1981). "Restavratsiia pamiatnikov novgorodskogo zodchestva" [The Restoration of Monuments of Novgorodian Architecture]. In: *Vosstanovlenie pamiatnikov kul'tury* [The Restoration of Cultural Monuments], ed. Dmitriy Likhachev. Moscow: Iskusstvo, pp. 43–72.

Suslova, Anna and Slavina, Tat'iana (1978). *Vladimir Suslov*. Leningrad: Stroiizdat LO.

Yakovlev, Dmitriy (2008). "Vladychnaia palata novgorodskogo Kremlia. Rekonstruktsiia pervonachal'nogo oblika (po materialam issledovanii 2006–2007 godov)" [The Reconstruction of the Original Appearance of the Archbishop's Palace in the Novgorod Kremlin (based on the investigations of 2006–07)], In: *Lazarevskie chteniia. Iskusstvo Vizantii, Drevnei Rusi, Zapadnoi Evropy. Materialy nauchnoi konferentsii 2008* [Lazarev Readings. The Art of Byzantium, Early Rus', Western Europe. Materials of the scholarly conference 2008], ed. Elena Efimova. Moscow: Izdatel'stvo Moskovskogo Universiteta. pp. 160–174.

7 The General Staff building in Saint Petersburg

From an empire-style administrative building to contemporary art venues for the Hermitage Museum

*Ekaterina Staniukovich-Denisova
and Emilia Khodinitu*

The state-owned museums and cultural institutions with a rich historical heritage that are located in the centre of Saint Petersburg have a pressing need for new, modern premises. Right up to the late twentieth century, the world-famous Hermitage, Mariinsky Theatre and Russian Museum were marked by an academic conservatism and operated in premises that last underwent major restoration in the years following the Second World War. The situation began to change in the 1990s, when, after the fall of the Iron Curtain and changes in economic conditions, a discussion began on ways of modernizing various aspects of the life of society. In Saint Petersburg, a unique city that has retained the integrity of its architectural appearance and the urban-planning structure of the imperial capital of the eighteenth to early twentieth centuries and that was the first in the USSR to be included in UNESCO's World Heritage List (1990), this inevitably affected the historical building stock.

While the 1990s were a period of active discussion, new projects, and the redistribution of ownership, in the first decade of the new millennium, with the emergence of new financial possibilities and mechanisms, decisions taken previously began to be put into effect and architectural plans started to be implemented. In the construction sphere in Russia, the gap grew between the ambitions of clients and the technology, which understandably lagged behind the times. This state of affairs was made worse by building legislation that did not fit the present-day realities and other factors in a situation when reforms of the state and financial sector were at fever pitch. The consequences were a slowing of the pace of construction and a general decline in quality, and, as a result, projects were dated and technically outmoded by the time they were completed.

In the early twenty-first century, the reconstruction of historical buildings in St Petersburg began to pick up pace with every passing day. By "reconstruction" in the present case, following the definition given by Aleksandr Kedrinskii, one of the founders of the Leningrad school of restoration, we mean "the adaptation of buildings to modern conditions or alterations occasioned by their use for a new purpose" (Kedrinskii 1999: 13). A number of Russian researchers with some

cause point to the erroneous use of the term and a substitution of concepts with respect to reconstruction and restoration in twenty-first-century St Petersburg in instances when "this results in buildings that are only partly historical monuments, even though listed as such" (Minchenok 2012: 130). Consequently, each case continues to raise a number of questions relating to the legal protected status of the building that houses the museum, to the permissibility of modern intrusion and also to the designs put forward by architects offering their solution to the museums' pressing issues.

The need to adapt historical buildings, including architectural monuments, to present-day demands is made more difficult by the fact that in St Petersburg there are certain legal restrictions on construction in the city centre and stringent rules on restoration. Meanwhile, strict scientific restoration without the introduction of new elements cannot provide the museums with the capabilities to display and utilize space that they are seeking. Further complications for construction work specific to St Petersburg are the high density of the historical buildings and marshy soils that prevent obtaining extra space by going underground.

The protection of monuments and the modernization of historical buildings in St Petersburg

Architectural restoration practice in Russia, and especially in Leningrad, took shape after the horrendous destruction of architectural monuments during the Second World War, and therefore it saw its priority as lying in the preservation of a building and its architectural features, at times at the expense of modern functionality, which at that moment had neither economic nor ideological underpinnings.

The principles of restoration were founded on maximum possible adherence to historical prototypes in the choice of materials and a solicitous attitude towards context, while the chief criterion for the restoration and reconstruction of monuments was authenticity. To a large extent this was due to the fact that, along with Leningrad's building stock as a whole, many architectural monuments (especially the "necklace" of suburban imperial residences) were seriously damaged. It was precisely as a result of this that the science of restoration began to develop, producing a unique methodology of re-creation and a school of devoted professionals.

The issue of historic towns and cities that had suffered destruction was common for the whole of post-war Europe. There were several possible approaches, including leaving everything as it was, memorializing the course of history and the horrors of war, or else investing titanic efforts to bring a monument back to life and return it to its former appearance. A third alternative was to clear the site and put up new buildings in place of the old.

Conservation of ruins in a region with a cold, damp northern climate does not provide for the reliable protection of monuments or their long-term survival, particularly when the materials were brick and plaster. The outlook was best for buildings every aspect of which was reconstructed that would reflect the era in which they were first created. This is borne out too by the difficulties that

protecting ruined buildings presents, and also by economic considerations – simply in order to preserve them, it is often necessary to reconstruct them partially or completely.

In Leningrad the decision was taken in favour of the total reconstruction of monuments. Scientific restoration developed, basing itself on surviving documentation and the method of analogies, for the sake of the main goal – to preserve the edifice and give it a new life, a new function. It is a different matter that the number of buildings taken under state protection began to expand only after the creation in the late 1960s of the All-Russian Society for the Preservation of Historical and Cultural Monuments and the establishment of a Committee for the State Monitoring, Use and Preservation of Historical and Cultural Monuments.

Already at that time a problem arose for which an optimal solution never was found, even by the early twenty-first century, when the catastrophic losses and destruction had already been made good. It lies in the contradiction between two demands being made of restoration: to preserve a maximum of what has survived while at the same time adapting the building to give it as long a functional lifespan as possible. The latter demand sometimes involved altering the layout or building on certain elements (Kedrinskii 1999: 11), which often pits specialist historians against a building's owners and restorers.

Among the most desirable potential uses for buildings that were cultural monuments was their conversion to serve as museums and the installation of displays and exhibitions there. These were devoted either to the history of the building itself or to more abstract themes, but such a repurposing of the buildings made it possible both to increase the number of museums in the city and at the same time to preserve the edifices themselves (Kedrinskii 1999: 179). As a result, in recent times it has become a common practice to reconstruct architectural monuments in the centre of the city, reorienting them towards a new function.

Any reconstruction, especially in Russia, also requires strict monitoring on the part of the authorities responsible for the protection of monuments, because owners and contractors often fail to carry out the work conscientiously or else they use inappropriate building materials. When the rules are not followed, a reconstruction threatens the loss of architectural heritage and not its regeneration. The key to the process lies in choosing a solution with good prospects, one that provides the monument with a long and functional future.

European experience has shown that reconstruction of architectural monuments often gives them a new life and development instead of ruination. One of many examples is Frankfurt am Main in Germany, where the historical city centre was almost completely destroyed. Despite proposals to demolish the few ruins that did remain, the municipal authorities came out in defence of the unique urban landscape and preserved several private residences, reopening them as a museum of sculpture and a museum of applied art. In this way, a real museum street was created that has become an important part of the city's cultural ambiance. The post-war tendency in the West called not for the re-creation of everything down to the smallest details in ideal condition but for the preservation of visible scars on the body of the building and non-replacement of losses, giving

visitors the opportunity to sense the history of the place (examples might be Frankfurt's Archaeological Museum, housed in a former Carmelite Monastery, and the Neues Museum in Berlin). The use of historical buildings as museums became a concept equated with the preservation of the historical urban environment (Giebelhausen 2011: 237).

In the twenty-first century, an ever-increasing tendency in the reconstruction of museums is to put up an ultra-modern building or complex in the immediate vicinity of the historical edifice or else to incorporate the edifice itself into the new ensemble. However, reconstructions, too, at times pursue different goals and vary in the quality of the original idea and its implementation (MacLeod 2005; Krauel 2013).

In Saint Petersburg, there is a certain state of opposition between construction companies eager to gain possession of plots and buildings in the city centre for the development of commercial business and protectionists such as historians, art scholars, architects and public organizations. As far back as 1990, the historical centre of the former capital was made a World Heritage Site with demarcation of the protected zone. With time that zone began to be reduced with new construction being permitted on the areas excluded from it, which arouses the discontent of protectionists, as do failures to comply with conservation legislation.

Still, even such an important and socially beneficial goal as the creation of new facilities for the Hermitage, the transfer of parts of the museum's stocks and the formations from them of new displays in the centre of the city evoke public criticism. Citizens, specialists in architectural conservation, museum people and architects adopt completely disparate positions, which makes the search for a compromise even more difficult. It is possible to speak about an explicable non-acceptance of the values of post-modernism, whose penetration into traditional Russian culture is sporadic in character, and about the prevailing lack of acknowledgement for the value and achievements of contemporary culture and art, particularly from our own country, of which architecture is inevitably an expression.

Russia's museum architecture is also highly idiosyncratic on account of its historically ordained trajectory of development. After the October coup d'etat in 1917, palaces and country mansions were nationalized and were no longer used for their original purpose. Some of them were fortunate enough to be turned into museums, while others were used to house various institutions – schools, hospitals, hostels for single workers or students, and so on. This promoted a state of affairs where museum collections accumulated, while the field of museum architecture did not develop right through until the 1960s. Hardly any large new art museums appeared in the country, the most notable exception being the new building of the Tretyakov Gallery on Krymsky Val in Moscow (1964–1983). Meanwhile, right up until the 1990s, contemporary art was taken to mean slightly modernized academic painting, then still known as Socialist Realism. Contemporary art as we know it today was not recognized by the authorities and therefore not by state museums either. The rare exhibitions that did take place were often semi-illicit in character, and the idea of any sort of permanent public display of such art belonged to the realm of science fiction. After contemporary art did begin

to appear in museums during *perestroika* and the difficulties people then had in digesting it, the question arose of the appropriateness of showing such art in the historical interiors of existing art museums and subsequently of the creation of new venues specially for it.

The General Staff building in a historical context

One of the largest and most publicly prominent projects of recent years in St Petersburg was the modernization of the Eastern Wing of the General Staff building, which had been transferred to the administration of the State Hermitage as far back as the late 1980s. The building of the General Staff came into being in several stages. In the first half of the eighteenth century, the area became built up with brick dwelling houses that stood tight up against one another in a continuous line along the embankment of the small River Moika. In the reign of Catherine II (1762–1796), an urban-planning commission headed by Aleksei Kvasov determined the shape that the block between Nevsky Prospekt and the Winter Palace should have and thus ordained the curved shape of Palace Square (Baryshnikova 1997: 620–623). Ten years later, to the design of Georg (Iurii) Veldten, houses in the Neo-Classical style were erected on the south side of the square opposite the Winter Palace with their façades arranged in a sweeping curve. The buildings on the square remained an uncoordinated irregular mass until 1811, when Emperor Alexander I took the decision to unite several civil ministries and the military administration (General Staff) in a single building on Palace Square (Fig. 7.1).

The design of the new building was entrusted to the St Petersburg architect Carlo Rossi. He proposed uniting the existing buildings behind a common façade in the shape of a parabolic arc, finally forming the south side of Palace Square, with a triumphal arch in the centre of the composition. The building work, which lasted from 1819 to 1828, resulted in the creation of dozens of interconnected blocks and internal courtyards, but all that complex labyrinth was concealed behind an austerely grand façade transformed the city's central square into a sumptuous empire-style ensemble. In this way, a whole city block took shape with a complex configuration, covering a huge area and containing hundreds of administrative offices as well as service rooms and grand apartments for high officials.

The Eastern Wing of the building, with three main storeys above a tall basement, was created to house the Ministry of Finance and the Ministry of Foreign Affairs. The internal layout is based on the idea of making it easy to get about by means of lengthy "backbone" corridors with rooms connected in enfilades on either side and large staircases (more than 20 historical staircases have survived) providing vertical connections. All the service facilities were hidden away on the upper floors and in five sizeable internal courtyards. In the opinion of Marianna Taranovskaia, who has studied Rossi's oeuvre, besides the multi-functional nature of the complex, the elaborate layout may also have been influenced by a desire to retain the walls of pre-existing structures (Taranovskaia 1980: 82). In the

Figure 7.1 View from Palace Square of the Eastern Wing of the General Staff building that today houses departments of the State Hermitage. Photograph by E. Khodinitu, 2017.

wing overlooking the Moika, the enfilade layout of the dwelling houses incorporated into the building during the reconstruction for the ministries was to a large extent retained. It should be noted that the modular character of the plots of land allotted by the state for private housing construction back in the early period

of the city's history and the strict, consistent building regulations in St Peters-
burg determined the compact construction of a dwelling around the perimeter
of its plot leaving a single courtyard in the centre. Right up until the early twen-
tieth century in the centre of the city, one does not come across instances of
the complete demolition of any masonry building in order to construct another.
Numerous studies of different buildings show that even when there were radical
outward changes, maximum use was still made of the existing walls. Alexander I
particularly, when giving his instructions, was constantly guided by the principle
of preserving and re-using old elements when reconstructing buildings, and this
applies even to such innovative projects as St Isaac's Cathedral and the Exchange
building.

In 1988 the Eastern Wing of the General Staff was given over to the State Her-
mitage for use as display areas, storage and service premises for the museum (there
was no mention of contemporary art at that time); the Western Wing remained
in the hands of the military. The Hermitage became the recipient of this gift
on account of its proximity to the main museum complex. The transfer of the
building came first, and only then did people begin to devise a concept for its
exploitation and reconstruction. The building was in a dangerous condition due
to the fact that for many years it had been occupied by various state institutions –
tenants and sub-tenants who were incapable of collectively monitoring the state
of such a grand edifice and carrying out proper repairs. Since the usage of the
building had not altered radically over the course of its history, its structure had
survived well. Back in the 1920s, the Moika-side wing had suffered badly from
a fire. On the other hand, the state rooms belonging to the Ministry of For-
eign Affairs overlooking Palace Square were in a quite good state of preservation
(Astrov 2016: 75–78). It was with the restoration of those halls decorated to
Rossi's designs that the reconstruction of the complex began in 2000–2002.

In the 1990s, in the absence of dedicated funding, a concept for the future
museum building was being worked out. In 1992, Mikhail Piotrovsky became
director of the museum and introduced modern approaches to museum practice.
That period saw the determination of the set of problems associated with adapt-
ing the historic administrative building for museum purposes while proceeding
from the idea of preserving Rossi's treatment of space. The actual historical struc-
ture, its anatomy, became the starting point for the modernization of the new
museum building.

The question was raised that still remains unresolved regarding the conveni-
ence of communications between the main complex of the Hermitage and the
General Staff, separated from it across the square, a particularly relevant issue
given the city's cold and rainy climate. People pointed to the need for a modern
vestibule linking the buildings. The creation of a space like the Louvre Pyramid
was dismissed out of hand, because it would destroy the architectural ensem-
ble of Palace Square. The construction of an underground facility beneath the
square (Tat'iana Slavina's plan) was also ruled out for a number of objective
reasons: the difficult soil conditions (in the eighteenth century a stream flowed
in the area); the presence of the Alexander Column, held up only by its own
weight, in the centre; and the proximity of historic buildings, not all of which

belong to the Hermitage. Mention should also be made of Iurii M. Denisov's proposal to construct a new entrance to the Hermitage (on the apron in front of Choristers' Bridge) in the form of a shallow amphitheatre, barely rising above ground level, leading to an underground corridor skirting Palace Square not far below the surface and branching towards the General Staff and the Small Hermitage.

At last the specifications were determined, and in 2002 the Russian Ministry of Culture announced an international competition to choose a designer. It was won by the St Petersburg–based architectural bureau Studio 44 headed by Oleg and Nikita Yavein (with the company Intarsia as contractor) (Yavein et al. 2009: 45; Yavein 2014; Fig. 7.2).

The brothers, born in the late 1940s and early 1950s, are members of a well-known architectural dynasty in Russia, and their background includes experience of the architectural approaches employed in this country throughout the twentieth century. The majority of their works demonstrate a devotion to the modernized classical and the use of ideas from our historical heritage (including Soviet Constructivism).

The plan for reconstruction lay in covering the five inner courtyards with glazed roofs – something that has become a textbook approach for the modernization of museums, implemented at the British Museum, the Rijksmuseum and elsewhere.

The new courtyard-halls alternate with a modern "insertion" – transforming halls within the transverse blocks. The walls in those halls can be rolled back, and the different surfaces have their own colour, making it possible to vary the design of the displays. Another important element of the project was the serious scientific restoration of the historical interiors of the Eastern Wing. Thus, the authors of the project proclaim that they have adopted and developed a key compositional idea of the main Hermitage complex found in the Winter Palace – the enfilade arrangement of spaces. One of the main stipulations laid down by the Hermitage administration was the creation of a new display space for the collection of Impressionists and nineteenth-century Western European art (Malich 2013). Specifically for those works, the architects designed halls with lighting from above that are marked by rich colours on the walls in combination with the coarse texture of concrete ceilings (Yavein et al. 2009: 32).

In 2007, the *Hermitage 20/21* project was launched with the aim of calling attention to works of contemporary art which at that time had still not been popularized in Russia. The administration went on to create a Department of Contemporary Art that is also housed in the Eastern Wing of the General Staff. The Hermitage, Russia's oldest and most authoritative museum, was characterized since its foundation by a deep respect for tradition in art and a striving to keep up with the times, something that again became noticeable in the period of Mikhail Piotrovsky's directorship.

The new museum in the General Staff building was formally opened in December 2014 as part of the celebrations for the 250th anniversary of the Hermitage,

Figure 7.2 Model of the Eastern Wing of the General Staff building. Design by the archi-
tect Nikita Yavein, Studio 44. Photograph by E. Khodinitu, 2017.

which is considered to have been founded in 1764. Today it is used to display
various collections, from works of jewellery presented to the imperial court to
Impressionist and avant-garde paintings, and also for high-profile temporary
exhibitions spanning the whole spectrum from antiquity to contemporary art.

Distinctive features of the new usage of the General Staff premises

Methods for displaying contemporary art were worked out in New York's Museum of Modern Art back in the twentieth century, but they still remain current. There they created spaces that were flexible with regard to the arrangement of displays and at the same time neutral. Prior to that experience, museums predominantly placed the exhibits in the luxurious interiors of palaces. In the case of the State Hermitage, that situation prevailed right up until 2014 and the opening of the General Staff building, intended for the presentation of contemporary art. Classical interiors are no longer suitable for video art and contemporary installations. The new forms of art require space, scale and a neutral setting that allow them to speak for themselves. The democratization of culture that resulted from the construction and creation of the Pompidou Centre in Paris (Giebelhausen 2011: 233) has continued to actively develop. According to a survey made by Natalia Shalina, "respondents tend to stress three main features that could distinguish museums of contemporary art from other museums: the nature of art represented, interactive displays, specific architecture" (Shalina 2015: 820f). The dual nature of present-day museums lies in the fact that they are called upon to preserve the spirit of the past while simultaneously responding to the challenges of contemporary life.

In Russia in the early 2000s, there was an awareness of the need for a rejuvenation of the largest state-owned museum. That was precisely the direction in which the Hermitage headed when planning the reconstruction of the Eastern Wing of the General Staff building. While leaving untouched the historical displays (dating from the post-war period) in the main complex and the actual structure of the classic Hermitage (with the exception of the Impressionist collection), the inclusion into the museum's premises of the new building on the opposite side of Palace Square made it possible to embark on a process of active modernization and adaption of the fresh facilities to the present-day needs of the museum.

From the second half of the twentieth century, the museum buildings that were erected have become sort of local landmarks, centres of the cultural life of a city. Assuming a status on a par with cathedrals, they turned into attractions for large masses of people. They have also played an important role in the formation and regeneration of the urban environment (Barranha: 2009, 2). Although in her study Helena Barranha is writing more about the construction of purpose-built museum premises, this assertion is also applicable to reconstructed historical buildings used to house a new museum. One example of this is the General Staff building on Palace Square in St Petersburg. Its location is geographically in the very heart of the city, but, until the reconstruction of its Eastern Wing, one of the largest edifices in the historical centre was completely inaccessible to its citizens. In Soviet times, the Eastern Wing was used by a number of different organizations, being reduced by the 1980s to such a state of dilapidation that it stood empty, while the Western Wing still today houses the Military Prosecutor's Office, where ordinary people are not admitted. The reconstruction of the

Eastern Wing carried out to the plan of Studio 44 opened up this magnificent building for the city, making it a new centre of cultural life and contemporary art. In the opinion of the Danish researcher Hans Ibelings,

> it is an intervention that manages to find a balance between the static monu-mentality of St. Petersburg's architectural heritage and the dynamism of the city.
> (Ibelings 2014: 70)

Additionally, the Eastern Wing of the General Staff building is important because it offers people open public spaces in which to work and relax, to study and pass time, which is also an important function of a modern-day museum (Barranha 2009: 12).

The use of buildings for museum purposes also makes it possible to preserve their historical elements even better, as in that event the building itself also becomes a sort of museum exhibit. However, such utilization also at times entails substantial changes to the edifice itself, which arouses much criticism. Besides restoration, there is a need for a review of the very role of museums in modern-day society. It has long since become understood that the conservative concep-tion of the museum – in which there is no place for cafés, magazines, lifts or escalators, rest areas and so on – is outdated. Increasingly, Russian museums, too, are drawing on the experience of their Western counterparts and reconsidering their displays and facilities to meet the demands of the present day.

In some parts of Carlo Rossi's enfilades, the historical interiors survived well to a greater or lesser extent. In accordance with established restoration practice, the specialists preserved and re-created the decoration of the halls to the greatest extent possible. The historical interiors are ideally suited to the display of classi-cal art, painting, applied art and sculpture from the earlier nineteenth century – in other words, items that might have adorned rooms of this sort when they were first in use. The connection between the General Staff and the Winter Palace can also be traced in the structure of the suites of grand rooms. The galleries in the Winter Palace were formed in the rooms of the palace itself that are splendidly suited to house such displays. In the General Staff building, lengthy galleries have been formed from the fairly small offices in which civil servants once spent their working lives. They have low ceilings and weak natural lighting, but nevertheless it was decided to use these enfilades to house the main display of classical art.

The ground floor of the refurbished General Staff building was conceived as a continuation of Palace Square and an extension of the public urban space. The project envisages it combining a number of functions: entrance zone and ticket offices, book shops and designer boutiques, cafés, Hermitage clubs and so on. The largest courtyard contains a built-in staircase-amphitheatre, providing a venue for lectures, discussions, concerts and film-shows – events inseparable from the concept of a "modern museum" (Fig. 7.3).

The predominantly grey colouring of the internal courtyard façades, re-created in keeping with Carlo Rossi's intentions, has proved acceptable and even sought-after for exhibition purposes. In 1817–1818, Alexander I gave orders that the façades

Figure 7.3 The great amphitheatre staircase in the fifth courtyard of the Eastern Wing of the General Staff building. Architects: Carlo Rossi (1819–1829), Nikita Yavein, Studio 44 (2004–2013). Photograph by E. Khodinitu, 2017.

of buildings in his capital and other Russian cities be painted in light colours – pale yellow, light grey, pale pink and a few other pastel shades. Roofs were required to be brown or green. The predominant tone of the walls of the rooms, in various shades of grey and other colours with a strong proportion of white, contrasts

effectively with some of the new spaces painted in bright rich colours: the new terracotta Red Staircase and the Red, Blue and Green Transformer Halls.

From the moment the restored empire-style interiors were opened to the public, the Hermitage began unrolling its exhibition activities in the General Staff building. The first major event in the modernized premises was the *Manifesta 10* biennale of contemporary art (curated by Kasper König) that took place in 2014, even before the official opening of the complex. *Manifesta* appeared at the tail end of the Cold War as a forum for the exchange of cultural ideas in a rejuvenated Europe, an attempt to stir up the established mode of life with the rebellious spirit of contemporary art. The themes of the biennale became freedom of thought, a critical view of life, politics and deep-rooted prejudices, a dialogue of past and future and the link between old and new in art, an open connection with the public and the discussion of problems. The aims of the exhibition proved to be in harmony with the new venue of the General Staff as the public witnessed it in operation for the first time. The New Great Enfilade, formed by the alternation of open courtyards and transformer halls, contained installations, both large-scale and small-sized ones. The exhibition was also disposed in the empire-style suites of rooms and in the new rooms in the fourth storey. The new display spaces permitted the inclusion of all sorts of contemporary art from video art to Timur Novikov's works on fabric; Thomas Hirschhorn's *Abschlag*, which occupied almost the whole of the third courtyard; and Ilya and Emilia Kabakov's *Red Wagon*.

This prompted people to look again at the courtyards of the General Staff, showing their scale and capacity to adapt to various forms of contemporary art. The biennale provided St Petersburg with a successful demonstration of the presentation of such works in the setting of a modified historical building. The aim had been achieved – *Manifesta* opened up (in all meanings of the phrase) the spaces of the General Staff for the people of the city and visitors to the Hermitage.

The reconstruction that was carried out produced a number of positive results. First and foremost, there is the expansion of the space to accommodate the museum's large and heterogeneous collections, and also the capacity to hold high-level exhibitions using the latest technologies and equipment, which was sometimes impossible in the setting of the Winter Palace. One of the key changes was that the Hermitage formed a department of contemporary art, for the successful functioning and representation of which a suitable environment was created at the same time, a museum meeting modern standards and visitors' requirements. Minimalist architecture that does not compete with the works themselves has since the last century been the basic prerequisite for the display of works of contemporary art (Giebelhausen 2011: 241), and the Hermitage has now acquired such a venue in the very heart of the city. The project also envisages the possibility of transforming various spaces to suit the needs of different exhibitions.

The museum has also acquired additional premises to accommodate its administration, the student club and educational centre, venues for holding lectures, seminars and concerts with substantial audiences. Besides contemporary architecture, there are also new traditional display spaces in the restored state rooms of the General Staff building. They resemble rooms in the Winter Palace and have

a similar interconnected enfilade arrangement making for a gradual ceremonious unfolding of the display. This reconstruction project allowed the retention of the luxurious character of the nineteenth-century metropolitan edifice and undoubtedly brought about an improvement of its physical condition. Tact with regard to the historical legacy made it possible to expand and improve the functionality of the building, but without altering its outward appearance, which is emblematic for the city, and thus leaving the ensemble of Palace Square unchanged.

A further highly important achievement was a fresh view of St Petersburg's classic architecture. This "nuanced" principle of interaction between historical and contemporary architecture (Fedotova 2016: 642) was accomplished through harmonious stylistic resonance. The majority of those who visited the General Staff after its opening were impressed by the spaces of the inner courtyards, the juxtaposing of empire architecture and the Yaveins' modern-day additions, reflecting the stylistic and technical capabilities of our own time. The architects managed to present an alternative version of the principle for combining old and new. By using a principle not brought in from outside but grown up from within, on the whole they manage to achieve their ambitious and difficult goal – to create a world-standard museum in a building that was not in any way intended for such a purpose.

The architectural solutions employed in the General Staff building may prove relevant know-how not only for museum design but also for the urban regeneration, since effectively what we have here is an example of the reconstruction of historical buildings as a means of their renewal and incorporation into the city environment and cultural life (Lukin 2009), the modernization of the historical building stock while preserving the exterior appearance of the city blocks, something the whole centre of St Petersburg needs. The city historically was given a less dense network of streets and roads than other European capitals, hence the large size of the blocks of housing. Opening up part of the space within those blocks to the general public could considerably improve the urban environment and how we get about on foot.

Today, ever more museums in Russia are seeking to rejuvenate their buildings and displays. The majority are located in historical buildings that are often architectural monuments protected by legislation so new construction in their immediate vicinity is formally forbidden. There are two obvious ways around this: either open a branch in new, purpose-built structures far away from the centre, or else modernize the historical buildings in pursuit of new functional, technical and display capabilities.

Practically all the world's largest art museums have undergone reconstruction in recent times, often successfully, but on occasion with very mixed results. The experience of carrying out projects in such major museums as the Louvre, British Museum, Neues Museum in Berlin, and Stedelijk Museum and Rijksmuseum in Amsterdam show the chief tendencies in the development of museum architecture on the premises of historical edifices in Europe. The main accent during modernization is placed on convenience, access, comfort and stylishness, while preference is also given to state-of-the-art technical advances for the sake

of a high-quality display. Those aims sometimes outweigh the preservation of the building itself as they entail changes of layout and internal structure and also significant alterations to the outward appearance of the museum (Uffelen 2011; Self 2014).

The situation in Russia differs in that here great emphasis is placed on the preservation of the building and its architectural features, sometimes at the expense of functionality and modernization (Trofimova 2010). This approach has been shaped by certain traditions in the restoration of architectural monuments established in the post-war years. However, the latest projects for the reconstruction of historical edifices for museum use are ever more frequently drawing upon the practices of Western architects who take much bolder decisions.

Museum architecture remains a problematic field in Russia because our country has not managed to establish a tradition of constructing modern museums as exists, for example, in the USA. Besides, experience shows that, in the main, people in Russia have a sceptical attitude towards the modernization of historical buildings, tending to criticize all projects from one viewpoint or another. There are also problems with financing large-scale projects, which in turn leads to poorer quality of the building materials used and of the work itself. That often results in disfigurement of the buildings and rejection of the innovations both by historians, art scholars and restoration specialists and by the actual museum visitors.

Regarding the architectural aspect of reconstruction, it is possible to conclude that only a project with an all-embracing, ambitious, important goal at its heart is capable of convincing the public of the need for change. An original, creative, fresh idea turns a reconstruction from just one more renovation of a historical building in the city centre into a significant event in the cultural life of the city.

On the whole, it is possible to observe that the reconstruction of art museums is increasingly in demand in Russia and the proposals are becoming bolder and more radical. The modernization of the country's major museums is intended to make them more up-to-date and functional, allowing them to create good-quality high-tech displays and display the gems of their collections to greater advantage. Still, intrusions into architectural monuments should at the same time be tactful, objectively necessary and aesthetically pleasing, so that the architecture can remain as much an object for appreciation as the museum exhibits.

References

Astrov, Il'ia (2016). *Glavnyi Shtab / Zdanie grazhdanskikh ministerstv* [The General Staff/ Civil Ministries Building], St. Petersburg: State Hermitage Publishing House.

Barranha, Helena (2009). "Beyond the Landmark: The Effective Contribution of Museum Architecture to Urban Renovation". In: *City Futures in a Globalising World*. Conference Papers. Madrid: European Urban Research Association/Universidad Rey Juan Carlos.

Baryshnikova, Ekaterina (1997). "Aleksei Kvasov". In: *Zodchie Sankt-Peterburga. XVIII stoletie* [The Architects of St. Petersburg. The 18th Century], ed. Iulia Artemieva et al. St. Petersburg: Lenizdat, pp. 609–634.

Fedotova, Natalia (2016). "Principles of Interaction Between Historic and Contemporary Architecture During the Modernization of Museum Strategies of the 20th–21st

Centuries". In: *Actual Problems of Theory and History of Art: Collection of Articles*. Vol. 6, eds. Anna V. Zakharova, Svetlana V. Maltseva, Ekaterina Yu. Staniukovich-Denisova. St. Petersburg: NP-Print. pp. 642–648.

Giebelhausen, Michaela (2011). *Museum Architecture: A Brief History. A Companion to Museum Studies*. Padstow, Cornwall: Blackwell Publishing.

Ibelings, Hans (2014). *Innate and brought in The Hermitage XXI. The New Art Museum in the General Staff Building*. London: Thames & Hudson.

Kedrinskii, Aleksandr (1999). *Osnovy restavratsii pamiatnikov arkhitektury* [The Basics of the Restoration of Architectural Monuments], Moscow: Izobrazitelnoe iskusstvo.

Krauel, Jacobo (2013). *Nouvelle architecture des musées*, Barcelona: Links Books.

MacLeod, Suzanne (ed.). (2005). *Reshaping Museum Space – Architecture, Design, Exhibitions*. London: Routledge.

Malich, Kseniia (2013). "Restoration and Reconstruction Project for the East Wing of the General Staff Building in St. Petersburg". In: *PROEKT ROSSIA*. 2013. No. 68(2). pp. 174–188. http://www.studio44.ru/rus_ver/novosti/publications/publ/ (Accessed 6 April 2015).

Lukin, Valerii (2009). *The Hermitage Museum and the City as the Museum in the Structure of Urban Space*. Save and promote the world heritage. Saint Petersburg and Berlin-Potsdam. ICOMOS. XLIX.

Minchenok, Elena (2012). "Slozhnye sluchai/Thorny Issues". In: *Sankt-Peterburg: Nasledie pod ugrozoi/ St Petersburg: Heritage at Risk* (a bilingual publication), ed. Elena Minchenok and Clementine Cecil. St. Petersburg: Skiphiya. pp. 124–131.

Self, Ronnie (2014). *The Architecture of Art Museums. A Decade of Design: 2000–2010*. London: Routledge.

Shalina, Natalia (2015). "Defining Museums of Contemporary Art: the Phenomenon of Their Popularity in Recent Decades". *Actual Problems of Theory and History of Art: Collection of Articles*. Vol. 5. eds. Anna V. Zakharova, Svetlana V. Maltseva, Ekaterina Yu. Staniukovich-Denisova. St. Petersburg, NP-Print Publ., 2015, pp. 815–828.

Taranovskaia, Marianna (1980). *Karl Rossi: arkhitektor, gradostroitel', khudozhnik* [Carlo Rossi: Architect, Town-Planner, Artist]. Leningrad: Stroiizdat.

Trofimova, Anna (ed.) (2010). Muzei mira v XXI veke: rekonstruktsiia, restavratsiia, reekspozitsiia. Materialy mezhdunarodnoi konferentsii 20–22 oktiabria 2008 goda (Museums of the 21st Century: Restoration, Reconstruction, Renovation: Proceedings of the International Conference, 20–22 October 2008) Trudy Gosudarstvennogo Ermitazha, L [Proceedings of the State Hermitage Museum, vol. L]. Saint Petersburg: State Hermitage Publishing House.

Uffelen, Chris van (2011). *Contemporary Museums – Architecture, History, Collections*. Salenstein, Switzerland: Braun.

Yavein, Oleg (2014). *The Hermitage XXI. The New Art Museum in the General Staff Building* London: Thames & Hudson.

Yavein, Oleg, Yavein, Nikita and Lemekhov, Vladimir (2009). *Novaya bolshaya anfilada* [The New Great Enfilade]. Saint Petersburg: Asterion.

8 The relevance of authenticity

Eidsvoll Constitution hall restoration 1814–2014

Hans-Henrik Egede-Nissen

Jean Cocteau once made a film named *Le Testament de Orphée*. In it, there is a scene where the Cocteau persona reassembles a flower, which he, the moment before, tore into pieces. The scene stages the impossible, and our rational selves are searching for the special effect. The *reverse motion* technique suppress the linearity of time; it makes it look as if the time might be reversed.

In contrast to the time itself, some of its devastations somehow can be reversed. The German cultural theoritician Aleida Assmann claims that *architecture* contains what she calls *die Gnade einer zweite Chance* – the mercy of the second possibility: in this particular case, the wheel of history seemingly can be rolled backwards (Assmann 2010: 23).

Reconstruction is the problem child of cultural heritage, not the least because it challenges the established demands in the field about so-called *material authenticity*. Already, A. N. Didron argued, back in 1839, that the least intervention is to prefer, stating that "it is better to consolidate than to repair, better to repair than to restore, better to restore than to rebuild, better to rebuild than to embellish; in no case must anything be added and, above all, nothing should be removed" (Jokilehto 2011: 138). These days, it seems as if the heritage field is opening up for reconstructions in rising degree – that being said without introducing possible explanations. In Norway, we have throughout the last century and a half seen a number of partial reconstructions – among them the tentative reconstruction of the Nidaros cathedral over a period of more than a century – along with relatively few complete, from-scratch, reconstructions: Fantoft stave church and Holmenkollen chapel being the most ambitious. The latter category has been reluctantly accepted rather than invigorated by the heritage authorities, who, for the most part, have stuck to the doctrine that basically is contained within the following statement by the current director general for Cultural Heritage, Jørn Holme: "Copies are nothing but false side scenes" (Holme 2009). Through this statement, Mr Holme, a jurist by education, placed himself behind an axiom in Western thinking about heritage: matter precedes form. A heritage object consists of the matter that once made it up, and when this matter ceases to exist, then coincidentally does the object. The rise of a new building with the same shape, made by the same kind of materials, does not alter the situation. If parts of the

object like the interior of a room have ceased to exist, the same counts as a rule of thumb: it's gone. The position is echoing Ruskin.

By the year 2014, however, all in a sudden we felt thrown back to the late nineteenth century, when the doctrine governing restoration processes was held by Viollet-le-Duc:

> To restore an edifice means neither to maintain it, nor to repair it, nor to rebuild it; it means to re-establish it in a completed state, which may in fact never have actually existed at any given time.
>
> (Stanley Price et.al. (eds.) 1996: 314)

The object of this very recent application of the French master's ideas were the Eidsvoll House (*Eidsvollsbygningen*), the building where the Norwegian Constitution was written (Fig. 8.1, 8.2).

The occasion was the Constitution's bicentenary, and the goal was to bring the house to look as it supposedly met the eye 200 years ago. Since earlier anniversaries have passed over the building, former attempts have been made to achieve the same goal – the result being inferior and misjudged measured by today's standards and knowledge.

A lot can be said about the current restoration as well as its predecessors. I will limit myself to problematize two aspects: the one being the notion that the building has become *more authentic* through the restoration; the other the fact that the restoration seriously challenges firm restoration principles.

Figure 8.1 The Eidsvoll house, garden façade. Photo credits: Trond Isaksen/Statsbygg.

Figure 8.2 The Eidsvoll House, main façade before the restoration. Photo by Evgeny Khodakovsky, August 2006.

Let me open up by a quotation:

> Authenticity is a key term in the field of cultural heritage. It is applied when we are about to consider if an object is valuable, in regard to what we shall keep and to consider how we shall manage cultural monuments in such a way that the knowledge and experience will be maintained. Authenticity does not necessarily mean original, but that what we see and maintain is real, that it is what it seem to be, and that the values and the history we want it to represent, really is at hand. Authenticity, therefore, must always be related to something: Which history do we want to tell? Which values do we want to maintain?
>
> (Holmene 2013: 148)

This was written by Ulf Holmene, senior advisor at the Directory of Cultural Heritage (*Riksantikvaren*), when presenting the directory's choice to bring the Eidsvoll House back to the splendour of 1814, the year when elected men from all over the country gathered here to draw up Norway's Constitution. The restoration, which was among the most invested and ambitious restoration projects ever to take place in Norway, received a massive media coverage. It was widely endorsed, although some critical voices were heard. Most notably, the secretary-general

of the Society for the Preservation of Norwegian Ancient Monuments, Ola H. Fjeldheim, raised harsh critique. His claim was that the restoration robbed the Eidsvoll House of its genuineness, and he asked rhetorically, "Why reduce the most important national symbol of Norway into a Disneyland of democracy?" (Fjeldheim 2011; the critique was further elaborated in Fjeldheim 2013).

What particularly came to my attention was the third sentence quoted: "Authenticity does not necessarily mean original, but that what we see and maintain is real, that they are what they seem to be, and that the values and the history we want them to represent, really are at hand." It poses no less trouble to comprehend in the Norwegian, but let me make a serious attempt to get behind the words. I take it to imply that "authentic" may mean both "original" and "real". For a characterization to give meaning, it must keep that which is characterized apart from a present opposite. A sentence like "multicellular humans" is devoid of meaning, because there is no such thing as single-celled human. "Multicellular humans" is to be considered a *tautology*. Likewise: should it be considered meaningful to denote physical objects as "authentic", we need to presume the existence of "inauthentic" objects. But can a physical object really be inauthentic, understood as "false"?

The Spanish art historian and conservator Professor Salvador Muñoz Viñas is strongly opposing such an understanding of physical reality. "*Objects cannot exist in a state of falsehood,*" he insists, "nor can they have a *false* nature. If they really exist, they are inherently *real*. The expected, imagined or preferred state of an object is not real unless it coincides with the existing object. The real, existing object can be altered through conservation to make it coincide with, or come closer to, a different, preferred state, but the object will be no more *real* than it was before" (Muñoz Viñas 2005: 93 [emphasis in original]). Holmene, on the other hand, like so many antiquarians, seems inclined to just that belief: "In our opinion, the Eidsvoll House now *has received* a reasonable authentic wholeness"; implicitly: the building has left a condition of inferior authenticity, reaching one superior.

Muñoz Viñas picks as his example Leonardo's drawing of the Virgin and the Child in the National Gallery of London, which was shot by a mentally disturbed person back in 1986, causing a hole in the figure of the Virgin. Being a conservator, Muñoz Viñas cannot refrain from delving into the laborious operations carried out by his colleagues, intending to reverse the impact of the shot on the drawing. No doubt, he states, this restoration was inevitable and the result is brilliant. But when asking whether Leonardo's drawing now is in a more authentic condition than it was after the shot, his answer is definitely no. "The successive conditions are all equally authentic," he states. "We cannot believe that it existed in a false condition when the hole was perfectly visible, for if a drawing is shot, it is bound to have a hole, an authentic hole, and this is how it will exist in the authentic, real world" (Muñoz Viñas 2005: 94). After giving more examples, he sums up: "[R]estoration does not make an object any truer than it was before, just truer to our expectations" (Muñoz Viñas 2005: 98). Very frequently, he claims, "'authentic' is confused for 'preferred' or 'expected'" (Muñoz Viñas 2005: 97).

Muñoz Viñas helps us realize that notions like genuineness and authenticity cannot be meaningfully applied to objects: objects merely *are*, as long as they exist. They may have been altered so much that they are unrecognisable, they may be copies, and they may be less than good copies, and the spectator may hold against them that they are copies, but it is simply behind their ontological capacity to be "false" or "true".

It is accordingly my conviction that the concept "authentic" lacks legitimacy in both of the most common ways it is used within the field of cultural heritage: "original" and "real". As synonym for "original" or "unaltered", it is superfluous; as synonym for "real", it is, as Muñoz Viñas helps us to see, meaningless. Holmene, however, uses the term in yet another sense, namely as synonym for "credible". But given this sense, even a total reconstruction, if only credible enough, can be called "authentic". If the building in question had for instance a Baroque church as its pattern, both may be called authentic Baroque churches. If so, the word "authentic" will be unsuited to distinguish between the original and its reconstruction. If Holmene really means that the original as well as the reconstruction *are* authentic, he is very close to accept Muñoz Viñas's conviction: that objects tautologically are authentic, and that the concept therefore is unsuited to distinguish between different categories of objects.

My belief is that the inclination to use the word "authentic" more or less haphazardly and logically inconsistent, which is in fact very common, could stem from the fact that authenticity is a universal demand. The antiquarian qualification process sets out from a consideration of authenticity: for an object to be considered worthy of safeguarding, or for a restoration to be claimed legitimate, it is essential that it meets the overall demand for authenticity. If it does, it lends legitimacy to the claims about values being present. Not surprisingly, antiquarians, when needed, will tend to stretch the concept towards inconsistence.

So it is understandable, but nonetheless worrying, that Holmene uses this concept to describe and legitimize a process which essentially is nothing but building a hypothesis in wood, plaster and canvas. By all means: I have no reason to doubt that the Eidsvoll House has come closer to its original appearance, and that it in a certain sense emerges more "credible" as a backdrop for visualizing the events in 1814. But to claim that it consequently has become *more authentic* is to lead the public astray. When spending extraordinary amounts of taxpayer's money on a restoration project, it seems very reasonable to demand that the argument on which it rests is made up of consistent notions. Despite its extensiveness, authenticity is not a consistent notion.

My second principal remark about the Eidsvoll project is that even significant alterations, which the building underwent long ago, has been upheaved to bring the building back to its presumed – though fairly well-documented – condition by 1814. This is in my regard in clear disaccord with the Venice Charter.

Let us take a closer look at one particular detail in the most famed room in the building, not to say in the whole country: the Constituent Assembly Room (*Rikssalen*), where the daily meetings took place in 1814. The room was made

iconic through Oscar Wergeland's painting from 1885, painted as he envisaged it to look by 1814 (Fig. 8.3).

By the time Wergeland made his painting, the hall had undergone several alterations. Being a convinced history painter, Wergeland tracked down several sources to be able to depict the historical situation faithfully. His investigation was considered well done in his time, so when the hall was reconstructed 11 years later, it took Wergeland's painterly reconstruction as its pattern. Wergeland, however, was misinformed about several details; among other things he took for granted that the fenestration, which he painted as he saw it, was original. However, the fire insurance protocols document that those (for their time) exceptionally large panes sometime between 1827 and 1846 had been replaced with much smaller formats, dividing the frames in two by six instead of one by three – double-barred. The reason for this change is not known, and it makes at least me curious: why would anyone order the original, high-fashioned, expensive panes to be replaced with old-fashioned, cheaper smaller formats? When entering the empire style, large panes were the obvious aesthetic preference – here Carsten Anker, whose home was Eidsvoll in 1814, was ahead of his time. Maybe the larger panes tended to break more easily, so that frequent changes posed a significant cost. However, improved production techniques had made it gradually cheaper to make larger panes by the time Mr Anker had the windows made, so the savings most likely were not so significant. And why only the Constituent Assembly Room window, as long as the large formats were kept at the rest of the east facade, until 1964? It's hard to explain, but the very fact that the change did take place

Figure 8.3 Oscar Wergeland: Eidsvoll 1814. Photo credits: Teigens fotoatelier.

would in itself normally be regarded as historically significant and the solution well worth preserving. Furthermore, that the hall was made iconic with the window in the given configuration would normally also figure as a strong reason to keep it that way. The same counts for the considerable age of the solution; it had been present for 168 years by the least (Fig. 8.4).

With the bicentenary, however, significant alterations like this one have been reversed along with insignificant ones, because a noble cause, a higher goal, has been posed: to bring the building back to its presumed appearance by 1814. That legitimizes another walk down the alley visited on two earlier occasions, in 1914 and 1964, where the material goal was exactly the same. The result was in both cases heavily critizized by posterity. In 2014, the critique raised was rejected by saying that, today, we know so much more, that the restoration rests on firm ground. However, expanded knowledge is no guarantee for historical correctness. Experience shows that new findings tend to challenge seemingly objective knowledge very often. The last restoration of the Royal Palace in Oslo, not that many years ago, was, like the Eidsvoll project, rooted in an expanded body of knowledge. Nonetheless, by then a most significant source to what were actually done when the castle was built, was overlooked in the archives, namely the painter's bills. They describe in detail which pigments were used for the different tasks. The discrepancy between what is described and the result of the restoration is in some places most significant. What gives us reason to believe that Eidsvoll will pose quite another case?

To go basic for a moment, there can be little doubt that in normative conservation theory there is embedded an obligation to preserve significant later alterations. Dr Michael Petzet, former president of ICOMOS, writes in his introduction, "Principles of Preservation", that a prime concern of the Charter of Venice is the preservation and conservation of the authentic fabric. "The 'originalness' of a monument does not, however," Petzet writes, "refer only to its earliest appearance but rather encompasses later alterations, referring to article 11 in the charter: "The valid contributions of all periods . . . must be respected'" (Petzet 2004: 7).

I'm under the impression that the restoration of the window in the Constituent Assembly Room contradicts this principle. Without investigating the legal standing of the charter, we can ascertain that as a doctrinary text approved by the general assembly of ICOMOS, the charter serves as an "official code in the field of conservation". I borrow this characterization from Piero Gazzola, the first president of ICOMOS. Gazzola further states:

> In fact, [the Venice Charter] constitutes an obligation which no one will be able to ignore, the spirit of which all experts will have to keep if they do not want to be considered cultural outlaws.
>
> (Petzet 2004: 7)

This text could have been expanded with equivalent examples from the same project, but I think this one is sufficient to illustrate my point: I don't claim

Figure 8.4 Window in the Constituent Assembly Room after restoration. Photo credits: Trond Isaksen/Statsbygg.

that what happened at Eidsvoll House necessarily is wrong, and not for a second will I doubt that people visiting Eidsvoll will bring home a positive memory. But the restoration of the founding place of Norway's Constitution obviously challenges leading principles in what the international community of conservators and antiquarians since the early sixties have considered *their* constitution. It has often been argued that a revision of the charter is high in demand. When what is regarded as the most important room in Norway is treated in disaccord with the charter, that is in my view underscoring the acute need for a revision. Obvious discrepancy between normative theory and practice is ultimately eroding the credibility of both.

References

Assmann, Aleida (2010). "Rekonstruktion – Die zweite Chance, oder: Architectur aus dem Archiv", In: W. Nerdinger, M. Eisen, and H. Strobl (ed.), *Geschichte der Rekonstruktion: Konstruktion der Geschichte*, München: Prestel Verlag, pp. 16–23.

Fjeldheim, Ola H. (2011). "Bygger seg vekk fra 1814", *Dagsavisen*, 16.05.

Fjeldheim, Ola H. (2013). "Eidsvoll 2014 – tilbake til fremtiden?" *Årbok: Foreningen til norske fortidsminnesmerkers bevaring*, No. 167, pp. 159–168.

Holme, Jørn (2009). "Kopier er falske kulisser", *Nationen*, 03.11.

Holmene, Ulf (2013). "Tilbake til 1814 – nok en gang!" *Årbok: Foreningen til norske fortidsminnesmerkers bevaring*, No. 167, pp. 131–158.

Jokilehto, Jukka (2011). *A History of Architectural Conservation*. New York: Routledge.

Muños Viñas, Salvador (2005). *Contemporary Theory of Conservation*. Oxford: Elsevier Butterworth-Heinemann.

Petzet, Michael (2004). "Principles of Conservation: An Introduction to the International Charters for Conservation and Restoration 40 Years After the Venice Charter", *Monuments and Sites* 1, p. 7.

Stanley Price, Nicholas, et al. (1996). *Historical and Philosophical Issues in the Conservation of Cultural Heritage*. Los Angeles: The Getty Conservation Institute.

9 Russian-Norwegian cooperation on cultural heritage

A personal experience

Dag Myklebust

In December 1994, the commission supervising work under the bilateral agreement on cooperation on environmental protection issues between the Russian Federation and Norway decided to include cultural heritage protection in its working programme. The Russian Institute for Cultural and Natural Heritage Research and the Norwegian Directorate for Cultural Heritage, the *Riksantikvaren*, should take charge of this specific part. Two chairpersons were appointed: Professor Yury Vedenin and me, as senior adviser at the directorate. The start of this work is described in Chapter 4 of this book.

To concretize a plan of action, the Russian side invited us to a meeting at Sortavala in the East of Russian Karelia, close to the border with Finland. Sortavala is a small town situated in what in the Soviet period had been a closed border area with very limited access for people not living there. This meant that all the participants found themselves on equally unknown ground, not only geographically, but also in terms of the type of cooperation that they were intended to create. Maybe this produced the psychological atmosphere for very constructive work in establishing a programme of action. The delegations were both composed in the same way: two people representing central authorities or institutions and three representatives from different parts of the geographical area where the joint Environmental Commission operated. This covered Northern Norway and North-Western Russia, the latter defined as the Karelian Republic, Murmansk and Arkhangelsk oblasts.

The working programme of the Cultural Heritage group had two initial statements of principles for the work:

(1) A policy for cultural heritage must be based on the built heritage seen in relation to its surrounding natural environment. The preservation work must be based on antiquarian and ecological principles, and both natural and cultural heritage must be made accessible to the public in a way that takes into consideration values in the environment as an entity.

(2) Cultural heritage protection must be closely connected with the work to change our patterns of consumption and production in a more sustainable direction. The work must be based on an understanding of the specifics of the object being worked on, the environmental impact on energy consumption,

pollution and resource management. Protection of cultural heritage must be seen in its full economic, social and political context, and be judged by its significance for society.

The working group agreed on an agenda for a variety of activities:

(a) To set up an expert group to look at legislation in this field and, if relevant, to propose improvements to the relevant authorities.
(b) To look at existing registration systems and data bases for describing natural and cultural heritage with the aim of exchanging knowledge and experience.
(c) To consider the possibilities for cooperation in protection of the cultural heritage of indigenous peoples.
(d) To examine the possibilities for co-operation in the sphere of petroglyphs.

It was also decided to set up an expert group on the restoration of wooden buildings. The group's mandate was to set up a team of craftspeople to develop techniques applicable for the conservation of wooden buildings, in accordance with a standard suitable for objects on the UNESCO World Heritage List. We had close contact with the other directorates that had participated in the Russian-Norwegian environmental cooperation earlier than we did. So, we had the advantage of studying their type of projects and the results they had achieved. All the other fields of cooperation had started with inventorying projects, which were important enough in themselves, but so abstract that their value was difficult to communicate.

In cultural heritage protection, too, inventory keeping is very important. However, it was easy for us to see that if we from the very start produced concrete physical results, such as restored buildings, we would gain a strategic advantage in the competition for resources to carry out our work. Even in some of our projects, we had to go through a period of registering and inventorying objects before we could turn out practical results, but by that stage we had built our credibility as being very practically oriented.

Restoration of wooden buildings

When we Norwegians came to the first meeting of the working group in Sortavala, our main interest was to start cooperation on the restoration of wooden buildings. The reason for this was that a Norwegian cultural heritage expedition to Archangelsk oblast in the wake of the 1991 geopolitical change had discovered a great similarity between the north-western Russian building tradition and the Norwegian one. One very big discovery was that a lost technique from traditional medieval Norwegian carpentry was actually seen being performed on a Russian building site. So, that skill could be reintroduced to Norway!

The Russians agreed on this being an important field for cooperation, and in 1996 a fact-finding mission of Norwegian experts visited Russia to view possible objects for a specific restoration collaboration. They looked at five different

wooden chapels in Arkhangelsk oblast and the Karelian Republic, and finally they chose the St. Nicholas Chapel in the village of Vershinino in the Kenozero National Park in Arkhangelsk oblast (Fig. 9.1).

This choice was a masterstroke. In the National Park's administration, led by the dynamic director general, Elena Flegontovna Shatkovskaya, we found the perfect partner. She was able to make vigorous decisions, mobilizing skilled carpenters on the Russian side and providing the logistic services needed to facilitate the practical work.

On the Norwegian side, we had a flying start because of the experience gathered in what we called the *Middelalderprosjekt*, literally the "Medieval Project". This was a huge national drive performed by the Directorate for Cultural Heritage to restore all Norway's timber buildings dating from before 1 April 1536 (considered to be the end of the medieval period in Norway, since that was the day that Norway changed from a Catholic country to a Lutheran Protestant one). The aim was to bring all medieval buildings up to a condition where only normal regular maintenance would be necessary. This project, led by the directorate's architect Anders Haslestad, developed an ideology based on using traditional tools, traditional methods for processing the building materials, and traditional building techniques.

In addition to this, the master carpenter Bjarne Lofthus had developed a lifting system based on hydraulic jacks that could raise buildings to permit the removal of structural members in need of repair, mostly the lowest logs, without dismantling the whole building. Equipped with these skills, in early autumn 1996, the Norwegian team went to the Kenozero National Park to start work on the St Nicholas Chapel together with their Russian colleagues. Initially they had the help of an interpreter, but soon they were able to communicate very well just using their tools.

The two restoration architects (Anders Haslestad and his Russian colleague Evgeny Bastrykin) were soulmates, and they laid a firm ideological platform for the work. What we never managed to establish, however, was a strategy for the traditional production of materials. The Norwegian idea is that restoration work starts in the forest with the carpenters choosing the best trees, and then this material is processed in a traditional way with the use of traditional tools. We had long discussions on this over a number of years, but the Russian side did not either understand or accept the Norwegian concept and kept making lists of the technical equipment they wanted. This ended with the purchase of a big tractor that was then named after the deputy leader on the Norwegian side of the project, Harald Ibenholt. To the best of our knowledge, Harald Odin (1) is still roaming the forests of the Kenozero National Park.

The St Nicholas Chapel was consecrated by Tikhon, bishop of Arkhangelsk and Kholmogory, in August 1997. This was a great event. A large number of people were present, among them the state secretary of the Norwegian Environment Ministry, Jesper Simonsen. It was a very touching moment when the local people were able for the first time to enter the chapel that had been closed since the revolution. The central location of the chapel, very visible on a little hill,

Figure 9.1 St. Nicholas Chapel in the village of Vershinino in the Kenozero National Park in Arkhangelsk oblast. Seventeenth century. Photograph by Natalia Shalina, 2011.

towering over the rest of the village, made it a symbol of change for the better. It had hopefully become something that could inspire the villagers in their daily struggle for life.

In the years that followed, two more chapels in the park were restored, first the Chapel of St John in the village of Zikhnovo, then the Chapel of the Holy Spirit in the defunct village of Glazovo. Also, a chapel in the Karelian Republic was restored in 1997–1999, using a second lifting rig that was donated to the museum at Kizhi, famed for its grand three-element wooden complex included in UNESCO's World Heritage List.

At Zikhnovo, two secular buildings were also restored with Norwegian funding and the use of the first lifting rig. These buildings were earmarked for a children's environmental summer camp like the one that already existed in the southern part of the national park. During this period the local craftspeople developed their skills enormously, and over the years they became able to use the lifting rig, which was donated to the park, on their own. Several other buildings were repaired by the park authority itself. Seeing our results also inspired some of the people living in the park to start restoration and do repair work themselves.

The biggest project ever undertaken by the park was the restoration of the Pochozerskii pogost in the village of Filippovskaya (Fig. 9.2).

That complex consists of a summer church, a heated winter church, a refectory and a bell-tower. The refectory, or dining hall, served as an assembly hall for the village community. This work started in 2002. Two Norwegian carpenters, who already had experience in working in the park, joined in operating the lifting system. The summer church is a large heavy structure, and the carpenters were not sure that the rig with its hydraulic jacks would actually be able to handle such a big load. It was a very thorny question, and the Russians were perhaps a bit more optimistic than the Norwegians. We were having a seminar on eco-tourism at the same time, for which we had engaged our most experienced interpreter, Dag Klaastad, and we decided to leave him with the carpenters to make sure that everybody involved in this complicated task understood each other. When lifting 160 tonnes, there is no room for misunderstandings.

We members of the "seminar" part of the Norwegian delegation arrived at Filippovskaya the day after the lifting, which went very successfully. We met an extremely proud crew of craftspeople. The proudest of all was Dag Klaastad, who now felt himself to be a real worker. Bjarne Lofthus took part in this operation, as did Hans Sundsvalen, who had taken leave from his position as mayor of his municipality in Norway to work on restoration in the Kenozero National Park.

For some years, we sent Norwegian craftspeople to work at Filippovskaya, and several people working on heritage protection in Norway have had the opportunity to enrich their experience in their professional field in this way. In the concluding years of this project, the funding of the restoration work was basically provided by the Ministry of Culture of the Russian Federation.

In the final stage of our cooperation, we had missions of two kinds. The first was sending fire prevention experts to the park. Norway is a country where the

Figure 9.2 Filippovskaya (Pochozerskii pogost), Kenozero. Church of the Procession of the Venerable Wood of the Cross. 1700. Photograph by Natalia Shalina, 2011.

risk of fires in buildings is high because of the combination of a large number of wooden constructions and a cold climate which requires heating over much of the year. Therefore, the *Riksantikvaren* has been working very seriously on protection of our cultural heritage from fire, and we consider ourselves a leading country in this field. Kenozero National park has many major challenges with important monuments situated in areas that are no longer inhabited and difficulties in obtaining a water supply for fighting fires. That is why there are no easy solutions. The park even had losses to fire during the period of our cooperation! In recent years, fire prevention efforts have continued with the installation of alarm systems and lightning conductors in many chapels.

Another element which is very important for the Norwegian side of the cooperation is the concept of maintenance. We spent several years looking for a good Russian word for "maintenance" which did not have any connotation of "repairing". You repair when damage has already occurred. The idea of maintenance is that you deal with things before they become a problem. You hammer in nails that are coming out of the wall planks, and you fix leaks as soon as you discover them. In this way, the value of the investment in a restoration will be retained for a longer period, and you do not have to undertake expensive new major repairs. A practical method is to make a checklist for each building, inspect it carefully every year, note down what needs to be done and then do it. The next year you check it again and make sure that what should have been done has been fixed. You do this every year, and at the same time you can clean the gutters of leaves, scrape lichen and moss off the roofs, check that the windows are in order, and so on.

We finally found the Russian word *podderzhanie* as a good translation of maintenance. Unfortunately, it is not an established concept among Russian craftspeople, so we have spent a lot of time explaining the idea and principles of *podderzhanie*. In 2006, 2007 and 2010, on joint missions with participation of people from our directorate and the park administration, we checked all the restored chapels demonstrating how the *podderzhanie* checklists work. We hope that the park itself will do this on an annual basis, so the material results of a very successful piece of cooperation on specific restoration work will not be lost for the future. We believe the present park administration now fully understands this. Three more churches have been restored in the past few years, and the Norwegian side has continued to insist on regular maintenance procedures.

In the final phase of the cooperation, we succeeded in carrying out a project on Norwegian soil, restoring a small building in the fishing village of Hamningberg. The settlement is now defunct, inhabited only in summer, but it is becoming increasingly important as a tourist destination. That is because it lies at the end of a scenic road on the north coast of the Varanger peninsula in the far North-East of Norway, close to Russia. Historically it was one of six Norwegian fishing villages from which Russian fishermen were allowed to fish. Therefore, we find in Hamningberg buildings made by Russian craftspeople in a characteristically Russian manner.

We picked out a little building representing the Russian fishermen's culture that was in great disrepair. We worked in the same way as we had done in Russia, setting up a project in close contact with the local authorities, this time the county of Finnmark, and having the restoration done by hired Russian and Norwegian craftspeople working in collaboration. In this way, the local carpenters got to learn more about the techniques used to create this part of built Russian heritage which is now Norway's responsibility to protect.

As in Kenozero National Park, 12 years earlier, it was a great moment when in 2009 we were able to celebrate a concrete result of our broad cooperation when the restoration of the building in Hamningberg was completed. As in Kenozero, the festivities were attended by a state secretary from the Norwegian Environment Ministry, Heidi Sørensen, as well as several Russian guests.

The Pomor trade and the contacts with Russia were very important for the Norwegians living in East Finnmark, and this is an integral part of their history as well. In Norway's easternmost city, Vardø, a Pomor Museum has been established. A replica of an authentic interior from a traditional Pomor dwelling house was commissioned from a craftsman in Arkhangelsk. He spoke no foreign languages and performed the work without fully understanding its purpose or its destination.

On our journey back from Hamningberg, we invited our Russian guests to visit the Pomor Museum. One of the party was a master carpenter who had participated in some of our projects in the Kenozero National Park, but, unlike many of the people we worked with there, he had never previously visited Norway. It was a great experience to see the astonished expression on his face when he suddenly saw his own work in front of him in the museum!

The social role of heritage protection and women's role in preserving culture

In Norwegian thinking on the protection of cultural heritage, it is essential that it has a purpose to justify it as an activity paid for by society. Cultural heritage protection must be of benefit to someone. It cannot merely be an activity performed to please the experts, but must be of meaning to society. At the same time, we need to see built heritage as a part of cultural complexes that also include non-material elements. Another aspect is that cultural heritage protection should, as far as possible, contribute to social development. Therefore, it was an important issue for us to encourage the use of local resources in a commercially viable manner.

In the difficult social situation in Kenozero National Park, with a declining population and a high rate of unemployment, this is easily exemplified by incorporating the perspective of the local women. Since olden times, women have been allotted a special role in society. All the concerns of tending the "family hearth", raising children, maintaining cultural values and passing them on to the next generation lay on their shoulders. Besides that, women participated very

actively in the wider working life, labouring in the fields, growing plants, rais-ing animals. They are the true keepers of local traditions, ceremonies and the secrets of folk art. From the age of eight or nine, peasant girls under their moth-ers' guidance started to master the marvellous and sophisticated women's crafts – spinning, weaving, needlework – and right from childhood prepared the dowry for their wedding. Then, during their entire life they produced clothing for the whole family and adorned the house with embroidered towels, bright floor run-ners and colourful patchwork bedspreads, creating objects of unique beauty. The Kenozero National Park's museum stocks contain true masterpieces of female applied art – towels woven by local craftswomen and embroidered with figures of remarkable birds and plant ornaments.

In the present, fairly difficult socio-economic conditions, women are assuming an increasingly active role in the region's development process. In 2005, imple-mentation of the project "Women's initiatives in the Kenozero National Park" started. The main participants in the project are enterprising local women who are interested in developing the local economy and are keen to "take destiny into their own hands". In 2007, the project "Feasibility study of the market utilization of non-wood forest resources as one of the alternative sources of income for the population in and adjacent to specially protected natural areas in North-West Russia" was launched. Women of Kenozero were the first to take an interest in the production of marketable commodities from such non-wood forest resources. According to the participants, the collection of mushrooms, berries and herbs is a customary practice, but today it is also becoming a source of additional income for the villagers and provides opportunities for them to develop their creative potential.

Earlier generations have left the Kenozero area a unique heritage – a large number of historical, cultural and architectural monuments, and among them the famous Kenozero chapels of remarkable beauty and diversity of design. Since its foundation, the Kenozero National Park has worked purposefully to preserve and restore these gems of folk craftsmanship. And local women have become wardens of the ancient monuments. They have been running things, keeping order, sounding the bell on holidays – and they are happy that the chapels have been restored, and that icons are coming back to the once plundered places of worship. There is no doubt that every inhabitant of the Kenozero area contrib-utes as far as possible to the economic development of the park's territory, but the local women, wise and enterprising, with firm and creative personalities, play a particularly significant part in this process.

Revitalizing a threatened culture

Another field which strongly brings in the human aspect is the preservation of the heritage of the area's indigenous people. The study and preservation of East Sami cultural monuments in Norway and Russia became a part of the broader Norwegian-Russian collaboration on conservation of cultural heritage. The work lasted from 1997 to 2001 in the form of a joint project carried out by a number

of participating institutions such as the Sami parliament (*Sametinget*), the Sami Council for the Preservation of Cultural Monuments and the Kola Research Centre. During various stages of the project, the following were also involved: the National Cultural Centre in Lovozero in Russia, the East Sami Museum and Svanhovd Ecological Centre in Norway, East Sami people from Norway and Russia and researchers from Tromsø University in Norway, the Institute for the History of Material Culture in Saint Petersburg, and the International Studies Centre of the Russian Academy of Sciences in Apatity, Murmansk oblast.

The main aim of the project was the registration, documentation and surveying of the East Sami monuments in their historical settlements and trading areas on the Norwegian and Russian sides of the border. This task was imposed by the urgent need for the monitoring, registration, conservation and scientific study of the East Sami cultural monuments in Northern Norway and on adjacent territories in the Murmansk oblast of the Russian Federation, as well as by the realization of a specific project to establish an East Sami Museum at *Skoltebyen* in Neiden (*skolt* is a word for East Sami people). The Soviet occupation of what used to be the Finnish border area to Norway made the population evacuate, and therefore this particular East Sami group found itself mostly outside its traditional settlement areas. This made the project especially relevant. Traditional settlements, grazing lands, family fishing and hunting areas, sacred places and burial sites have ended up on the territories of three modern states: Norway, Russia and Finland.

It is worth adding that most of the settlements on Russian soil became inaccessible due to their location in the frontier zone. Decades after the last resettlement of the East Sami ethnic group, owing to international cooperation and to this particular project, the Sami were granted an opportunity to visit their native places, seasonal sites, and ancestors' graves and to participate directly in the research. It should be noted that the method of involving Sami representatives in the working process was validated by the course of the whole project and benefited both the East Sami community and the researchers. Indigenous representatives participated in archaeological excavations, worked as guides and were helpful in organizing work on the sites.

The project included two conferences: one at the beginning, held in Neiden, Norway, and another on completion of the project in Apatity, Russia. There was a survey of the documents referring to the East Sami kept in Russian, Norwegian and Finnish archives, and of course the actual registration, documentation and analysis of the East Sami cultural monuments.

The project can undoubtedly be considered a success. Almost all the goals set were achieved despite the difficulties of working in the frontier zone on the Russian side of the border.

It would be no exaggeration to say that the real importance of the project with its interdisciplinary approach, its international team and some application-oriented goals goes beyond the particular research results, such as the registration and mapping of new cultural monuments (identified from interviews) and old ones (known from previous research in the area). The new information about sites on Russian territory is of special importance since such registration

and documentation was being carried out for the first time there. Analysis of the integrity of the objects studied on the Russian side shows a great degree of destruction of the monuments, and an absence of necessary monitoring of their condition due to the inaccessibility of the sites or lack of knowledge about them. Numerous life stories, collected during interviewing, significantly broadened our knowledge of the material and spiritual culture, traditional management and migration strategies of the East Sami families in the twentieth century.

Addressing East Sami intellectual and material values within that project with indigenous people's active and immediate participation contributed to the strengthening of their rich, specific identity, realized in various different forms. The project can also be regarded as part of a long-term and laborious work for the preservation of the common East Sami cultural heritage – so necessary for consolidating their cultural identity.

Protection of rock carvings in Karelia

After the discovery of the rock art on the coast of Lake Onega in 1848, the petroglyphs in the area of the River Vyg were not publicly known until 1926. This rock art, dated to between 4500 and 3000 BC, is not only extremely attractive and unique but also easily accessible for tourists. Seen as a part of the development of tourism in north-western Russia, it has great potential for a considerable increase in the number of visitors, but, without access control and systematic visitor management, the prehistoric works face grave deterioration and even destruction.

During the many years of research, no proper database for cultural management purposes had been made, and the documentation was scattered and unsystematic. Therefore, the project aimed to create a digital database holding as much information as possible about the panels and individual figures. They were impacted by natural factors – such as encroaching vegetation, high water levels, snow and ice, freezing and thawing – and by people walking and driving on the rock art surfaces, making graffiti and fires, and otherwise damaging the petroglyphs and their environment when camping in the immediate vicinity. There is pressure to develop the rock art sites on both Lake Onega and the River Vyg as tourist destinations, which may seriously damage or even destroy this precious heritage. An urgent need existed to address the preservation of the art itself.

The project was conducted during two periods – phase 1: 1998–2001; phase 2: 2007–2008. The project leaders were Dr Nadezhda V. Lobanova (researcher at the Russian Academy of Sciences in Petrozavodsk and, during this phase, head of the Department for the Protection of Archaeological Monuments at the State Centre for the Protection of Cultural and Historical Monuments of the Ministry of Culture, Republic of Karelia) and Dr Knut Helskog (professor at Tromsø University Museum). In phase 2, Dr Anne-Sophie Hygen from the Directorate for Cultural Heritage in Norway became a member of the project group. To inform the public of the value of the rock art, the booklet "Onega Petroglyphs" was published in 1998.

Phase 1 of the joint Norwegian-Karelian project "Preservation of the Karelian Petroglyphs" was the first international undertaking dealing with the Karelian rock art. A substantial amount of data on the status of the petroglyphs was collected, including assessments of the degree of their deterioration caused by natural and anthropogenic processes. Moreover, new methods of conservation were worked out, and new petroglyphs were detected both in the Lake Onega area and in the lower reaches of the Vyg. The project made it possible to develop new approaches to documenting petroglyphs in Karelia. The protection of rock art could be promoted, and popularization and education based on Norwegian research experience and achievements would promote and ultimately strengthen scholarly links and mutual interest in Karelian and Norwegian rock art.

Epilogue: a spin-off

Through collaboration, not only with another country but also with your sister directorates under the same ministry, in our case the Environment Ministry, you learn a lot from other fields of expertise, but also meet people other than those with whom you deliberately seek contact. This may even mean that you use small parts of the resources you have at your disposal for projects outside the formal sphere of cooperation. A colleague from another directorate took me on a trip along the south coast of the Murmansk peninsula. We drove as far eastwards as possible and ended up in the village of Varzuga. A very good salmon river with the same name divides the village in two. The western part has a road connection to the rest of the world; the part to the east is a village with no cars, and obviously with a strong culture of keeping things tidy around the houses and maintaining them well.

There we met an enthusiast, diehard old Communist and retired gymnastics teacher. He was born in Varzuga, and he will be buried there. The enthusiast's name is Piotr Zaborchikov. His passion is restoring old buildings. We became fascinated by the strength and energy that Piotr radiated. A Norwegian-Russian friendship was forged. Piotr mostly works alone. He prefers it that way, but he does not mind others joining in, as long as they do everything his way. This presented a great challenge in collaboration, both for him and for us. When we first met, most of his tools were homemade – good enough, but not very efficient.

Over the years, he has received tools and materials from the Norwegian Directorate, which speeded up his work. Piotr was for a long period unsure about the directorate's motives in supporting the conservation work in Varzuga. In Piotr's view, it was not possible for somebody to give money and equipment for restoration without demanding something in return! Would the Norwegians want to take away one or more of the houses when the work was finished? Today we think Piotr is confident in the belief that there are institutions and people who support his work simply because it is a good thing – without any hidden agendas.

Piotr's work is based on the values of the cultural heritage of his village appreciated not only by him but also by his neighbours and fellow citizens. Cultural heritage must be of benefit to someone. Modern thinking on heritage protection has shifted the focus from the objects themselves to the people for whom we are preserving them. This anthropocentric perspective on cultural heritage gives it a deeper meaning and value. Piotr stands out as a personification of that.

Part III

Contemporary preservation of recent heritage

10 Neglected heritage

Khrushchev mass housing in Leningrad

Ekaterina Staniukovich-Denisova and Daria Liubimova

The term "Khrushchev's legacy" is predominantly associated with his policies and the cultural "Thaw", the various aspects and significance of which continue to be studied today. With regard to the architectural legacy of that period, things are far more complex. On the one hand, the considerable efforts made by specialist historians and architects to achieve recognition of the value of works of Soviet avant-garde architecture from the 1920s and 1930s and the need to preserve them (e.g., *Future Anterior: Journal of Historic Preservation, History, Theory, and Criticism*, Vol. 5, No. 1, Special Issue on the Preservation of Soviet Heritage [Summer 2008]) opened up the way for recognition of the next phase of Modernist architecture – in the period between the second half of the 1950s and the 1980s (the exhibition "Soviet Modernism 1955–1991. Unknown Stories" at the Architekturzentrum in Vienna in 2013; the creation of an Institute of Modernism in Moscow in 2015; and publication of a special reference guidebook [Bronovitskaya et al. 2016]). On the other hand, instances of the scientific restoration of such buildings remain very rare (the Mel'nikov House in Moscow), and even internationally recognized edifices (Moisei Ginzburg's Narkomfin Building in Moscow, or Erich Mendelsohn's electric substation in St Petersburg) are in a parlous state. Given this situation, does it make sense to raise the question of the preservation of examples of ordinary housing development?

The "micro-districts" of housing constructed in the USSR on the initiative of Nikita Khrushchev (first secretary of the Communist Party's Central Committee in 1953–1964) in the second half of the 1950s and 1960s are at present on the whole rejected by specialists and broad sections of the public (Meuser and Zadorin 2015) as architectural and artistic heritage. The criticism levelled at them includes accusations of sweeping standardization of extremely simplified artistic approaches and of the pursuit of cost reductions at the expense of the convenience of the living space and the quality of the building work (when better-quality housing appeared, people even coined the disparaging term *khrushchoby* patterned on the word *trushchoby*, meaning "slums"). The construction of mass housing under Khrushchev in both rural and urban areas remains a still incompletely comprehended period in Soviet architecture and is most often examined as a phenomenon in cultural history (Gorlov 2015), although positive shifts in the study of it have become clearly evident in recent years (Varga-Harris 2008; Grishin and Ovcharenko 2012; Kazakova 2013; Appolonov 2013; Harris 2013; Meerovich 2016: 32).

In housing construction in the USSR of the 1950s, several fundamental problems accumulated: urbanization, a severely insufficient housing stock due to the destruction of the Second World War, the critical dilapidation of temporary housing for workers and a trend for people to seek to live separately in single-family units. In the 1920s, the construction side of Soviet housing policy had been directed towards communal living in hostels, house-communes, barracks-type housing and so on (Meerovich 2005: 182). In apartment houses with several storeys, families of "ordinary people" were also allotted housing by the room. The revolutionary idea of the commune and a collective way of life did not prove successful. After the war a pressing need arose for the mass-scale relocation of citizens out of barracks, hostels, communal flats and other housing "unsuitable for the purpose" into very basic, but nonetheless individual, single-family units, and it was this need that Khrushchev's programme of mass construction was intended to meet. It became one of the chief fields of the Thaw-era reforms that became known as the "revolution in social and everyday life", an important result of which was that Khrushchev rehabilitated such elementary human needs as housing, clothing and food. "The new approach expressed itself most fully in the push for housing construction, for individual apartments. Even if that flat did not exist, even if it only loomed indistinctly as a long-term prospect ten years hence – the very legitimacy of being able to aspire to a home of one's own gave legitimacy to the desire to have furniture that met one's personal tastes, more than that, it legitimized the very right to have individual tastes, to be an *I* different from the *we*" (Popov 1994: 47). On the other hand, this was a physiologically minimal standard of housing, and the new apartments were physically unable to accommodate non-standard "family heirloom" furniture (no matter whether the family had been noble or peasant) and could take only modern-day regular furniture and fittings. The micro-districts of Khrushchev housing were supposed to become an incubator for the builders of the "bright future" that was Communism.

The priorities for architectural and constructional practice changed. Now individual architects or teams of them (architectural studios) focussed not only on designing unique one-off objects (Khan-Magomedov 2013). There was active development of designs for an apartment house of a new type to be reproduced in large numbers. This was made possible by the authorities, and after them the architects, acknowledging social problems and demands as something that should shape contemporary architecture (Khan-Magomedov 1958: 47).

Besides social issues, artistic ones were also raised. In the early years of the deployment of concrete panel construction on a mass scale (1957–1960s), architects repeatedly held forth in a propagandist manner on the pages of the magazine *Arkhitektura SSSR* (Architecture of the USSR), attempting to give a new interpretation to aesthetic concepts. The basic tenet became an updated thesis of functionalism, that

> the beauty of architectural forms arises as a quality determined by the utilitarian and functional aspect of the architectural construction.
>
> (Minervin and Fedorov 1958: 42)

A high aesthetic value was attributed to "pure" art, truthful and logical, in which function and construction closely interact. The Thaw made active contacts with the West possible. Under the slogan "We'll catch up and overtake!", groups of architects were sent on working visits abroad so as to study and then make maximum use of contemporary mainstream European and American achievements. They brought back numerous samples and architectural journals. Personal contacts were established, and Soviet architects participated in international competitions (Yakushenko 2016; Bellat 2007, Bellat 2014). French and Scandinavian expertise in industrial construction methods was of particular interest. Soviet architects also participated in the UN-Habitat programme that addressed the topics of renewal and mass construction.

Architects devoted attention to questions of a compositional urban-planning character as a means of bringing beauty into the functionally rational system of a micro-district. For example, the method of placing buildings around the perimeter of a city block, which was traditional for the centre of Leningrad, was replaced by a less rigid layout. Landscape architecture also became popular. On the initiative of Liubov' Zalesskaia, in 1955, the Moscow branch of the Architects' Union created a "Greenery" section that later became the Commission for Landscape Architecture. The use of natural elements in the architectural and planning composition of the city was promoted with the large-scale landscaping of open spaces, improvement of public gardens, and the like. This compensated for the fairly Spartan look of the residential buildings. Today it is specifically the abundance of greenery that makes these neighbourhoods attractive to their residents.

The simplicity with which the façades were finished was attributed to the pointlessness of various decorative "embellishments" (according to the ideological programme of government resolutions) and was regarded as one of the main aesthetic properties of contemporary architecture along with the innovations of technology (Autio-Sarasmo 2001). This aspect again makes it possible to detect a link between the architecture of Khrushchev's time and the works of the Constructivists. Post-war Soviet architects, nonetheless, coyly denied any direct connection with the Constructivists, accusing them of blind devotion to "formalism", the pursuit of non-standard and unusual designs, which allegedly did not always accord with the functions of the building. The line of continuity running through the whole evolution of Soviet architecture was, however, evident. It is well known that architects suffered less than all other creative professions from the Stalinist repressions. Uninterruptedly from back before the revolution, through changes of name and structure, architects received highly professional training in the schools of Leningrad (the Institute of Civil Engineers – the Leningrad Institute of Communal Construction Engineers – the Leningrad Engineering and Construction Institute and Petrograd's VKhUTEMAS – Leningrad's VKhUTEIN [1921–1923–1930] – Repin Academy of Arts) and Moscow (VKhUTEMAS – Moscow Architectural Institute). Soviet architects as the creative profession most dependent on state commissions flexibly changed their style depending on the conditions. A creative position differing from the party line could provide the occasion for eliminating a competitor. Unarguably, simplicity and concision

as a means of conveying constructional and functional logic were perceived as a positive aesthetic quality in both periods of Soviet Modernism (the "first" being Constructivism, the "second" under Khrushchev). As early as 1972, however, in *Arkhitektura SSSR*, Andrei Ikonnikov declared it necessary to emphasize the difference between simplicity as a quality of art that emerges from the synthesizing work of the artist and as a product that arises automatically from the restriction of the set of tasks expected of architecture by excluding the artistic ones (Ikonnikov 1972: 8). Mass construction was annihilating architecture as an art form. It was becoming too monotonous and soulless, which in Iurii Kurbatov's opinion was the result of introducing methods of "primitive technologism" as the worst variety of functionalism (Kurbatov 2008: 111).

Total rejection of the mass housing projects of the Khrushchev era does not, however, solve the problems of their comprehension. Moreover, minimalizing their good points in every possible way is not conducive to the processes of renovation. They did perform their historical mission, meeting the minimum requirements for family housing. According to Henry W. Morton's data, between 1956 and 1970, 126.5 million Soviet citizens, over half the population of the country, moved into new homes (Varga-Harris 2011: 164–165).

It was from the middle years of the century that Soviet architecture began to return to "the highroad of the style-setting development of world architecture" (Khan-Magomedov 2013: 130–140) – in other words, to post-war Modernism. In residential architecture under Khrushchev a revolutionary transition took place to industrial standardized methods of construction. The prefabricated elements were produced by integrated house-building factories with assembly and installation taking place directly on the building site. The keynote in the process was economy – of both materials and time. As a consequence, the dimensions of the flats were reduced, building materials and structures standardized. The whole country became one huge building site, funded from the budget without economic benefits in the short term. The factories simply could not allow themselves to produce elements for individualized designs, which would have meant rejigging the production lines.

The solution to that problem was standard design series intended for large-scale housing developments. There were all-union, republican and city series of apartment blocks. In Leningrad the main series ended up being 1-506, OD, 1-335, 1-464, 1LG-507, 1-528kp and GI-1, 2, 3 and 4, together with their later modifications. The letters are indications of either the designing organization or the manufacturer.

Standardized prefabricated construction in Leningrad

The shift to an industrialized method of construction in Leningrad coincided with the drafting of a general plan for the city covering the period 1957–1965. Design studios worked on projects for neighbourhoods (up to 150 hectares) of standardized five-storey housing without lifts without incorporating premises for social facilities and everyday services. Separate standard designs were developed

for pre-school institutions, schools, shops and blocks for social facilities and eve-ryday services. Designs for cinemas would appear later. By 1965, ten new housing areas were created in accordance with the "theory of a multi-tiered formation of housing and service system: micro-district – city block – residential district – planning district". In all this, one of the most important tasks laid out in the general plan for the development of Leningrad as a leading industrial and cultural centre was "the limitation of further territorial expansion and reduction of den-sity with a cessation of new industrial construction" (Sementsov 2008: 12). This was supposed to lead to the stabilization (or even reduction) of the population of Leningrad and its redistribution into satellite towns. The rapid changes in the structure of the city through the creation of consolidated areas of land suitable for building facilitated the mass-scale industrialized method of construction.

Standardized construction using factory-made elements began in Leningrad later than in other cities. There was no strong base of industrial enterprises for the development of prefabricated construction, so time was needed to set up produc-tion. In May 1955, the first apartment house made of large panels was constructed at 10 Ulitsa Poliarnikov. Outwardly it resembled the *stalinki* (the colloquial name for apartment houses with several storeys put up between the second half of the 1930s and the early 1950s). Then, in 1956–1958, apartment houses were erected on blocks number 122 and 123 in the Nevsky district 9 (Figs. 10.1 and 10.2).

The first series of large-element prefabricated apartment houses in Leningrad (1-506) was developed on the basis of these buildings. Despite the fact that it was the first experimental series of large-panel prefabricated construction in Lenin-grad, this series has basic characteristics that place it in the *stalinka* category.

The principle used to differentiate between *stalinka* and *khrushchevka* (the sim-plified terms used everywhere for the large-panel prefabricated apartment houses from the period in question) is not so much chronological as structural. Apart-ment houses of the Stalin period typically had spacious rooms all opening into a corridor, a separate bathroom and toilet in each flat, high (3 metre) ceilings, good-quality finishing of the façade panels (more often than not including deco-rative motifs), and full or partial facing with tiles or sand-lime brick. The ground floor might be faced with concrete slabs. The 1-506 still conformed to that pat-tern. Meanwhile in Moscow, as a first experimental effort, they constructed apart-ment houses in the ninth block of Novye Cheremushki, which already accorded fully with the definition of *khrushchevka*. Nevertheless, in Leningrad they did not suspend the construction of other series that real-estate brokers today place in the *stalinka* category, such as the brick-built 1-405 series (a design created as far back as 1953) and the 1-460.

Soon the designing of typical *khrushchevki* began. The efforts of the Leningrad branch of the *Gorstroiproekt* state design institute in 1957–1958 produced the series 1-335. Its constructional basis was a frame-and-panel design with an inter-nal frame, transverse girders and load-bearing external walls (Zhuravlev, Nau-mova 1975: 569). This made it possible to reduce the weight of walls between rooms (8 cm) and between apartments (two layers of the same slabs with a 4 cm air gap between them). The series proved to have substantial shortcomings: thin

Figure 10.1 Assembly of a large-panel apartment house on Block 123 of Ivanovskaya
 Ulitsa in the Neva District of St Petersburg. Photograph from the magazine
 Arkhitektura SSSR, 1958, No. 1, p. 30.

separation walls and external walls leading to very poor noise insulation and great
heat loss, and combined bathroom and toilet. However, the absence of internal
load-bearing walls makes it possible to change the layout of apartments during
renovation.

The OD series (produced by the Obukhovskii Domostroitel'nyi Kombinat –
Obukhovo House-Building Factory) was designed by the Lenproekt Institute in
1959–1960. This design was analogous to the K-7 first mass series in Moscow. The

Figure 10.2 The experimental Block 122 of standard-design housing in the Neva District. Photograph from the magazine *Arkhitektura SSSR*, 1958, No. 1 (article by Iu. Shass, "Blocks of large-panel apartment houses in Leningrad", pp. 30–38).

need to demolish such buildings is not disputed nowadays as they have the same serious shortcomings as the 1-335 series, further exacerbated by the absence of balconies (Fig. 10.3).

The 1-464 series was a design produced in 1958 by the all-union state design institute Giprostroiindustriia belonging to Gosstroi, the State Committee for Construction. Its constructional distinction lay in the close spacing of the load-bearing transverse walls (2.6 or 3.2 metres apart), the panels of the external and internal walls being the size of one room and the floor/ceiling panels being supported at the edges.

The series most widely used in Leningrad were the GI and 1LG-570. The GI series was designed in the Lenproekt institute in 1959. It had a frameless constructional design with three longitudinal load-bearing walls. The external walls differed from all other series in having two horizontal rows of elements for each storey. The main constructional distinction of these five-storey buildings was strong walls built of aerated concrete, which makes it possible to reconstruct them and extend them upwards. It should be noted, though, that the materials from which the GI series buildings were made have been found to contain a considerable amount of asbestos, raising health concerns. A serious shortcoming of the GI series is the lack of balconies. On the other hand, they contain only three- to five-room flats with windows on both sides of the building, which makes it possible today to alter the layout and make them more comfortable.

The 1LG- 570 series was also designed in the Lenproekt institute in 1959, and again it has a frameless constructional design with three longitudinal load-bearing walls. The external finish of the panels is modest and restrained – large ceramic tiles or smaller ones (supplied on sheets). In all the flats the toilet and bathroom are separate, which is an undoubted advantage. The location of the 1LG- 570 series buildings is advantageous, as they are found in the Moskovsky district, where real estate prices are among the highest in Saint Petersburg.

The 1-528kp series is the best in terms of quality as it was built of brick. The majority of the buildings have balconies, but the five-storey versions often have bay windows with red insets. In this case the bay windows are a felicitous artistic decision, producing a pleasing play of shapes on the surface of the facade.

Each series of buildings was allotted to particular house-building factories that then produced them. As a result, the various series are distributed unevenly across the city, being concentrated in groups in certain districts and neighbourhoods. This makes the implementation of renovation projects targeted at specific series easier. At the same time, the fact that these apartment houses cover several adjacent city blocks at once complicates the process of renovation, if we presume that it will be carried out a block at a time, covering a large residential neighbourhood.

Ways of modernization and the problems of the Khrushchev mass housing in St Petersburg

The problems associated with the present-day exploitation of the standard five-storey apartment blocks belonging to the first mass series lie in the cramped space

Figure 10.3 Apartment house of the OD series. 115, Babushkina ulitsa, building 5. Constructed in 1964. Photograph by D. Liubimova, 2017.

in the flats, the ineffective use of heating, the lack of lifts and the dilapidated and outdated architectural appearance of the buildings. Nevertheless, studies of many Leningrad standardized buildings have not revealed physical deterioration of the construction (Appolonov 2013:10), which makes it possible to raise the question of their renovation. The advantages of reconstruction of the old buildings over plans that call for the demolition and new construction in these neighbourhoods are less financial outlay and the preservation of the urban environment to which the local residents are accustomed.

The scale of the work can vary widely: reconstruction within the residential unit (flat), reconstruction within the bounds of one storey of a section of an apartment block, reconstruction of the public spaces (the design of the entrance and stairwell, building on a lift shaft), reconstruction of the ground floor (to create communal areas or premises for social facilities and everyday services), or a comprehensive reconstruction of the building (Appolonov 2013:11f).

At the present time, it is possible to identify several different approaches to the modernization of *khrushchevki* that have been tried in this country:

(1) "Mini-modernization" that comprises insulation and decorative finishing of the façades, enlargement of balconies and loggias, the replacement of doors and windows complete with their frames, minimal alteration of the layout of the flats, partial or complete renovation of the utilities, replacement of the roof and other repair work to improve living conditions. All together, such work to improve the physical condition of the building might be called a general overhaul.

(2) "Maximum modernization" that comprises both work to insulate the façades and major changes to the layout of the apartments, turning a cramped two-roomed flat into a spacious one-roomed flat, the creation of wide entrance halls, separate toilet and bathroom, and other improvements to the layout of the flat. Aleksei Appolonov puts forward his own plans for the reconstruction of existing apartment houses of the standardized series as a contribution to state programmes for the social protection of groups within the population that have limited mobility (Appolonov 2012:5). In his projects for the reconstruction of apartments, the architect takes into consideration all the different categories of families that might include somebody in a wheelchair: a wheelchair user living on his or her own, a couple, a three-person family including a wheelchair user, a family with a child and a wheelchair user. The redesign of the apartments should first and foremost include enlargement of the rooms and doorways in accordance with the average turning circle of a wheelchair, and partial combination of the space (separate rooms) to eliminate obstacles to movement.

(3) Reconstruction – besides all the refurbishment work listed above, this version includes expansion of the living space by building onto the façades, with increased area in the rooms adjoining the end walls. It envisages extension of the building upwards with a mansard roof or structures of between two and four storeys. In this event, the outward appearance of the building is

transformed. Such modernization can be carried out with or without the rehousing of the occupants. Probably the best-known project of this type is the wide-bodied apartment houses. These are built on the site of existing apartment blocks with five storeys or less that are incorporated into the structure of the new wide-bodied apartment houses. Such buildings have become known as houses of secondary development (Chuvilova, Kravchenko 2011: 100). The utilities and facilities in such a building are common to both parts. Structurally, the new part of the building stands on separate foundations and places no extra load on the apartment house being reconstructed.

(4) The radical approach which means the total demolition of *khrushchevki* (the first mass series, officially slated for demolition) and the construction of modern neighbourhoods in their place. Nevertheless, such an approach is sometimes coolly received by the residents: the areas of *khrushchevka* housing are established neighbourhoods with good facilities and greenery, a mature landscape, developed infrastructure and smooth-working transport connections.

(5) A shift to the creation of a micro-district of the "garden-city" type. This approach to reconstruction has been employed more in the re-united Germany (in the lands of the former GDR). It consists of reducing the height of the buildings, constructing broad terraces and flexible layouts, and so on. In Russia, however, due to different urban-planning and social conditions, such an approach proved not very appropriate. In Saint Petersburg, especially in areas closer to the centre (which the *khrushchevka* micro-districts are becoming in our time) with a well-developed infrastructure, companies seeking a rapid return on investment are coming to prefer the method of "infill construction" (meeting only the minimal requirements for levels of illumination and insulation), the result of which is always a worsening of living conditions and the ecological situation.

(6) The last version of reconstruction is an urban-planning strategy (Akhmedova, Borisova 2012: 10). It entails tackling the question of increased density of construction (effective use of land) and also overcoming the poor artistic appearance of monotonous *khrushchevka* neighbourhoods by improved urban-planning approaches. In the USSR much attention was devoted precisely to urban planning (the layout of micro-districts or streets). However, it did not always manage to achieve the desired aesthetic effect. For example, Andrei Ikonnikov noted that in Leningrad, shortcomings manifested themselves in the development of the Malaya Okhta area and of the right bank of the Neva above the Volodarsky Bridge, while the monotony of linear development on the perimeter in the absence of a central spatial core clearly reduces the aesthetic qualities of blocks 8 and 9 in the Avtovo area (Ikonnikov 1966: 51). What is required is creation of buildings with self-contained shapes, the insertion of apartment houses, the creation of high-rise architectural features, the addition of new parts to existing buildings and so on. The strategy will undoubtedly incorporate parts of all the approaches just listed. Its implementation will be long-term and possible only in stages, from one micro-district to the next, with substantial investment of capital.

Within the housing stock of Saint Petersburg, flats belonging to the first mass series make up about 8.9 million square metres, or roughly 10 per cent. The approach to solving the problem of *khrushchevki* has changed twice. In the year 2000, the government of Saint Petersburg published a resolution that approved a "Regional Programme for the Reconstruction of Apartment Houses of the First Mass Series" (Government 2000). A number of buildings did undergo refurbishment. Eight years later, however, in 2008, a new municipal law was adapted on a targeted programme for "The Development of Built-Up Areas in Saint Petersburg" that envisaged the rehousing of the residents of the mass-series apartment houses and their subsequent demolition (or, in only a few cases, partial reconstruction). Reaction to these programmes found reflection both in professional discussion (the international congress on "Modernization of Apartment Houses of the First Mass Series and the Utilities Infrastructure of Cities, Towns and Settlements" held in Saint Petersburg on 23–26 May 2000) and in an upsurge of publications on the subjects in the periodic press (Kurbatov 2000: 18–21).

Nevertheless, work carried out to refurbish mass-series apartment houses in Saint Petersburg has not been extensive. Large-scale projects such as the complete reconstruction of a building or renovation with extension upwards have been sporadic and were experimental, pilot versions. In the main, refurbishment is following the mini-modernization scenario (a general overhaul without rehousing the residents or changing the layout of the flats). The main method of redecorating the façades has been to paint them in different colours, accentuating the vertical features above the entrance doorways.

A more serious modernization project is the reconstruction of the building with the addition of a mansard storey without rehousing the occupants. The pilot version of such a renovation was carried out on a building of the 1LG-507 series (on Torzhkovskaya Ulitsa) (Fig. 10.4) in 1999–2001.

This was the first experimental upward extension of a prefabricated five-storey building in Russia. It was carried out by the firm LENZHILNIIPROEKT in collaboration with Scandinavian companies (including the "Foundation for Mansard Housing in Russia"). This isolated experience proved positive, but it has never been repeated on other buildings.

Probably the most radical example of complete renovation was the apartment house at 117, Ulitsa Babushkina (Fig. 10.5).

The work, carried out between 1994 and 1996, included rehousing the residents for the duration. The next stage was the construction around the building, on a separate foundation of an additional frame at a distance from the walls of the original building that supported the new structures (storeys). As a result, the width of the apartment house increased by 2.5 metres, and four new floors were added. The existing apartments were enlarged: the rooms up to 19 m², the kitchens to 10–12 m², while bathroom and toilet were separated.

Similar renovation projects (the addition of a mansard storey or two to four extra floors) have been carried out in Moscow until very recently in far greater numbers. Moreover, Moscow's Department of Urban-Planning Policy issued methodological recommendations in 2013 on drawing up plans for the reconstruction of

Figure 10.4 Apartment house of the 1-LG-507 series. 16, Torzhkovskaya ulitsa, Saint Petersburg. Reconstructed in 1999–2001. Photograph by D. Liubimova, 2017.

Figure 10.5 Apartment house of the OD series, 117, Babushkina Ulitsa, building 1. Renovated between 1994 and 1996. Photograph by D. Liubimova, 2017.

apartment houses of the early mass series with extension upwards or outwards. In February 2017, however, President Putin in a conversation with Sergei Sobianin, the mayor of Moscow, spoke of the advisability of demolishing Moscow's *khrush-chevki* instead of carrying out a general overhaul of them. That, in the president's opinion, is what Muscovites expect (the *Today* news programme, NTV channel, 21 February 2017).

It is precisely this last, radical method of modernizing the neighbourhoods of mass prefabricated panel buildings (i.e. demolition) that is gradually beginning to be implemented in Saint Petersburg. The method employed in such cases is that the chosen developer first constructs a new apartment house near the *khrushchevki* slated for demolition and then rehouses people from them into the new building. The plot of land vacated after demolition becomes the property of the developer.

Today in Saint Petersburg we see very little interest in the modernization and reconstruction of apartment houses belonging to the mass series of Khrushchev's time. The actual implementation most often takes the form of an ordinary general overhaul, while radical reconstructions are no more than isolated instances. Building companies in Saint Petersburg, in contrast to Moscow, are not suffering from an acute shortage of plots for the expansion of the housing stock. At the present time, huge estates are being constructed in remote districts on the outskirts.

Another serious obstacle is the economic expense. Unarguably any refurbishment requires capital investment, and the state more often than not needs to get private investors involved. However, while in the case of a reconstruction it proves possible to cover the investors' outlay through the sale of apartments in the mansard storey or additional floors; in the case of mini-modernization or maximum modernization it is the state that plays the chief role. A return on those investments is possible only in the long term, through significant reductions in expenditure on the heating of the apartments thanks to the insulation of the façades.

Specialists have already begun to give commentaries in response to the Russian president's recent pronouncement about the total demolition of Moscow's *khrushchevki*. In an interview with *Afisha Daily* (https://daily.afisha.ru/cities/4676-eta-arhitektura-ekonomit-nashi-emocii-anna-bronovickaya-o-pyatietazhkah), Anna Bronovitskaya, an architectural historian specializing in Modernism, talks about the opportunities that those buildings can provide residents, if their small apartments are occupied by a single person or a couple rather than a large family. She pointed to ecological damage the city might also suffer from the demolition of those buildings and infill construction, leading to greater pollution and the destruction of green areas. Referring to the exemplary ninth block of Moscow's Cheremushki district, which has the status of a "valuable city-forming fragment", but where not a single residential building is protected from reconstruction, Bronovitskaya postulates the aesthetic value of such architecture, which makes it possible to speak of heritage and thus of a right to preservation and protection. What does she see their non-historical value as being for people today? In the fact that "just as the outward appearance of this architecture economized on human emotions, the space in a small apartment saves physical effort" providing for comfortable living in a large city.

References

Akhmedova, Elena and Borisova, Elena (2012). "Mirovoi opyt reorganizatsii massovoi zastroiki 60–70-kh gg. XX v. v krupneishikh gorodakh" [International Experience in the Reorganization of Mass Construction Projects in the 1960s – 70s in Megalopolises]. In: *Vestnik SGASU. Gradostroitel'stvo i arkhitektura. [Bulletin of Samara State University of Architecture and Construction. Urban Planning and Architecture]*. No1. p. 10.

Appolonov, Aleksei (2012). "Arkhitekturnaia sreda Sankt-Peterburga s uchetom social'no-demograficheskih osobennostei prozhivaniia malomobil'nykh grupp naseleniia v zhilykh domakh massovykh serii" [The St. Petersburg architectural environment taking into account socio-demographic characteristic of people with limited mobility living in mass series housing] In: *Vestnik grazhdanskikh inzhenerov [Civil Engineers' Bulletin* 6 (35)], pp. 5–8.

Appolonov, Aleksei (2013). "Osnovnye napravleniia rekonstruktsii zhilykh domov mass-ovykh serii Sankt-Peterburga" [The Main Trends in Reconstruction of Mass-Series Apartment Houses in Saint Petersburg] In: *Vestnik grazhdanskikh inzhenerov [Civil Engineers' Bulletin]* No 2 (37) pp. 10–13.

Autio-Sarasmo, Sari (2001). "Khrushchev and the Challenge of Technological Progress". In: *Khrushchev in the Kremlin: Policy and Government in the Soviet Union, 1953–1964*, ed. Jeremy Smith and Melanie Ilic. New York: Routledge. pp. 133–149.

Bellat, Fabien (2007). *France-URSS: Regards sur l'architecture (1931–1958)*. PhD thesis, Department of Art History and Archaeology, Paris West University Nanterre La Defense (University of Paris X).

Bellat, Fabien (2014). *Amériques-URSS: Architectures du défi*. Paris: Chaudun.

Bronovitskaya, Anna, Malinin, Nikolai and Kazakova, Olga (2016). *Moskva: Arkhitektura Sovetskogo Modernizma* [Moscow: Soviet Modernist Architecture 1955–1991: A Guidebook]. Moscow: Garage.

Chuvilova, I., Kravchenko, Viktor (2011). "Kompleksnye metody rekonstruktsii i modernizatsii massovoi zhiloi zastroiki" [Complex methods of reconstruction and modernization of mass housing construction] In: *ACADEMIA. Arkhitektura i stroitel'stvo. [ACADEMIA. Architecture and Construction]* No3. p. 100.

Gorlov, Vladimir (2015). "Izmeneniia zhiznennykh tsennostei sovetskikh liudei pri reshenii zhilishchnoi problemy v 1950–1960-e gody" [Changes in Soviet People's Values in Life During the Solving of the Housing Problem in the 1950s–1960s]. In: *Vestnik MGOU [Herald of Moscow State Regional University]*, Series: History and Political Science, No 1. pp. 55–62.

Government of St. Petersburg. (2000). O regional'noi programme rekonstruktsii zhilykh domov pervykh massovykh serii v Sankt-Peterburge. Postanovlenie от 10.02.2000 No 4. [On the regional programme for reconstruction of housing of the first mass series in St. Petersburg. Decree of 10 February 2000 No 4] http://docs.pravo.ru/document/view/528269/641687. Accessed 13 January 2017.

Grishin, Sergei and Ovcharenko, Daniil (2012). "O evropeiskom opyte sokhraneniia massovoi zhilishchnoi zastroiki industrial'nogo domostroeniia vtoroi poloviny XX v." [On the European Experience of Conservation of Mass Industrial-Built Housing From the Second Half of the 20th Century] In: *Vestnik grazhdanskikh inzhenerov [Civil Engineers Bulletin]* No 6 (35).

Harris, Steven E. (2013). *Communism on Tomorrow Street: Mass Housing and Everyday Life After Stalin*. Washington, DC: Woodrow Wilson Center Press; Baltimore: Johns Hopkins University Press.

Ikonnikov, Andrei (1966). *Esteticheskie problemy massovogo zhilishchnogo stroitel'stva* [Aesthetic problems of mass housing construction] Leningrad: Stroizdat, 1966. p. 51.

Ikonnikov, Andrei (1972). "Funktsiia, forma, obraz". [Function, Form, Image] In: *Arkhitektura SSSR* [Architecture of the USSR], No 2. p. 8.

Kazakova, O. (ed.) (2013). *Estetika ottepeli: novoe v arkhitekture, iskusstve, kul'ture* [Aesthetics of the Thaw: What Was New in Architecture, Art, Culture]. Moscow: ROSSPEN.

Khan-Magomedov, Selim (1958). "O roli arkhitektora v pereustroistve byta" [On the Role of the Architect in the Reconstruction of Everyday Life". In: *Arkhitektura SSSR*. [Architecture of the USSR], No 1. p. 47.

Khan-Magomedov, Selim (2013). "Khrushchevskii utilitarizm: pliusy i minusy" [Khrushchev's Utilitarianism: The Pros and Cons]. In: *Estetika ottepeli: novoe v arkhitekture, iskusstve, kul'ture* [Aesthetics of the Thaw: What Was New in Architecture, Art, Culture]. Moscow: ROSSPEN.

Kurbatov, Iurii (2000). "Rekonstruktsiia piatietazhek i arkhitekturno-gradostroitel'noe edinstvo goroda" [Reconstruction of the Five-Storey Buildings and the Architectural and Urban-Planning Cohesion of the City] In: *Zodchii. 21 vek, Vestnik* [Architect. 21st Century, Bulletin]. St. Petersburg. pp. 18–21.

Kurbatov, Iurii (2008). *Petrograd. Leningrad. Sankt-Peterburg. Arkhitekturno-gradostroitel'nye uroki* [Petrograd. Leningrad. St. Petersburg. Architectural and Urban Planning Lessons]. St. Petersburg: Iskusstvo SPb.

Meerovich, Mark (2005). *Kvadratnye metry, opredeliaiushchie soznanie. Gosudarstvennaia zhilishchnaia politika v SSSR. 1921–1941* [Square Metres Determining Perceptions: State Housing Policy in the USSR. 1921–1941]. Stuttgart: Ibidem-Verlag.

Meerovich, Mark (2016). "Ot kommunal'nogo – k individual'nomu: neizuchennye stranitsy zhilishchnoi reformy N.S. Khrushcheva" [From Collective to Individual: Unexplored Pages of Khrushchev's Housing Reform]. In: *Vestnik TGASU* [Vestnik of Tomsk State University of Architecture and Building] No 2. pp. 28–33.

Meuser, Phillip and Zadorin, Dimitrii (2015). *Towards a Typology of Soviet Mass Housing*. Berlin: DOM Publishers.

Minervin, Georgii and Fedorov, Mstislav. (1958). Ob esteticheskikh kachestvakh massovogo stroitel'stva [On the aesthetic qualities of mass construction] In: *Arkhitektura SSSR*. [Architecture of the USSR], No 2. p. 42.

Popov, Gavriil (1994). "Uroki Khrushcheva" [The Lessons of Khruschhev] In: *Dialog* [Dialogue] No 8.

Sementsov, Sergei (2008). "Gradostroitel'noe razvitie Leningrada 1957–1965" [The Urban-Planning Development of Leningrad, 1957–65] In: *Vestnik grazhdanskih inzhenerov* [Civil Engineers Bulletin] No 1 (14).

Varga-Harris, Christine (2008). Homemaking and the Aesthetic and Moral Perimeters of the Soviet Home during the Khrushchev Era. In: *Journal of Social History* No 41 (3). pp. 561–589.

Varga-Harris, Christine (2011). "Khrushchevka, kommunalka: sotsializm i povsednevnost' vo vremia 'ottepeli'" [Khrushchovka, Communal Flat, Socialism and Everyday Life During the "thaw"]. In: *Noveishaia istoriia Rossii* [Modern History of Russia], No 1, pp. 160–166.

Yakushenko, Olga (2016). "Soviet Architecture and the West: The Discovery and Assimilation of Western Narratives and Practices in Soviet Architecture in the late 1950s – 1960s". In: *Laboratorium*. 2016. No 8(2). pp. 76–102.

Zhuravlev, Anatolii and Naumova, Nataliia. (1975). "Arkhitektura zhilykh i massovykh obshchestvennykh zdanii 1955–1970" [The Architecture of Residential and Mass-Produced Public Buildings 1955–1970]. In: *Vseobshchaia istoriia arkhitektury* [A General History of Architecture], Vol. 12, Book 1, Moscow: Izdatel'stvo literatury po stroitelstvu. p. 569.

11 Individual wooden dwelling houses of the first half and middle of the twentieth century

Problems of the study, conservation and restoration

Andrei Bode

The twentieth century left a highly contrasting and dynamic mark on the development of architecture. The period was characterized by fundamental changes of style, the use of new building materials and methods, and radical shifts in the understanding of the very tectonics of buildings. Against this motley many-sided background, one stable line stands out, going back into the distant past and practically unaffected by innovations. I am referring to the individual wooden dwelling houses constructed in the villages and small towns of Russia's central regions right up until the 1960s. Their structure and general composition derived from age-old building traditions and only certain individual parts of the building, the finishing of the walls and some details accorded with their own present era. Architecturally these houses underwent no substantial changes during the entire period of their construction in the twentieth century.

A fundamental change in the development of Soviet architecture took place following the well-known government resolution of 1955, "On the elimination of excesses in design and construction". It did not directly affect private individual low-rise housing, but, given the scale of its impact on state construction, it had an inevitable influence on the whole sphere of architecture and building.

Roughly from the 1960s, the construction of traditional wooden dwelling houses began to decline. Furthermore, mass demolition of areas of low-rise wooden buildings began so as to make way for new construction projects. This took place with particular frequency in villages that had been absorbed by growing cities and in small towns, leading to radical changes in the architectural environment. In smaller rural villages, due to the relatively low rate of building activity, this process proceeded at a slower pace. The replacement of old houses with new ones took place piecemeal, on separate properties. The new individual dwelling houses now had different layouts and new simplified shapes. Generic modular designs became common. Despite considerable losses, though, today in many Russian villages significant enclaves of old wooden buildings still survive, not to mention the isolated examples that can be found in practically every settlement.

What is a traditional wooden dwelling house from the twentieth century like? First of all, it is a building constructed of logs in the traditional technique of

horizontal cribs employed in Russia since time immemorial. Secondly, the layout of the building reflects the structure of a traditional dwelling, and it is possible to trace direct connections with various historical types of house. Thirdly and finally, the decoration of the façades represents a reworking of the styles and tendencies that existed in the second half of the nineteenth century and the beginning of the twentieth, but at the same time the façades possess their own artistic and stylistic integrity. Let us examine these three aspects.

The construction of buildings from logs in Russia has a history going back many centuries because for this country it was the most readily available and rational method. The basic unit is the crib or frame (*srub*) consisting of logs laid horizontally, usually in a square or rectangle, with notched joints at the corners. This method of construction was employed in many other countries as well, but the distinctive feature of Russian log-frame construction, though, is the particularly tight coupling of the logs. Adjoining logs fit deeply into their neighbours thanks to lengthwise channels cut into them and large reliable notches at the corners, giving the frame structures solidity and stability. This is particularly important in the construction of large churches made entirely in the log-frame technique. They can reach over 40 metres in height. One example is the Ascension Church from 1654 in the village of Piyala in Arkhangelsk region (Zabello et al. 1942:7). It measures 44 metres vertically to the base of the cross, making it the tallest wooden church in Russia. Historical sources indicate that in olden times there were even taller places of worship built of timber. Such soaring structures can be made from logs only by using the Russian framework construction technique.

Besides firmness, the tight joints between the logs make a building warm, which is particularly important in the construction of dwellings. The joints at the corners of the frame were made in such a way that part of the log extended outwards. This is the most common method of connecting logs, used in all types of building. Such corner joints (*v oblo* or *s ostatkom*) were better at keeping heat in. Wooden dwelling houses of the first half and middle of the twentieth century continued the age-old tradition of log construction (Makovetskii 1954: 13). The builders used the same methods to make the logs lie tightly on one another and to interlock at the corners as their forerunners had many years before. For the best heat insulation in dwellings, moss gathered in the forest was traditionally packed between the logs. In twentieth-century dwellings, moss was no longer used so extensively, being replaced by flax tow. The material changed, but the principle for keeping heat in the building remained the same. The packing of log frames with soft material derived from plants is also a distinctive feature of Russian wooden buildings in contrast to those found in other countries.

Wooden dwelling houses of the first half and middle of the twentieth century display traditional construction not only of the walls but also of other elements. The floors and ceilings were made from broad thick planks laid over log beams. To reduce heat loss through the floor, it was made double. The gap between the lower counterfloor and the finished upper one was filled with earth. The temperature in the space below the floor remained above freezing in winter thanks to the log walls. Small vents that allowed the circulation of air beneath the floor were

closed up tightly for the winter. With this type of air space below, floors were sometimes made single rather than double. Where the beams had to span large areas, they were supported by props resting directly on the ground. The same sort of props were installed beneath the beams in the place where the stove was to be built, because it stood directly on the floor and did not have its own foundation as is the usual practice nowadays.

To insulate the ceiling, earth was spread on top of it or else a layer of clay mixed with straw to avoid serious cracking. The methods of insulating ceilings with natural materials are fairly efficient. They were used for a very long time in rural dwellings, until they were replaced by modern factory-made alternatives.

The construction of roofs did undergo certain changes compared to the time-honoured methods. In traditional wooden houses, the substructure of the roof was usually made from logs like the walls. That was reliable and long-lasting, but required a lot of material. In twentieth-century buildings, the roofs were given a lighter construction of rafters. It cannot be said that arrangements of rafters were never used in traditional Russian wooden construction. There are historical examples of buildings with tent roofs and hipped roofs supported by rafters. Of course, the framed roofs of twentieth-century houses did not represent a continuation of any traditions: this was a constructional advance corresponding to the conditions of the time. At the same time though, the arrangement of such roofs did run contrary to traditions, especially as their shape and pitch were almost the same as on historical dwellings.

The construction of window and door openings in houses of the first half and middle of the twentieth century was carried out in essentially the same way as in buildings from the period immediately before. They were made from elements of lighter weight than those used in the 1600s and 1700s, but they were connected between themselves and with the logs of the walls in roughly the same way as in the olden days.

The constructional arrangement of village houses in the first half and middle of the twentieth century to a large extent followed traditional approaches developed through centuries of experience. The size and cross-section of components changed, with a need to economize on materials making itself felt, but the fundamental arrangement and the functional character of the main structures remained unchanged. From a constructional viewpoint, the building of wooden dwelling houses in the twentieth century can quite legitimately be regarded as a continuation of long-established traditions.

While traditional-style dwelling houses in the nineteenth and early twentieth centuries represented several different types of architectural layout and quite often reached considerable size, the Soviet period was marked by rural dwellings of fairly small dimensions and a limited range of types. The basic element for a twentieth-century wooden house is a roughly square log frame, measuring about 7 by 7 or 6 by 6 metres, and heated by a brick stove. This frame is adjoined successively along a single axis by an entrance hall and a covered work yard. The total length of such a complex is roughly between 15 and 20 metres. A rectangular building like this beneath a single common roof represents the predominant

type of dwelling in the majority of regions in Russia. It is placed perpendicular to the street with the main gable end facing it. Another, less common, type takes the form of a rectangular log frame containing two living rooms each with a roughly square floor plan. Houses of this sort are placed lengthwise along the road. Entrance halls or service premises were built onto the opposite side from the road, but usually a dwelling of this sort would not have a large work yard attached.

Those were the main types, each having a fair number of variants, expressing themselves in the presence of additional internal walls, the location of entrances and the placement of annexes. The form of the covered work yard was very varied: it could be attached to the dwelling house, be a separate structure or else be split into several parts. In Soviet times the composition of rural homesteads became simpler due to the reduction in the size of peasant holdings, or indeed their complete absence. It is important to note that all the layouts seen in houses of the initial Soviet period up to the 1960s were nothing new – they have their direct counterparts among the historical buildings of the nineteenth and early twentieth centuries (Fig. 11.1).

I will focus now on the main, residential part of the building. It has its own history that can be studied through examples of houses from the eighteenth and nineteenth centuries. In the simplest version, a dwelling consisted of a rectangular, near-square log frame. The development of the structure of the peasant house and the appearance first of partitions, and then log-built walls, begins, as we know, with the division of the interior into different zones that was initially indicated by the *vorontsy*, shelves the width of a single plank crossing the space at head height. Partition walls running lengthwise and crosswise from the stove led to the development of variations in the internal structure of the building, with the addition of a fifth log wall in one direction or the other, or, in the most advanced form, of two further walls at right angles to each other.

Soviet-era houses, being relatively small, mainly had a single living area not subdivided by substantial walls. This simplification represents a return from the advanced layouts characteristic of wealthy houses at the beginning of the century to simple, archaic arrangements. However, the internal organization of the single space within the living part of the house still retained the traditional zones, marked by lightweight partitions.

The division into zones is primarily bound up with location of the stove. In old peasant houses, where the stove had no chimney, it was placed in the corner. The mouth (fire-box) of the stove could face either the entrance or the main façade. The placement of the stove with its mouth to the entrance is considered the most archaic arrangement and has become firmly established in the folk architecture of Karelia due to its especial conservatism (Orfinskii and Grishina 2009:273, 295). The orientation of the mouth of the stove determines the purpose of the rooms or zones within the house. A mouth facing the entrance places the kitchen area in that part of the interior space. In the opposite corner from the entrance, when there are partitions or more substantial walls, a separate "best room" is created that is called the *gornitsa*. If the mouth of the stove faces the main façade, the

Figure 11.1 The main types of layout found in twetieth-century wooden houses: (1) – four walls with an indication of internal zoning; (2) – five walls, longitudinal version; (3) – five walls, transverse version; (4) – six walls.

kitchen area is accordingly located in front of it and occupies the corner of the space allotted to the *gornitsa* in the previous arrangement.

Moving the stove closer to a more central position was a consequence of the addition of a chimney (Orfinskii and Grishina 2009: 295). In smaller peasant houses of the late nineteenth and early twentieth centuries, the stove is usually located by the wall that contains the entrance, closer to the middle of it. In more advanced types of building, such as those with five and six log walls, it is placed nearer the centre of the structure. Quite often this led to a sort of circular layout with each room connected to the next. With such an arrangement, in both large and small houses, the traditional internal division of the dwelling into zones was no longer so clearly in evidence. We find roughly the same picture in houses of the first half and middle of the twentieth century.

The internal zoning traditionally determined the placement of the windows on the façades. The creation of a lengthwise partition from the stove to the front wall of the house is reflected in the asymmetrical arrangement of windows on the main façade. The increase in the span of wall between the windows corresponds to the division of the internal space, between the main more strongly lit living area and the kitchen part or the *gornitsa*. Such an uneven distribution of windows on the façade corresponding to the internal division of the dwelling is common in various parts of Russia. On the side walls, the windows were placed closer to the main façade and opposite the entrance to the house.

Most houses of the first half and middle of the twentieth century, irrespective even of the type of building, have a monotonous row of three or four identical evenly spaced windows on the main façade. This is a very late way of doing things that spread under the influence of urban architecture (Orfinskii and Grishina 2009: 294). In individual housing construction, already from the late nineteenth century onwards, we can observe the disappearance of the traditional practice for the placement of the windows that was determined by the need to bring light to various parts of the interior. The windows were now distributed evenly across all the walls, investing the building with outward regularity, but at the same time the previous internal zoning was preserved. This peculiarity is present in all the twentieth-century houses examined.

In the central Russian regions, small houses with three-windowed main façades predominated. The arrangement of three windows is considered the most archaic. Seventeenth-century drawings show dwelling houses with three, albeit small cut-out, windows on the gable walls. Thus, in the stably preserved number of windows on the façades of the twentieth-century houses, we can perceive echoes of ancient practices.

Stylistically, the decoration of the façades on houses of the first half and middle of the twentieth century is reminiscent of a belated Classicism overlaid by influences from the "Russian style" and echoes of folk traditions. The façades are clearly eclectic, yet at the same time they do have an artistic integrity. The character of their decoration took shape in the late nineteenth and early twentieth centuries, becoming widely used in the urban setting of two-storey wooden houses and then surviving longest in rural construction (Fig. 11.2).

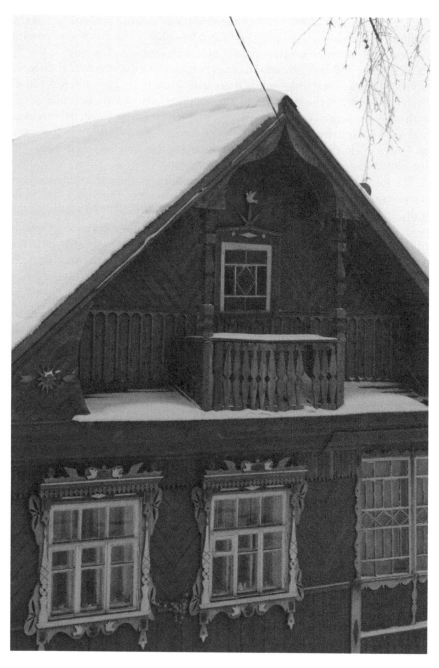

Figure 11.2 A mid-twentieth-century house in the village of Krivtsovo, Moscow region.
Photograph by A. Bode, 2012.

The log walls were quite often left bare or else faced with boards. The corners were embellished with a simplified semblance of pilasters with separately made unsophisticated decorative elements attached onto them. Classically inspired motifs express themselves most clearly in the shapes of the cornices. Sometimes, these were overloaded with decorative details, including brackets, rosettes and patterned edges. The window surrounds were made in a fairly large variety of ways from schematic reproductions of simple compositions based on classical orders to richly embellished fretwork carving. If we compare houses from the beginning of the century with those that were constructed after 1917, the former stand out noticeably for the elaborateness of their decoration. Houses of the Soviet era were finished in a simpler manner.

To fill the door and window openings, the builders consistently used methods from the nineteenth and early twentieth centuries. Entrance doors for the house were made up of broad thick planks joined together by two cross bars. Gates for the work yard were made in the same manner. Panelled doors were used inside the house and sometimes painted with decorative compositions. The windows usually had frames holding six panes of glass.

Above the main façade there was either the gable end or the sloping hip of the roof. Peasant houses of earlier times had proper *svetëlki* – small attic rooms beneath the slope of the roof that were formed by a separate frame of logs or split half-logs. If the house had a two-pitched roof made of logs, the side walls of the *svetëlki* were jointed into the gable wall. In houses with a hipped roof, the *svetëlki* project through the slope of the hip and share a single ridge with the house as a whole. In different houses, such attic rooms could have ordinary single or broad, double or even triple, windows. In the most recent houses of the Soviet era, the *svetëlki* were reduced to a decoratively finished little window on the gable. On houses with a hipped roof, a small decorative superstructure containing a window would serve as a reminder of the attic room (Fig. 11.3). This sort of miniature *svetëlka* became a characteristic feature of most of the wooden dwelling houses of the first half and middle of the twentieth century that were examined.

Another characteristic feature of twentieth-century houses was the use of colour. People have always tried to make dwelling houses look attractive. Window surrounds, shutters and cornices were painted in contrasting colours and sometimes even with ornamental compositions. The extensive use of sawn timber, however, producing an abundance of board surfaces and components also meant painting was required for the preservation of the wood. As a result, the entire building apart from the service premises became coloured. In the twentieth century, villages had a very smart and cheerful appearance.

It is worth noting that in the first half and middle of the twentieth century, no plans were drawn up for the construction of individual dwelling houses. Such documentation was simply not required. The construction was carried out on the basis of earlier prototypes and the future owners' indications with regard to size and the arrangement of elements. We have here, it is possible to say, a genuine phenomenon, when in the industrial twentieth century the medieval method of building by copying a pattern flourished on a tremendous scale.

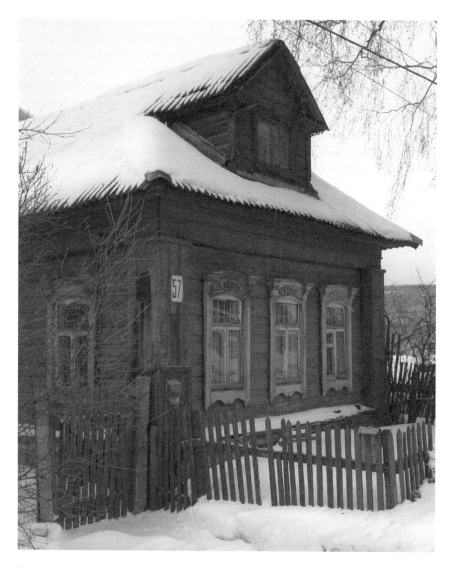

Figure 11.3 A house from the first half of the twentieth century in the village of Pavel'tsevo, Moscow Region. Photograph by A. Bode, 2012.

The small rural houses of the early twentieth century and the dwellings of the Soviet era differ substantially from the wealthy homes or dachas constructed to architects' designs. The layouts of the latter are not traditional but invented by professionals, and they display a certain influence from the asymmetric compositions of the Art Nouveau style. The idea of decorating façades in imitation of various historical or national styles also came originally from professional architects.

But the mass construction of ordinary rural housing without the involvement of architects naturally encouraged a return to traditional and more rational approaches to layout and the arrangement of volumes. Only details of the treatment of the façades survived from professional architecture, but they too were interpreted in a fairly free manner by craftsmen belonging to the common people.

So, the twentieth-century dwelling houses studied have a deep-rooted traditional structural core that was dressed in new "clothing" by applying orderliness to the elements and details along with a decorative finish to the façades. In essence, they are a continuation of the building practice of the late nineteenth and early twentieth centuries, but on a smaller scale and with fewer different types. What took place was a sort of archaization of architectural and functional approaches. Nevertheless, what is common in architecture, constructions and decor makers it possible to conclude that the construction of ordinary individual dwellings between the late nineteenth century and the 1960s represents a single tendency. It is simply that it dragged on chronologically and continued deep into an era when the evolution of architecture was proceeding along completely different lines.

It is possible to identify a number of basic characteristic features of houses from the first half and middle of the twentieth century. They include a predominantly simple single-axis structure, including dwelling house, entrance hall and work yard. The houses in the main consist of a one-part frame. The work yards are for the most part of no great size. The location of the stove in the majority of houses tends towards the long axis of the structure, while the middle of houses with internal log walls is occupied by several stoves to heat the different rooms.

While remaining within the general bounds of tradition, houses of the first half and middle of the twentieth century did introduce a certain amount of innovation. During this period, many established devices and forms in wooden architecture were simplified or transformed, or else disappeared, giving way to solutions that that were more rational in terms of economizing on material and standardizing elements. This applies to the framing of door and window openings, the covering of walls and the use of pre-shaped and appliqué carved elements in the decoration.

On the other hand, even in these relatively late buildings no few fairly archaic approaches are clearly in evidence. They include the log construction of the walls, the texture of their surface (in the absence of cladding), the construction of the ceilings and staircase, a gate flanked by massive bars in the work yards, and small windows. All these devices take us back to the authentic traditions of Russian wooden architecture.

This combination of characteristics from different time periods makes up the distinctive look of the wooden rural house of the first half and middle of the twentieth century. Despite certain constructional innovations, in its traditional structure, general forms, functional zoning, and certain archaic details, the memory of a centuries-old building culture is evidently still present.

At the present time, it is possible to identify two trends in the preservation of the wooden architectural legacy left to us by the twentieth century. One of

them lies in the preservation and restoration of objects of cultural heritage, but it includes only buildings dating from the earlier part of the century and not from the middle years. There are practically no ordinary rural dwelling houses among them. In the main these are outstanding wooden edifices, such as dachas, mansions, estate houses or ordinary urban dwellings, which differ from rural ones. Ordinary rural dwelling houses from the Soviet period are not acknowledged as objects of cultural heritage, and they are not specially preserved as architectural monuments. Their preservation takes place as part of a different tendency: the museumization of particular buildings that are of memorial significance due to their association with life of some distinguished person. There are a fair few such places in all regions of Russia, but they are isolated cases and do not form an architectural and historical milieu or a complex of buildings.

In historical towns, it is possible to come across small single-storey wooden houses that are typologically similar to rural buildings. They are included among objects of cultural heritage. There are quite a number of such houses in Tomsk, and they can also be found in Vologda, Torzhok, Pereslavl-Zalessky, Kargopol and other towns. Since these buildings are fairly modest and yield pride of place to more prominent edifices in those places, in the majority of cases the authorities never get round to their restoration. Understandably, in restoration, priority goes to buildings that are larger and architecturally impressive and that play an active role in forming the urban landscape.

Besides that, individual dwelling houses, both in towns and in the countryside, while being objects of cultural heritage are as a rule private property. To carry out a restoration, the owner should apply to an organization licensed to carry out such work, which is a very expensive business. It is rare that owners are able to afford to do so and also actually have such intentions. For them, as in centuries gone by, it is far easier to build a new house than to restore an old one. The owners of old houses find their property a burden, and they dream of moving to more modern and comfortable housing as soon as possible. Wealthy owners, too, are not always interested in additional expenditure on restoration. The combination of all these factors create stubborn problems hindering the restoration of individual dwelling houses.

One exception is cases when the historical look of the building is in line with the commercial interests of the owner, when a house is used as, for example, retail or exhibition premises. In that event, the owner will maintain the building, irrespective of whether or not it is registered as an object of cultural heritage, will carry out repairs in a timely manner and will keep the adjoining area in good order. Occasionally, such buildings are even completed or extended with annexes in the historical style. Instances of this can be seen in small historical towns that have a steady stream of visitors, such as Pereslavl-Zalessky, Myshkin and Gorodets.

The institutions known as house-museums account for quite a number of the rural individual dwelling houses that interest us. Let me mention a few examples.

The house-museum of the prominent Soviet-era political figure Mikhail Kalinin in the village of Verkhnaya Troitsa in the Tver region was built between

1913 and 1916. Initially, it was a traditional peasant house from the early twentieth century with four windows on the façade and a *svetëlka* beneath the roof. In 1927 the building was reconstructed: the Russian stove was moved from the main house to an extension that was used as a kitchen, while the space thus freed up was divided with partition walls; the terrace was enlarged, and a room for summer use was created in the attic. The house acquired something of the character of a dacha, but on the whole it remained little changed. The log walls go well with the carved window surrounds and the decoration of the *svetëlka*. What is remarkable is that Kalinin's house stands in a row of buildings of the same sort, and so the village presents a very homogeneous environment from the first half of the twentieth century. This is a positive example of the preservation of an object of cultural heritage in an authentic setting.

The house-museum of Konstantin Tsiolkovsky in Kaluga – which the scientist, inventor and pioneer of the theory of space travel bought in 1904 – was also extended at a later date, but the old part, with a three-window façade and gable facing the street, has survived well. In this building the urban influence is particularly noticeable in the form of the smooth cladding of the walls and the simple classical-style cornices and window surrounds. The house was restored in the 1960s. The surrounding historical setting has undergone changes. A main road running nearby and large apartment blocks border a small area of low-rise buildings including the Tsiolkovsky house.

Also noteworthy is the memorial house devoted to the poetess Marina Tsvetayeva at Bolshevo outside Moscow. The building was constructed in 1933 as a dacha, but in terms of type it is very similar to traditional rural houses with three windows on the front façade and a small window for ventilation on the plank gable. It is architecturally simple and accords with late examples of such buildings.

An interesting example of a small twentieth-century rural dwelling is the house-museum of the mother of the Great Patriotic War hero General Nikolai Vatutin, situated in the village of Vatutino (renamed in his honour) in Belgorod region. This building, constructed by soldiers in 1944–1945, after the general's death, is well preserved and kept in good order. A distinctive feature is that all its façades and decorative details are painted.

The house-museum of General Pavel Batov in the village of Felisovo in the Yaroslavl region is a typical example of a rural dwelling from the first half of the twentieth century. It is a fairly large house with a work yard. Its walls are not clad, with the logs left uncovered. The windows are embellished with fretwork surrounds. The hipped roof has a small decorative *svetëlka*.

We can also include in this category the house-museums of Academician Alexei Ukhtomsky in Rybinsk, the legendary Civil War Red Army commander Vasily Chapayev in Balakovo, the writer Pavel Bazhov in Yekaterinburg, and others. These examples differ in that they do not exist in a historical setting of the same scale. The small historical houses have survived amid modern development only because of the importance of their owners for Russian history and culture, but the buildings themselves are lost amid their surroundings and do not make a strong impression. The memorial significance of such houses ensures their

preservation. Although in this instance the architectural characteristics of the object are not such a prime concern, the historical monument status and visitors coming constantly to the museum obliges those responsible for them to carry out work to conserve and restore them in a timely manner. Perhaps those restorations are not of such a high quality and artistic level as seen on more significant objects, but they do make it possible to preserve types of twentieth-century individual low-rise housing. Admittedly, such measures, aimed at safeguarding a single object, do not extend to the surrounding historical environment. In some settlements, there are conservation areas for objects of cultural heritage or the territory of a particular tourist sight. They regulate new construction, maintaining the scale of the historical locality, the chief characteristics and the colour scheme. This is sufficient to preserve the general historical appearance of a settlement but not enough to preserve the actual historical structures. For that, a programme of restoration is required.

Certainly, in their natural environment, villages and rural settlements, historical wooden houses are so far being preserved due to the fact that people of the older generation live in them who are unwilling or unable for financial reasons to reconstruct or replace them. In other words, the conservation of a historical locality takes place by default because of the low level of activity in villages that used to be livelier and wealthier.

When old houses are being replaced by new ones, traditional types of dwelling are sadly no longer being reproduced. The traditional kind of house is something we are no longer used to, because the living space inside is one single whole, including the kitchen, and not divided into properly separated rooms. This is convenient and sensible for the traditional lifestyle and occupations, but people's way of life has changed fundamentally. Even if they practice individual farming, they go about it differently. That is why the design of peasant house that developed over the centuries is no longer in demand. For a present-day person, used to an apartment-style layout of the home, a building like that is inconvenient. It is a rare exception when the historical appearance of such a house is restored or carefully tended by its owners.

In the villages, wooden houses built before the 1960s are being demolished and replaced one at a time on the same plots of land. Sometimes, this process happens like an avalanche, sometimes it proceeds very slowly, but everywhere it is inexorably expanding. The houses are growing old; they are coming to the end of their lifespans. In time, fewer and fewer of them will remain. In the foreseeable future, practically all these houses will be replaced with new ones that have a different shape and layout. In other words, these buildings seem doomed to disappear.

The houses in question represent a fairly late cultural stratum that itself already differs from authentic traditional wooden construction, which is customarily assumed to have the greatest historical, architectural and artistic value. At the same time, they stand out sharply from other twentieth-century architecture. Its history was one of very significant, one might even say, radical changes, while individual dwelling houses persistently retained their traditional characteristics.

The historical and cultural value of this phenomenon is evident, but insufficiently understood at present. There is no awareness of the importance of such buildings even among the professional community. There is not a single work of scholarly research that gives a thorough analysis of the architectural, constructional and stylistic characteristics of houses from the first half and middle of the twentieth century. Today works of architecture dating from the 1960s and 1970s are already being seen as pieces of cultural heritage. They are, admittedly, outstanding creations of celebrated architects, and not ordinary buildings. The architecture of wooden dwelling houses of the Soviet era undoubtedly requires study, a comprehension of its place in the general course of history and the development of culture. And out of that comprehension should come systematic, targeted programmes and specific measures for their preservation.

References

Makovetskii, Ivan (1954). *Pamiatniki narodnogo zodchestva srednego Povolzh'ia* [Monuments of Folk Architecture of the Middle Volga Region], Moscow: Izdatel'stvo Akademii nauk SSSR.

Orfinskii, Vyacheslav and Grishina, Irina (2009). *Traditsionnyi karel'skii dom* [The Traditional Karelian House], Petrozavodsk: Izdatel'stvo PetrGU.

Zabello, Sofia, Ivanov, Vladimir and Maksimov, Pëtr (1942). *Russkoe dereviannoe zodchestvo* [*Russian Wooden Architecture*], Moscow: Izdatel'stvo Akademii arkhitektury SSSR.

12 Hated heritage

Architecture of the Norwegian welfare state

Siri Skjold Lexau

Architecture and social responsibility

Post-war public architecture in Western welfare states was built to improve the lives of the population. All the same, there was, and probably still is, a substantial divergence of opinion between experts and the public on how stately building projects should look. The people who were supposed to benefit from contemporary public architecture expected traditional qualities such as 'beauty' and 'dignity' in official buildings. They did not find these in the new ideals of contemporary architects. They even felt offended by the state's willingness to invest huge sums of money in 'ugly', grey buildings of repetitive design, built of unembellished concrete. The ideas of the so-called 'new monumentality' were in many ways suitable for public building projects, and we find those design ideals reflected in many buildings constructed in the decades following the Second World War. Paradoxically, the grand-scale, raw concrete architecture of late modernist monumentality tends to be especially disliked by the people whom it should serve. So – did the state 'cast its pearls before swine'? Probably not, but still politicians and people in general did not always appreciate the qualities 'hidden' in the brutalist aesthetic language which was hard for them to understand in the same way as professionals did.

The significance of welfare state architecture as a tool for social change has often been underestimated, or else remained uninvestigated. According to architects Mark Swenarton, Tom Avermaete and Dirk van den Heuvel, the term 'welfare state' stems from Britain, where the vision of social support extending 'from the cradle to the grave' was set out in the 1942 *Beveridge Report*. It originated in the massive demographic changes of the nineteenth century, when former systems of welfare provided by the church, the family, guilds and other bodies lost their close relation to the inhabitants of a community. Industrialization and population growth necessitated organization on a national scale, and the resources to cope collectively with the emerging 'social question' came from increased productivity as a result of industrialization (Swenarton, et al. 2015: 7f).

The emergence of a public system for social security is closely connected with the rise of workers' organizations in the early 1900s and the establishment of labour parties, but it was just as much a result of a situation that had developed beyond the capacity of former social security structures to cope. Earlier,

successful and responsible industrialists provided certain social services to their own employees, out of both humane and economic considerations. Happy and healthy workers were simply more useful than a sick and poverty-stricken population. German and British entrepreneurs were among the first to institutionalize such practices, which originated in the capitalist system and were highly dependent on the social conscience of the individual industrialist.

The 1930s experimentation with modernistic technology and aesthetics did not change much in this respect, but the development of ideologies, including core values and the quest for egalitarian societies, prepared the ground for social changes through architecture. The welfare state had some major tasks to solve, not least to prevent high death rates among children, health problems and poverty, which affected the population. These challenges were closely connected to the technical infrastructure of big cities, including water supply, sewerage systems, public transportation – and housing. Therefore, architects and city planners were presented with much more complex problems to solve and had to develop other skills than the engineering of defensive systems and communication lines. Still, both public administrators and architects tended for a long time to develop cities by constructing monumental edifices to celebrate the history of emerging national states, while the population was suffering on many levels. In Norway, the far-sighted head of the Oslo Planning Department, Harald Hals, pointed out this problem in his lecture at the Nordisk Byggnadsdag in Stockholm in 1927. There he asserted that architects put a lot of effort into their competition entries for monumental buildings and the design of residences for rich people, while the need to provide housing of adequate quality for 80 per cent of the population was more or less ignored (Lexau 1998: 36).

New monumentality

In the 1940s, strong voices advocated the need to put welfare state policies into architectural practice. The Swiss architectural historian Sigfried Giedion (1888–1968), the Spanish architect Josep Lluís Sert (1902–1983) and the French artist Fernand Léger (1881–1955) made a statement in 1943 with the influential paper called 'Nine Points on Monumentality', originally intended for publication in a volume of the *American Abstract Artists* (Ockman 1993: 27–30). Giedion's essay 'The Need for a New Monumentality' followed the next year. The main message was that public resources should be used to meet the state's obligations to contemporary society's *living* members and their everyday needs, not on costly monuments to the dead. The manifesto 'Nine Points on Monumentality' appeared in the Danish publication *Arkitekten* in 1948, and Giedion visited Norway the same year to give a lecture to the Oslo Arkitektforening (Association of Architects). He referred to Marcel Breuer (1902–1981) and his principles of clarity of expression, the value of a plan, and the effect of materials, construction, and details (Henjum 2010: 109). In the wake of social developments demanding more egalitarian societies, the growth of workers' movements, and political labour parties, the call for a 'new monumentality' for the benefit of the people grew strong.

The notion of the welfare state in the following text will be understood and used according to the generalized interpretation of the concept expressed by the Danish sociologist Gøsta Esping-Andersen. He classified the most developed welfare state systems into three categories: Social Democratic (the Nordic countries Sweden, Denmark, Norway, Finland and Iceland), Conservative (Germany and France) and Liberal (e.g. the USA, based on insurance contributions) (Esping-Andersen 1990: 71). The Social Democratic welfare state system found in Norway is an administrative concept where the state has assumed general responsibility for securing the inhabitants equal access to education, a minimum income, health care, a minimum housing standard and other social services. The resources for these services are provided by a progressive taxation system, where higher taxes are imposed on people with high incomes.

The Second World War and the German occupation put a halt to the development of 'New Monumentality' dedicated to the people, as monumentality for the people had a completely different meaning during the Nazi regime. After the bombing of the war years, planning ideals were founded on 'old monumentality', while the rebuilding of houses for a large part of the average population called for immediate investments on economical, functional and aesthetic levels, both during and after the war. Between 1945 and 1960, 368,681 residences were built in Norway (Norberg-Schulz 1983: 11). Traditional building styles were combined with modernist, functional planning solutions and larger windows, which led to better lighting conditions in the interior and better contact between indoors and outdoors. The quality of the exterior design and the properties of the materials were counted upon in and of themselves to ensure adequate architectural quality, and in such a way substantial sections of the population were provided with simple houses designed by architects, but with no excess decorative ornamentation. Such houses were often a result of competitions for building types. Dwellings were, to a large extent, designed by applying traditional building types and regional variations to modernized houses mostly constructed in wood.

Housing got the best of modernistic ideals in the first years after the war. When the most urgent need was to provide housing for people who had lost their homes, the construction of public institutions became a major challenge. This is the point of departure for our discussion here, as the idea of a 'new monumentality' may be perceived very clearly as an architectural language of public institutions. In Norway, there was a great need for contemporary contributions to the built urban landscape. Many buildings for public administration, education and social welfare purposes that were created to meet the needs of the newly independent nation in the 1910s had become too small after several decades of population growth or had been lost due to war damage. A modern attitude demanded a new kind of monumentality for public buildings. At the same time, the buildings were expected to be easily accessible for everyone to serve their welfare needs. A substantial growth in public service institutions and their administration called for very large office buildings. Raw concrete with few decorative details and no stylistic excesses beyond the aesthetic qualities of the concrete itself became the preferred material to satisfy that demand.

Brutalism

The theories and experiments with materials of the Swiss-French architect Le Corbusier (pseudonym for Charles-Édouard Jeanneret 1887–1965) seem to have fitted perfectly the demand for new, powerful aesthetics in late modernism. The puristic white boxes belonged to the 1920s and 1930s; now it was time in contemporary architecture to bring to the fore the qualities of concrete, not covered or treated in expensive ways without necessity. Le Corbusier had shown its aesthetic potential in his *Unité d'Habitation* in Marseilles (finished in 1952), where all the concrete surfaces were left uncovered, including the visible traces of the formwork made of wood. He called this kind of raw concrete *béton brut*. The Swedish architect Hans Asplund used the term 'neo-brutalists' about his colleagues Bengt Edman and Lennart Holm, when describing their designs for Villa Göth in Uppsala in 1949, and the term spread quickly among colleagues in Britain (Frampton 1985: 262). British architecture critic Reyner Banham has ultimately been honoured as the person to identify *New Brutalism* as a style with certain characteristics (Banham 1955: 358–361). The British architects Alison (1928–1993) and Peter Smithson (1923–2003), members of the Independent Group at the Institute of Contemporary Arts in London and the dissenter group of CIAM, Team X, came to be reference theorists and practitioners of 'another' modern architecture in the second half of the twentieth century. Their field of investigations concerned architectural development, welfare state policy and the development of Western consumer culture. They attracted global attention for their design of Hunstanton school in Norfolk, a kind of manifesto of 'New Brutalism' showing a formal heritage from both Ludwig Mies van der Rohe (1886–1969) and Le Corbusier: materials should be used uncovered, *as found*, unless it is necessary to protect them against climatic conditions, and the structure and technical installations should be visible from the outside.

Kenneth Frampton was one of the first to point to the relationship between 'New Brutalism' and the welfare state, showing the significance of acts of parliaments as motors for the construction of new towns and an extensive school building programme. School designs were carried out partly 'in the so-called Contemporary Style, which was largely modelled on the official architecture of Sweden's long-established Welfare State' (Frampton 1985: 262). The 'contemporary style' was typically executed with coarse, grainy, untreated materials such as brick and/or concrete, combined with glass and steel, an alternative to the 'reduced' Neo-Georgian manner for municipal schools. In this period, we also see the emergence of new, raw façade materials such as weathering steel, which develops a characteristic 'rusty' appearance, and unplaned wood. A complicated interrelationship between contemporary and former architectural/national styles can be found almost everywhere in the years around 1950. Soon, however, brutalist-style characteristics emerged very clearly as the main tendency: 'Up to the mid-1950s truth to materials remained an essential precept of architecture, manifesting itself initially in an obsessive concern for the expressive articulation of mechanical and structural elements' (Frampton 1985: 265).

The principles of New Brutalism can be detected in many of the major build-ing projects carried out in Norway during the 1950s–1970s. This is also the con-text in which the Norwegian architect Erling Viksjø (1910–1971), who would be one of the nation's most prominent architects of the period, laid the foundation of his professional career. We will take a closer look at some of his works and some others that may serve to illustrate how architects and public commissioners inter-preted international ideals to produce major building projects for the Norwegian welfare state. It is evident that Viksjø had the principles of 'New Brutalism' more or less in front of him when he started to design parts of the Government Quarter in Oslo, but he enriched them with his innovative use of concrete.

The government building in Oslo – 'a dominant centerpiece'

The main government building, the H-block, as it is known, was designed to house offices of the state administration in a succession of stages over the period 1940 to 1958. *Statens bygge- og eiendomsdirektorat* (The Directorate for Building and Properties) announced an open competition for the Government Building project in 1939, and 49 entries were submitted. The requirements were to pro-vide an economic and effective arrangement of ground plans combined with a suitably grand design. In March 1940, the entries *Rytme* designed by Ove Bang and Øivin Holst Grimsgaard, *Vestibyle* by Erling Viksjø, *U* by Nils Holter and *Fri* by Dagfinn Morseth and Mads Wiel Gedde were identified as four equal winners (Tostrup 2012: 92, 95–96). Viksjø's entry presents a rather strict grid-like exterior, with window frames set back from the outer façade. In many ways, this makes his proposal stronger, but also heavier than other entries, such as Bang's more transparent glass body. A second competition was announced after the war, and Viksjø's project emerged as the winner. Extensive discussions followed the com-petition as an area of beautiful, coherent architecture called the 'Empire Quarter' would have to be demolished to make space for the government buildings. This included the Military Hospital from 1807, designed by Christian Collett, a mater-nity clinic (*Fødselsstiftelsen*) from 1829 and the National Hospital (*Rikshospitalet*) from 1842, both designed by Christian Heinrich Grosch. As architect and art historian Hallvard Trohaug has pointed out, the planning and construction of the Government Quarter led to the first wide-ranging debate on architectural conservation in post-war Norway (Trohaug 1999: 20).

As a result, Viksjø proposed a solution where the existing buildings in the area would be integrated into the new plans, but the building committee rejected it. The new government building proposed by Viksjø was a high-rise slab positioned perpendicular to the Art Nouveau 'Old Government Building', designed by Hen-rik Bull (1864–1953) in 1906, and a slimmer version of the original H-block proposal was implemented. The competition entry is more ornamented than the final design, showing that tradition still prevailed in the decoration of prestig-ious buildings. A monumental entrance led to a spacious lobby two floors high. The final design, however, presents a uniform, rastered 'grid-iron' façade with an additive, modular structure. The main building volume is raised on columns,

in accordance with Le Corbusier's idea of lifting buildings to preserve the terrain beneath. The lobby ended up considerably smaller and more simplified than in the initial competition entry, and the entrance is set back from the façade. A glazed canteen topped with a wing-shaped roof construction partially embraces the lower floors. The original proposal had been transformed into a less expensive solution. Construction started in 1956, and the H-block was inaugurated in 1958 (Fig. 12.1).

Figure 12.1 Erling Viksjø: the H-block of the Government Quarter in Oslo, 1958. Photo: Teigens fotoatelier/Nasjonalmuseet.

The building was the first of three planned construction phases. Two further stages in the development of the area were anticipated, but only one of them was completed. In 1952, Viksjø made sketches for a possible second, lower building, with a ground plan in the shape of a capital T (Henjum 2008: 20). He continued to work on possible extensions of the Government Quarter and a drawing probably made in 1958 shows the lower building's final shape as a Y. Viksjø may well have had Marcel Breuer's X-shaped design (in collaboration with Pier Luigi Nervi and Bernard Zehrfus) for the UNESCO Headquarters in Paris (1952–1958) in his mind, as that architect had been advocated as a role model by Giedion in his lecture in Oslo ten years earlier. The Arne Garborgs *plass* (square) was partly covered over, creating a foundation for the so-called Y-block that was completed in 1969–1970. The Y shape also created two separate squares in front of monumental buildings in the neighbourhood: the Trinity Church (designed by Alexis de Chateauneuf and built in 1858) and Deichmanske Library (designed by Nils Reiersen and built in 1933). The façade was given the same architectural style as the H-block and was also supposed to be raised on columns. It ended up on a more massive foundation, but its curved shape with only three storeys above the ground contrasts strongly with the 15-storey slab of the H-block. The third and last phase in the original plan, a slab on the opposite side of Grubbegata, was never realized according to the original plans. Around the H-block, a romantic park reflecting the classical features of the 'Empire Quarter' was laid out, and a double row of linden trees was preserved to lead up to the entrance.

Both buildings are adorned by an innovative concrete/stone surface called 'natural concrete' created by a method invented and patented by Erling Viksjø and the engineer Sverre Jystad. Before the cement of the façades had fully cured, the formwork was removed and the surface sandblasted to create a durable and beautiful surface in which the natural stone aggregate appeared as decorative elements. In this way, Viksjø's buildings constructed by concrete casting acquired façades of natural stone. Using different colours and sizes of pebble, varying patterns and roughness give the surfaces diverse qualities. The sandblasting technique also made it possible to produce works of art directly on concrete façades or interior walls. By letting artists use sandblasting as a means of creative expression, Viksjø sought to integrate art into his architecture. Carl Nesjar (1920–2015), who collaborated closely with Pablo Picasso (1881–1973) over a period of 17 years, is the prominent contemporary artist best known for using such methods (Fig. 12.2).

The buildings also have integrated into them works by the young Norwegian artists Tore Haaland (1918–2006), Odd Tandberg (1924–), Inger Sitter (1929–2015) and Kai Fjell (1907–1989). Fjell decorated the ground-level passage through the H-block, while Nesjar and Sitter did the lobby. Most artists performed the sandblasting of their own works, while Nesjar did the works by Picasso and Fjell. The other artists embellished the walls of the stairwell. Viksjø himself made pictograms representing the various ministries on the end façade, sandblasted with stencils. Carl Nesjar applied motifs designed by Picasso to Y-block's façade on Akersgata and in the lobby. In 1990, the top floor of the H-block was removed to make way for two new floors designed by Per Viksjø, the son of Erling.

Figure 12.2 Integrated art works designed by Picasso in the Y-block. Photo: Teigens fotoalelier/Nasjonalmuseet.

The new floors have glazed walls and are set back inside the silhouette of the main building volume, but this changes the former firm lines of the cornice. The passage on the ground floor has also been incorporated into the lobby. The area – which connects the H-block, Y-block and other buildings together – is partly designed to continue the qualities of the natural concrete façades. Geometrical patterns give vitality to the pedestrian areas, which connected the buildings, open-air parking and garages.

Originally, the territory around the H-block and Y-block was an open, publicly accessible area where anybody could walk literally *through* the lavish buildings of the state administration. The architects had persuaded both the state and other commissioners that concrete had a lot of attractive characteristics such as constructional strength, weather resistance and minimal maintenance (e.g. Viksjø 1951: 58–60). So, efforts were made to invite the public in and to bring the person in the street into the dynamics of a democratic architecture. In June 2011, the Directorate for Cultural Heritage in Norway was preparing a plan for the preservation of selected buildings owned by the state. Both the H-block and the Y-block were listed for protection. However, after the bomb attack that hit the area just one month later, consideration of possible future uses of the now

damaged buildings started again from scratch. After extensive discussions, several inquiries and reports, Prime Minister Erna Solberg and Minister of Municipal Affairs and Modernization Jan Tore Sanner presented the plan for a New Government Quarter in 2014, stating:

> The H-block is the most significant iconic building of the modern Norwegian welfare state after the Second World War. The H-block is among the best examples of monumental modernism, and the art works occupy a special position among recent Norwegian history of art and architecture.
>
> (Author unknown 2014)

Currently, it seems that only the front façade and the integrated art in the interior of the H-block will be protected, while extensions and annexes may be approved. The Y-block will be demolished and replaced by an open square.

Hated high-rise – Bergen town hall pokes the city in the eye

As with the Government Quarter in Oslo, prolonged discussions preceded another of Viksjø's public building projects: the Town Hall in Bergen. After a major fire in 1916, a completely new layout for the city centre created the same year included a Town Hall (Lilienberg and Greve 1916). The Town Hall was situated outside the areas affected by the fire, and it was not until 1951 that the municipality announced an 'ideas competition' for the project. Initially, one of the five entries, out of 60, to proceed to a second evaluation, Erling Viksjø's project *Gård i gård*, a high-rise with 14 storeys surrounded by lower buildings of two and three floors, was finally awarded first prize in 1953 (Trohaug 1999: 34). The design included two courtyards – one of them, containing the complex entrance, open to the street. The lobby, council hall and ceremonial hall would face the outer yard, while many of the offices overlooked the inner yard. This high-rise would again be raised on columns above the ground, connecting the two courtyards, while for the council chamber and the ceremonial hall a semi-detached cubic volume was proposed, also on columns. The façades were to have a white concrete surface, contrasting with a base of natural stone (Fig. 12.3).

The height of 51 m and the large footprint (13.6 by 47.95 m) were at the time completely alien to the city's urban environment, as no one else was allowed to build that high. Furthermore, important listed buildings had to go to make way for the project. The plan envisaged demolition of all existing buildings on the designated site, except Hagerupsgården, Gamle Rådhus (the Old Town Hall) and Magistratgården, all built in the eighteenth century. In January 1970, a petition with 16,500 signatures and an appeal in the local newspaper signed by 75 architects demanded that the municipal council reconsider the project (Grønlie 1995: 853 and *Bergens Tidende* 1970: 9). In an interview published in the same daily paper, Viksjø himself described the project as his best proposal ever (Alham and Bøe 1970).

Figure 12.3 Erling Viksjø: Competition entry *Gård i gård*, 1951. Design sketch for Bergen
Town Hall. Nasjonalmuseet.

Engineering work for the lower buildings started in 1956, but stopped in 1958
(Trohaug 1999: 34). Over the following years, the municipality initiated great
plans for redevelopment of the adjacent Marken area through a special, semi-
municipal division established in 1961, the Saneringsinstitutt (Redevelopment
Department) made up of municipal planners and representatives of the local
public. It was decided to demolish the whole area, but the scheme met with furi-
ous protests from the inhabitants of Bergen across social and professional lines.
From 1960 to 1970, both planning authorities and builders underwent a change
of mindset from blind belief in progress and efficiency to paying attention to
the value of existing historic structures. Limited renewal coupled with reuse of
existing buildings emerged as an option with economic advantages. Finally, the
protesters succeeded in halting the demolition plans in 1974. Meanwhile, con-
struction of the Town Hall resumed from 1971, but now with the high-rise block
as the priority to be completed. The lower buildings were left unfinished except
for the canteen attached to the tower, as the municipal administration decided to
preserve the Manufakturhus from 1646, one of the city's oldest buildings. In the
end, the Town Hall of Bergen, completed in 1974, was given not white façades
but natural concrete ones like the government buildings in Oslo (Fig. 12.4).

The building is partially raised on powerful pillars or pilotis, in addition to
foundations of concrete frames. The stairwell is visible as an attached, vertical
element on the rear, south-eastern façade, and a relatively windowless top floor
completes the composition. The lobby faces Rådhusgaten to the north-west.

Figure 12.4 Natural concrete at the end wall of the Town Hall in Bergen. Photo: Siri
Skjold Lexau.

Repetitive grid-iron façades with windows set back in the wall make the overall
design of the building similar to the H-block of the Government Quarter, but
the Town Hall has no integrated sandblasted art works. On the other hand, the
end wall has a rough appearance with a horizontal fluted pattern. The tower rises
above mostly small-scale urban construction that the city's population was accus-
tomed to, and the grey, raw and 'brutal' Town Hall remained for many years 'hate
object number 1' among the inhabitants of Bergen. However, very soon a new
project seems set to challenge that status.

Late modernism fights back: a blow to villas of
upper-class Bergen

Around 1960 Allégaten, part of the Nygård Hill district in Bergen, was a street
with villas in lush gardens on the west side, while low-rise apartment houses lined
the street on the east. It was a quiet place with trees and gardens, which at the
time became regarded as an inefficient part of the city's structure. The struggle to
keep this neighbourhood was lost when a zoning plan securing the area for uni-
versity expansion was approved in 1964. Large parts of the Nygård Hill area were
listed for demolition to make way for the rapidly growing University of Bergen and

its need for new buildings and car parks for the use of staff and students. The plan envisaged a row of nine high-rise blocks with lower building between them on that southern part of the hill. It entailed eliminating seven large villas with luxuriant gardens, forming a substantial part of the greenery in the area. In this way, the picturesque character of the district would be completely changed (Fig. 12.5).

Harald Ramm Østgaard (1920–2005), who was appointed architect for this part of the plan, regarded the proposed high-rise blocks to be too 'massive' a solution for the setting. He put forward a more 'compact' version of the project in 1970, which also saved an existing group of Art Nouveau–style buildings dating from around 1900. In 1974, construction of the Natural Sciences Building started as part of the university's expansion, which was much needed to handle, among other things, scientific issues relating to the oil boom in the North Sea. Several tactics were employed to connect the building to its environment. First, an open space was created on Allégaten by setting the long-side façade back from the street front. On both the short sides, stair arrangements and walls made of natural stone made a smoother transition from the huge concrete building volume to existing stone walls and the park. Several technical functions are integrated into the cornice to reduce the visual impact of the whole volume towering up from the street. It would, however, be a clear understatement to say that the rectangular building body in its final state is not massive. The façade on Allégaten is 163 metres long, the short sides measure 43 metres, and the building's gross floor area

Figure 12.5 Harald Ramm Østgaard: The Natural Sciences Building, Allégaten 41, Bergen, 1977. Photo: Thomas Vindal Christensen.

is 47,000 m². The building, completed in 1977, rises seven storeys above the level of the street, and five storeys on the opposite side face the Nygård park.

The way the elements are put together is staging the structure in powerful dimensions. Structural elements such as the base, columns, floors, walls in stair-wells and the cornice were all made with cast concrete, while façades, stairs and floors in the auditoriums are prefabricated concrete elements. The system of hanging columns, sunscreens and balconies are also made of prefabricated con-crete (Røyrane 2015: 22). Above the ground floor containing the garage, window openings alternate with massive parts of the wall structure on four storeys, which appear identical on the façade. Against the sky, the building's elevation ends with a powerful cornice. The exterior shows the grid effect that appears when construction joints are extended to the front of the façade and used as articulat-ing elements. The central lobby opens up the interior with a vertical movement including a set of ramps running from bottom to top. This middle section breaks the horizontality that otherwise dominates the building.

The plan of each floor is a long narrow rectangle, symmetrically arranged with corridors running along the sides of the building forming a U-shape on each side of the central lobby. The long corridors lead to offices, laboratories and lecture halls. The whole structure is designed on a modular basis, making it possible to move most of the room dividers around, a characteristic feature of this kind of flexible, system-based building. Initially, it was built to house the Department of Chemistry, parts of the Department of Geology, a Seismographic Centre, a botanical museum and a zoological laboratory with housing for animals and a zoological museum. Reading rooms, offices, seminar rooms and auditoriums are situated on the lower floors, while the three upper floors contain laboratories and accommodation for animals. A canteen seating 400 persons is situated on a mezzanine above the ground floor, while the garage beneath the building can accommodate 130 cars.

Østgaard was an architect sensitive to the latest influences of his time. The clear construction and the undisguised materials put the Natural Sciences build-ing well within the definition of brutalism, and Østgaard himself pointed to the Japanese architect Kunio Maekawa (1905–1986) and his Kyoto Kaikan concert hall from 1960 as a source of inspiration. We may recognize both the ramps and other secondary building elements, which tie the building to its surroundings, and the striking façade structure and cornice. In many ways, Østgaard applied these elements in a more powerful way than Maekawa, recalling just as much the structural qualities of the Kagawa government office, designed by Kenzo Tange (1913–2005) and completed around the same time, in 1958.

In 2014, the Natural Sciences Building was listed as part of a national protec-tion plan for state-owned buildings on account of its significant architectural and historic qualities. The protection plan includes the exterior of the building, its interior in the entrance area and all levels of the central lobby. This also includes common areas connected to the lobby. Further, two laboratories on the fourth floor are to be preserved. A lot of exterior and interior details and their treatment are included in the listing, to preserve the main structure of the architectonic

expression, and to keep details such as elements of the façade and the use of materials and surfaces (Fig. 12.6).

The outdoor features designed by landscape architect Endre Vik (1926–2013) are also included in the preservation plan to protect the architectonic values that were designed and executed at the same time as the building itself. The listing may seem a paradox to many people. The building is publicly regarded as one of

Figure 12.6 Interior materials of the Natural Sciences Building. Photo: Siri Skjold Lexau.

the ugliest in the city, the more so as it supplanted beautiful gardens and stately houses. At the same time, it has proved its durability and practicality. It is flexible and strong, it has lavish material quality, and the staff are very satisfied with the enduring functionality of offices, lecture halls and laboratories.

A love triangle: new monumentality, brutalism and the welfare state

The decades after the Second World War saw a great expansion of public administration due to the commitments of the welfare state. Architects and developers had an effective building technology at hand, and they used it to create huge public buildings in accordance with contemporary architectural ideals. Ideas of 'honest materials' without décor and unnecessary treatment were the guidelines, and a powerful architecture of strong and rugged materials emerged. We have looked at three building projects in Norway that were quite controversial at the time of their construction, pushing existing historical buildings aside through demolition. People were furious, both at their loss and at the authorities' autocratic right to destroy their environment and impose huge, ugly buildings on their neighbourhoods and beautiful city centres.

More people obtained higher education in the post-war years and now stood up for their rights against experts who should not necessarily be allowed to have a monopoly of planning decisions. After 1970, things changed. Public planning is now expected to take the existing physical, social and cultural context into account and that should be a guideline for further planning and new buildings. People have to be informed, be allowed to participate and be heard when projects are planned in their area. In this respect, we may regard the European Architectural Year, declared by the Council of Europe in 1975, as a definite turning point marking new ideals in city planning. As a result, 40 places in Europe, three in Norway (Nusfjord, Røros and Stavanger), were chosen as 'pilot projects' to investigate possible rehabilitation solutions, re-use of existing structures and only an infill of contemporary architecture. The examples had a huge impact in many places, showing that demolishing and re-building were not necessarily always superior solutions.

Consequently, the Government Quarter, Bergen Town Hall and the Natural Sciences Building would probably have been even more difficult to realize if they had been initiated after 1975. The heritage value of the 'Empire Quarter' in Oslo would have been difficult to ignore, while the height and scale of the Bergen Town Hall project might have meant it was moved to a site away from the main visual axes of the city centre, where it would have been possible to accommodate all the building elements. The Natural Sciences Building, a huge block constructed of reinforced concrete elements, can be said to be quite 'brutal' compared to the remaining much smaller buildings in the neighbourhood. Seen from above, from the mountains surrounding Bergen such as Fløyen or Ulriken, it looks like a huge ship that landed in the middle of a low-rise residential neighbourhood. In the attractive environment of Allégaten, the massive concrete construction could be

perceived as an architectonic bomb blast. The rugged look of its façade and its sheer size were completely alien to people living in the area. The existing urban milieu was a coherent collection of villas that represented living history. Today it might have been identified as a leading feature, outweighing the plans for massive building volumes. Østgaard's 'compact' building block would probably have been scaled down to more fragmented and less brutal dimensions. Maybe it would not have proved possible to find solutions for the functional needs of the Faculty of Natural Sciences at all – in this area.

The main reason for people's hatred of such buildings was their sheer size compared to existing structures in the familiar urban setting, but in addition there was the architectonic language and the style, completely different from everything that had been built in cities before. Architects and other professionals have, however, always recognized the qualities of the building in itself, even if the choice of architectural language and scale in its setting were debatable. Today, it may still be difficult to overlook the 'offensive' character of brutalist buildings, but they tell us a lot about innovative technology, creative architects and the ideals of the post-war decades. That is also the reason for the official recognition of their qualities and the listing of both the H-block in the Government Quarter and the Natural Sciences Building as important architectural heritage of the highest category, according to Norwegian heritage legislation. They are buildings designed according to the ideals of the 1950s and 1960s, some even implemented at a time when the planning principles that made them possible had changed to their disadvantage. New ideals of more diverse city planning were getting a foothold at the same time. Bergen Town Hall is not yet listed, but it is recognized by DOCOMOMO (International Committee for Documentation and Conservation of buildings, sites and neighbourhoods of the Modern Movement) as an important example of twentieth-century architecture, and it will probably be listed soon. The 'hated' buildings represent clear ideas of a limited epoch, which left a solid physical imprint on our city centres. They therefore tell significant stories of outspoken ideals of using architecture as a political tool to change society for the better.

Sources

Author unknown (1970). "'Folkeavstemning om rådhuset' and 'Arkitektene vil ha rådhusprosjektet vurdert på nytt'", *Bergens Tidende*. Bergen: 21 January 1970. Available at https://bergensiana.files.wordpress.com/2011/01/rc3a5dhuset.jpg, visited 07 November 2016.

Author unknown, Statsministerens kontor (2014). www.regjeringen.no/no/aktuelt/dep/kmd/nett-tv/Nett-TV-Pressekonferanse-om-Regjeringskvartalet/id760974/ (Accessed 15 August 2016).

Banham, Reyner (1955). "The New Brutalism", *Architectural Review*, December 1955, London: EMAP. pp. 358–363.

Alham (pseudonym) and Bøe, S. (1970). "Rådhusarkitekten", *Bergens Tidende*, Bergen: 07 February 1970.

Esping-Andersen, Gøsta (1990). *The Three Worlds of Welfare Capitalism*. Cambridge: Polity Press.

Frampton, Kenneth (1985). *Modern Architecture. A Critical History*. London and New York: Thames and Hudson.

Giedion, Sigfried (1944). "The Need for a New Monumentality". In: *New Architecture and City Planning. A Symposium*, ed. Paul Zucker. New York: Philosophical Library.

Grønlie, Tore (1995). "Bergenspolitikken". Bergen Bys Historie, Vol. IV. Bergen: Alma Mater.

Henjum, Berit Johanne (2008). Erling Viksjøs rådhusutkast i Bergen 1951–53. Sett i en monografisk og typologisk sammenheng, Master's thesis in art history, Oslo University.

Henjum, Berit Johanne (2010). "'Det beste jeg noen gang har laget'. Erling Viksøs rådhusutkast i Bergen (1951–53). In: *Brytninger. Norsk arkitektur 1945–65*, ed. E. Johnsen. Oslo: Nasjonalmuseet.

Jenssen, Hugo Lauritz (2013). *Høyblokken. En bygningsbiografi*. Oslo: Press.

Lexau, Siri Skjold (1998). "Boligens plass i Harald Hals' generalplan fra 1929". In: *Nye hjem. Bomiljøer i mellomkrigstiden, By og bygd XXXV, Norsk folkemuseums årbok 1997–1998*, eds. M.B. Bing and E. Johnsen. Oslo: Norsk folkemuseum.

Lilienberg, Albert and Georg Jens Greve (1916). Forslag til Regulering av de Anno Dom 1916 brændte dele av Bergen. Bergen City Archive: The archives of *Reguleringsvesenet i Bergen*, A-0967.

Norberg-Schulz, Christian (1983). "Fra gjenreisning til omverdenskrise. Norsk arkitektur 1945–1980". In: Knut Berg et al. (eds). *Norsk kunsthistorie*, vol. 7, Oslo: Gyldendal.

Ockman, Joan and Eigen, Edward (1993). *Architecture Culture 1948–1968. A Documentary Anthology*. New York: Rizzoli.

Røyrane, Eva (2015). *Forvaltningsplan Realfagbygget, Allégaten 41*. Bergen: UiB Eiendomsavdelingen.

Swenarton, Mark, Avermaete, Tom and Heuvel, Dirk van den (2015). *Architecture and the Welfare State*. London: Routledge.

Tostrup, Elisabeth (2012). "Høye idealer på kronglete tomt: konkurransen om ny regjeringsbygning i 1939–1940". In: *Arkitekturårbok 2012*. Oslo: Pax.

Trohaug, Hallvard (1999). *Arkitekt Erling Viksjø*. Oslo: Norsk Arkitekturmuseum.

Viksjø, Erling (1951). 'Fasadebetong?'. *Byggekunst* 3, 1951, Oslo: Arkitekturforlaget.

Viksjø, Erling (1959). 'Det nye regjeringsbygget', *Byggekunst* 1, 1959, Oslo: Arkitekturforlaget.

13 Experimental preservation of an arctic settlement Piramida on Spitzbergen

A Russian view of the *120 hours* 2015 architectural competition

Ekaterina Staniukovich-Denisova

The environmental approaches that have become particularly popular in the contemporary architecture of the Scandinavian countries are also being extended to historical objects undergoing preservation. It was the Norwegians who in 2015 made the experimental preservation of a semi-abandoned settlement on Spitsbergen the subject of the architectural competition *120 Hours* that raised a number of basic issues relating to the preservation of buildings from the recent past. In this chapter I shall discuss the variety of solutions put forward by participants in the competition for architecture students on how to deal with the embodiment of a Soviet utopia of the 1950s–1980s in the Arctic: the unique settlement called Piramida or Pyramiden. The non-restrictive design criteria with regard to the functioning of the object (regarded as a "site") stimulated a search for conceptual approaches across a wide spectrum (including art objects and performances) that reflect the transformation of the concept of architecture in the twenty-first century.

The Arctic as a unique territory of dialogue and innovation

Historically the arena for direct contacts and cultural interaction between Russians and Norwegians has been the Arctic region and, above all, its sea routes.

To the Russian mind, the Arctic, which in the twentieth century emerged from historical isolation and increased in significance many times over, is a natural continuation of the cultural concept of the Russian North. Environmental conditions and the course of historical development in that part of Russia determined its specific regional identity, in which, more than anywhere else, features of the national culture and character have survived undistorted by conquests and extraneous external elements. This has made the Russian North particularly attractive at times when there was a search for national origins and a reassessment of future courses for the thinking metropolitan intelligentsia.

A distinctive feature of Northern culture is its location in extreme geographic and climatic conditions. The folk culture of the Russian North formed at the extreme of the survival of the ethnos, when the question of its continued

existence was a real and pressing one. In such a "threshold situation", a culture will mobilize all its inner resources. Mechanisms of self-preservation become engaged that are bound up with ensuring its integrity. In the struggle for survival, many insignificant features are abandoned and the urge to preserve cultural identity, reflectivity and introversion increase strongly. The culture looks to its original foundations. The role of its self-awareness increases, serving as a buttress for its self-preservation (Terebikhin 1993: 144f). To all appearances, what has just been said can to a large extent also apply to the Northern Norwegians, with whom today's Pomors often feel a sense of common genetics.

In the twenty-first century, due to the ever-increasing accessibility of the unexploited riches of the Arctic and the latest explorations of the continental shelf, it is becoming a new geopolitical region, the "geotory" (Riabtsev 2015) of a dialogue between developed countries in which the two basic concepts of "preservation" and "development" exist side-by-side.

The Spitsbergen or Svalbard archipelago is often termed the key to the Arctic due to its unique geographical position and unique status in international law (Portsel 2011). Russian Pomors, as well as the (Norwegian) Vikings, visited the archipelago long before its official discovery in 1596, when the Dutch mariner Willem Barents added Bear Island and the "land of sharp-pointed mountains" – Spitsbergen – to his chart (Zinger 1975: 31, 33, 41). Subsequently, these lands were opened up and exploited by mariners from the countries of Northern Europe. The Pomors, who called the archipelago Grumant, were drawn to its eastern part, which was located closer to Russia. As late as the beginning of the twentieth century, Spitsbergen did not belong to anybody. Industrialists of various nationalities, primarily Norwegian and Russian, engaged freely in economic activity there. At the Paris Peace Conference in 1920, representatives of the United Kingdom, the Netherlands, Denmark, Italy, Norway, France, the USA, Sweden and Japan agreed a treaty placing the land areas of Spitsbergen under Norwegian sovereignty, but at the same time all 41 states that acceded to the treaty (including the USSR from 1935) obtained the right to carry out industrial, commercial and scientific research activities there on a basis of complete equality and the demilitarized status of the archipelago.

The need to increase coal supplies led to the purchase of plots of land on Billefjord and the construction by the Soviet Arktikugol' group of enterprises of a coal-mining plant and a workers' settlement attached to it. The place became known as Piramida – "The Pyramid" – from the shape of the mountain that towers above it. During the war, the inhabitants and equipment were evacuated, and it was only in 1946, with the arrival of 600 polar workers, that construction of the mine and settlement really began.

Actually, the colony, with a population that rose to over 1,000, continued to develop right up to the moment when the mine closed due to unprofitability in 1998 as a settlement that reflected the finest achievements of Soviet construction in Arctic conditions. The technologies required to build in permafrost conditions were experimental, but so too were the means developed to provide for the psychical and psychological comfort of people working in the extremes of polar

night and polar day. This opportunity appeared thanks to an ideological mandate to demonstrate the advantages of the Socialist way of life in comparison with the neighbouring Norwegian settlements. In the Cold War era, the life of the shift-working miners was supposed to serve as "a model of the Communist future". They were guaranteed complete social security: wages considerably above what was usual in the country and excellent conditions – free catering, a swimming pool, a hothouse, farm and their own amateur music and dance group. The architectural-spatial construction that was created successfully met the task of producing a favourable artificial environment and life-support systems. Even after being abandoned almost twenty years ago, the settlement (which is still the property of a Russian state-owned enterprise) is impressive for the degree to which utopian intentions were actually accomplished.

After the political events involving Russia in 2014, which also had a negative effect on collaboration in the Arctic (Lukin 2014: 54–64; Portsel 2014), the architectural competition focussing on a Russian settlement on Spitsbergen could have been regarded as a challenge to Russia's interests (Osnovy 2008), if it had acquired international resonance in the political sphere.

The *120 hours* 2015 competition and the Russian settlement of Pyramiden on Spitsbergen

The Norwegian architectural competition *120 hours* (five days) was initiated by students of the Oslo School of Architecture and Design in 2010. Its original aim was to create a platform to present projects by Norwegian students to the worldwide architectural community, but it quite rapidly acquired an international character.

The competition is open to students from all over the world, who can enter either as a single person or in teams of up to three working together. (Here and below all information about the competition and projects have been taken from the official site: www.120hours.no.) The participants' intensive work over a five-day period is preceded by discussion in the format of talks or lectures devoted both to the broad cultural, environmental and architectural context of the chosen object, which has not yet been announced to the entrants, and issues relating to the development of contemporary architecture as a whole. More talks follow at the end. As can be seen from the competition results, it is precisely these discussions that determine the vector of the majority of projects, and their content can be sensed fairly easily. The jury invariably includes someone from the faculty of the Oslo School of Architecture, a representative of the student body and a couple of international experts who are practicing architects.

The first competitions were directed towards solving local problems within the city that were being actively discussed by its citizens and the professional community. This sort of practice is typical generally for teaching projects in architecture. The twentieth century provides us with many examples of a practicing architect who also taught setting his students as exercises projects on which he himself was working, participating in a real design competition. The most outstanding

example is the Constructivist Ivan Leonidov's brilliant graduation project for the Lenin Institute of Library Science in Moscow (1927). Anyway, in 2011 the location offered to the entrants was Tullinløkka, an open space in the centre of Oslo; in 2012 they were asked for a "long-term strategy" for an internal courtyard space; in 2013 for the design of a dock in Geiranger fjord; in 2014 the theme was "sustainability" in a parkland recreation zone.

The 2014 event already attracted considerably more entries, submitted from around the globe, and for the first time the competition website presented not only the projects that took the top three prizes but also another ten given an honourable mention by the jury and the remaining more than 600 submissions.

In my opinion, the 2015 event played a special role in changing and expanding the framework of the competition itself. Up until that time, the proposed tasks were in essence confined to a single construction. Now, though, the choice was a whole urban organism in a unique geographical location with an eloquent past and a history in literature and film.

The theme chosen for 2015 was "Experimental Preservation". The organizers promised: "The assignment will challenge you to redefine the traditional concepts of preservation, to question existing frameworks and experiment beyond established rules." The jury, too, this time included not only practitioners and teachers of architecture but also an exhibition curator specializing in contemporary art. So, the project moved beyond the limits of just specialists "talking shop", and the stage was set for multipolarity and multiple vectors in the forthcoming entries. The striking and imagination-stirring nature of the object and the international topicality of the theme encouraged an expansion of the range of competition entrants. In the 2015 section on the website, we find no fewer than 725 fully completed project proposals.

It is no coincidence that the choice as the focus for the participants' ideas and efforts fell on the Soviet coal-mining settlement of Pyramiden on Spitsbergen, presented as a ghost town. Its mine was closed in 1998. The settlement was shut down and effectively abandoned. The cold dry climate strongly retards decay, but things left in the building were systematically looted by delinquent visitors. Since 2007 the Russian state-owned Arktikugol' group, which still owns the vacated settlement, has been making efforts to turn it into a tourist sight and base with a hotel for excursions in the picturesque surroundings.

The central area of the settlement took the form of a strongly elongated rectangle covered with a lawn, something unique above the Arctic Circle. Either side of it were the residential blocks (for men, women and families), a house of culture (community centre), a canteen and other buildings (Fig. 13.1).

The largest buildings were five-storey blocks of the mass housing type common back in the Soviet Union. Besides designs for linear towns, the Mall or Champs-Élysées, as the inhabitants called these, evoke persistent associations with Lúcio Costa and Oscar Niemeyer's Brasília.

An enduring symbol of the place is its industrial transport installation: a cableway raised high on wooden posts for the great buckets that carried the coal from the mine down the slope of the mountain. Among the identifiable landmarks are

Figure 13.1 The Pyramiden settlement, Spitsbergen. Photograph by Per-Erik Skramstad, 2010.

a monument in the form of a portrait bust of Lenin set on a pedestal gazing at a glacier and the stepped-spire monument with the Pyramiden name-sign in Russian and Norwegian and the last load of coal extracted at its base.

Architectural structures, even abandoned ones, are elements of the cultural space. That is to say, besides their functional, constructional and aesthetic qualities, they continue to be the bearers of a host of meanings, symbols and ideas. By forming shapes, architecture organizes space in which "the values adopted by the society become materialized" (Ikonnikov 2006:11). Due to its permanence and obviousness, architecture predominates over a culture's other means of communication or "symbolic forms". In a number of the projects, we shall see how entrants translate the existing structures into the category of symbols.

Many projects play on the idea of the Arctic as a frozen (in a literal and metaphorical sense) part of the planet, devoid of history, where everything remains eternal and unchanged. The erroneousness of this belief has been shown by Emmerson, who predicted that the role of the Arctic will grow in such highly important aspects of our common future as energy security, climate change, globalization and the balance between economic development and environmental protection (Emmerson 2010). Other popular lines proved to be interpretations and connotations relating to the literary world of magic realism from Kjartan Fløgstad's 2007 book *Pyramiden: Portrett av ein forlaten utopi* and fantasies on the theme of the episode about the place in the History Channel's *Life after People* series.

Spitsbergen's real-life situation also dictates unusual approaches.

Hans Peter Blankholm formulated the current threats – "climate change (melting of the polar ice and rising sea levels; decreasing permafrost; wind erosion; re-growth) and human impact (demographic influx, economic expansion, atmospheric pollution, petro-industrial and mineral exploitation, hydroelectricity, fishing industry, tourism and recreation" – faced by the Arctic's archaeological heritage, and also cultural resource management strategies of open information and interdisciplinary dialogue that should undoubtedly be extended to cultural heritage as a whole. Blankholm considers the most important of these to be "to strengthen continuity and development of archaeological research, education, and public outreach in the Polar regions of the World; to promote dialogue and collaboration between researchers and the public; to facilitate the development of methodological and theoretical directions; and to enhance awareness of research on cultural resource management and the protection of sites and monuments in the Polar regions" (Blankholm 2009:24).

The realities of the constructions' existence in the Arctic, along with other, natural peculiarities of the locality (a concealed on-going endogenous fire in the mine; the encroachment of the islands' native fauna – polar bears and birds – into the habitat deserted by humans) provided a starting point for many entrants.

Meanwhile, the law on environmental protection in force on the Svalbard archipelago states that traces of human activity on the island, *from 1945 onwards*, are protected and form part of the cultural heritage of the territory.

The 2015 winners and innovative approaches to the idea of preservation

The winner in 2015 was a project entitled *Remember work?* by Jarand Nå and David Ottosson, both from the Lund School of Architecture. The annotation for the project, which is its strongest feature, pragmatically conveys a message about the need to preserve the memory of the colossal amount of human labour invested, irrespective of its character – forced or altruistic: "Work is at the heart of politics and restauration [sic]." The authors propose combining two approaches to perpetuating the memory of labour. "One way to memorialize work spatially is to put in additional work to preserve it. This creates a potentially endless, recursive loop, one which can give a positive sentimental experience – but one we feel Pyramiden perhaps doesn't need. Another way to commemorate work spatially is to re-enact it." The shock-workers mining coal should be replaced by "a repurposed industrial robot, that might be reprogrammed to work in hospitality, curation, or to maintain a video feed" moving around a continuous star-shaped track (Fig. 13.2).

Second place went to *Axis of Pyramiden* by a team of three from the Czech Republic – Matyáš Švejdík, Marek Nedelka and Pavel Špringl – for the idea to "leave the place to live its own life, we leave it to the birds, foxes, polar bears and few lost ar[c]tic wanderers, for whom Pyramiden is going to be a small laboratory". They proposed preserving a virtual image of the settlement, by creating

Figure 13.2 The winning project of *120 Hours* 2015 Experimental Preservation – *Remember work?* Jarand Nå and David Ottosson (Lund School of Architecture). Source: www.120hours.no.

a light installation based on its existing town-planning axes (from the centre to the harbour and centre to the mine) with several beams forming the edges of a gigantic pyramid visible from space. They saw the non-material character of their method of preservation as being analogous to the *120 Hours* architectural competition (Fig. 13.3).

The third-placed entry *The Frozen Dream of Pyramiden* by Hong-Anh Do and Hoang-Anh Tran (Ecole d'Architecture de Paris, France) modernizes Viollet-le-Duc's conception of conservation that should be accompanied by an improvement of the object being preserved. They also regard the *120 Hours* 2015 competition itself as "one of the media technique[s] to bring the non-physical value of Pyramiden to society". In their project, the pair would seek to get the media involved "to attract attention to Pyramiden" by having journalists experience the harsh conditions of life on an expedition while shooting a month-long reality television programme at the settlement.

Since 2014, the jury has also selected ten more noteworthy projects, which as a rule represent either the main tendencies or the most original solutions. They stand out for their interdisciplinary character and reflect various approaches to the idea of preservation, from traditional to radical: conservation, maintenance, modernization, replication, inventory-taking, cataloguing and more.

In the installation *Vanished into thin air . . .* by Agnieszka Lewicka, Monika Frydryszak and Michał Witkowski (Warsaw University of Technology, Poland, Fig. 13.4), seamless mirrors covering the façades of several of the large buildings reflect the untouched landscape and symbolize the sudden historic disappearance of such a political giant as the Soviet Union and of the settlement of Pyramiden together with its inhabitants.

In *Pyramiden. Polar Bears. Preservation?*, Dominic Walker, Deborah Adler and Tim Rodber (University of Sheffield, UK) decide that we need to protect Pyramiden from humans and leave it to the bears: "If bears cannot reproduce fast enough they may need a hand (pun intended). Why not clone the polar bears in the newly build lab?"

The Catalogue, a project by Gabriel Wulf (Architectural Association, UK), proposes taking an inventory, by dismantling and sorting out the components of the existing buildings: "Rethinking the value of the physical substance, the actual materials of the buildings as originals, containing memory and cultural value . . . Taking apart the existing buildings, and arrang[ing] their materials on the former footprint of the building, a collection, an inventory of the past is created. Catalogued, rearranged, and re-sorted, these stacks of materials open up the possibilities of reimagining and re-memorizing the past in the present. And at the same time, the newly created collection creates a spatial experience and inspirational source. On a stroll through the town, every building will be represented in its individual way. Like this, a former wooden structure, catalogued as piles of mostly wooden elements triggers the imagination and experience in a completely different sense than the piles and stacks of a stone building. . . . [T]he catalogued inventory represents a new beginning, laid out as source materials for future development and ideas."

Figure 13.3 The second prize of *120* Hours 2015 Experimental Preservation – *Axis of Pyramiden*. Matyáš Švejdík, Academy of Arts, Architecture & Design in Prague; Marek Nedelka, Technical University of Liberec; Pavel Špringl, Technical University of Liberec, Czech Republic. Source: www.120hours.no.

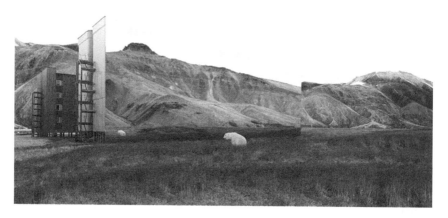

Figure 13.4 The Polish project that received an honourable mention at *120 Hours* 2015 Experimental Preservation – *Vanished into thin air* . . . Agnieszka Lewicka, Monika Frydryszak and Michał Witkowski (Warsaw University of Technology, Poland). Source: www.120hours.no.

Before the material remnants of Pyramiden become lost due to the melting of Svalbard's permafrost and glaciers, Martin Henseler, Marc Timo Berg and Lucas Becker (BTU Cottbus-Senftenberg, Germany) propose saving its spirit for posterity by *Translocating Pyramiden*: "By casting the outer shells of the buildings in concrete, the volumes and textures are preserved. The encased buildings will be translocated to all 41 signatories of the treaty. We want each state to have [its] own share of the cultural artefact from Pyramiden before it is disappearing."

In the project *Ruin of the Immediate Present*, Rebecca Ploj, Liam Denhamer and Anya Martsenko (AA School of Architecture, London) suggest celebrating "the 'failure' of Pyramiden, re-inventing it as a ruin, a place of pilgrimage dedicated to aesthetic admiration", along the lines of Piranesi's *Scenographia Campi Martii*.

In *Preserver Preserved*, Bennett Oh, Mark Wang and Wayne Yan (University of Waterloo, Canada) propose moving the fertile soil, which was at one time brought from the mainland and provided fruits and greenery for the inhabitants' enjoyment, "into the existing architecture as an initial gesture of safekeeping. By seeding the buildings with the potential for life, this intervention allows us to document the existing layout of the site while creating a radically new interpretation for the function of these buildings in the future."

The Finnish project *Tapis vert* by Johanna Brummer and Heini-Emilia Saari (Aalto University School of Art, Design and Architecture) suggests that the signatory countries of the Svalbard Treaty jointly take care of the lawn grown artificially on imported chernozem soil, each watering its own section as a mark of dedication to the future.

The hypothesis of Jessica Jiang, Sun Jae Choi and Helena Rong (Cornell University, USA) is that "destruction, adaptation, and preservation are symbiotic

subsystems. [Their project] *superCloud* proposes the construction of a data center, infrastructure for server farms that handle internet traffic, that archives the memory of Pyramiden and then imposes this new programmatic order on the site."

The most radical method suggested for preserving the memory was to set a date – 20 February 2015 – invite guests and burn the settlement down in an eye-catching way, as Nero once did with Rome. *Pyramiden on Fire* was proposed by Sixuan Li, Kun Ma and Ya Liu (University of Sheffield, UK). This piece of performance art would be intended to "remind us to introspect current action in architectural preservation".

Russian proposals

For the first time in 2015, a Russian project, *Imprint*, was among those receiving an honourable mention. Anvar Garipov, Lyubov Timofeeva and Radmir Gelmutdinov (Ural State Academy of Architecture and Arts) ponder upon what is more important to preserve – the material or the content, whether there is a difference between copy and original in post-modern culture. Their idea lies in preserving the contrast between the naïve idealistic creation of the human being (the urban structure) and the magic of nature, enhancing it by the creation of a new precise grid of raised walkway-streets. Such a human creation, whatever its ultimate fate might be, will testify to outer space about the presence of our species (Fig. 13.5).

More than 40 projects from Russia are featured on the site. Most strongly represented is Kazan State University of Architecture and Engineering with 17 entries, while others come from students of architecture in Moscow, St Petersburg, Saratov, Nizhny Novgorod, Yekaterinburg, Tomsk and Rostov-na-Donu.

The very attractive and highly romantic project *Stars and Constellations* from Polina Shtanko and Xenia Bylinina (Moscow Architectural Institute) suggests covering the mountainside and bay in a myriad of little lights to make it seem that the polar sky has come down to Earth. *The City of 1000 Pyramids* by Maria K (Moscow Architectural Institute) covers the mountainside with a host of pyramids encasing both preserved and new structures. *The Town Frozen in Time* by Ilsiyar Rakhimova (Kazan) repopulates the settlement with concrete statues of its former inhabitants, the miners and their families. The cableway inspired students from Saratov to create a big-dipper-type "fairground ride" in the project *Energy for Conservation* and a glazed promenade in *The Melting Way*.

Some of the entries conceive of Pyramiden as a place where many people have been happy. *Sky Village* by a team based in St Petersburg – Ivan Mylnikov, Anna Kutilina (Russian Academy of Fine Arts) and Ivan Karnitskii (Saint Petersburg State University of Architecture and Civil Engineering) – suggests creating new living and working spaces in floating airships.

The project *Medics of Pyramiden* by Karina Ashrapova (Kazan) proposes recognizing the cyclicality in the development of the place and populating it with hermit monks devoting themselves to meditation. *Peace! Labour! May!* by Alena Pavluk (Moscow State University of Civil Engineering) calls for role-playing, acting out a May Day procession on location. *Lenin, salute!* by Leilya (Kazan)

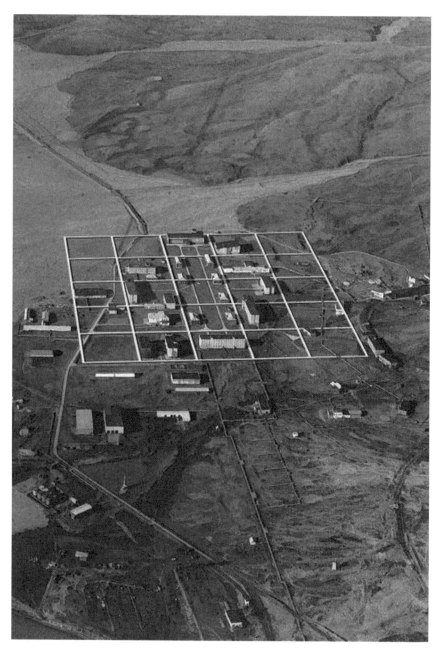

Figure 13.5 The Russian project that received an honourable mention at *120 Hours* 2015 Experimental Preservation – *Imprint*. Anvar Garipov, Lyubov Timofeeva and Radmir Gelmutdinov (Ural State Academy of Architecture and Arts, Yekaterinburg).

suggests bringing statues of Lenin from all parts of the former USSR and arranging them like in the Museion sculpture park on Krymsky Val in Moscow, while *A Masoleum* (sic) by Diana Bibisheva (Kazan) proposes re-creating the shape of the Lenin Mausoleum in Red Square around the monument to Lenin in Pyramiden.

In *The Town of Eternal Happiness*, Alisa Silanteva (Kazan) suggests giving the place to different countries for 30 years at a time, so that each of them uses it to hold its own celebration and to create its own utopia but then at the end of its time takes everything away so as to hand over the site to the next state just as it was. The project *The Mystery of Pyramiden*, by Darya Kozlova and Maria Shapchenko (Saint Petersburg University of Architecture and Civil Engineering), presented in comic-book style, turns the settlement into a setting for role-playing games and interactive entertainments, with the money raised from them going towards the restoration of the buildings. The project *Pyramiden Cinema* by Gulfia Kutlahmetova (Kazan) turns the buildings of the settlement into sound stages for a film studio. *Ice Town* by Valeriya Miftakhova (Kazan) calls for a fashion week once a year to breathe life into the settlement. The project by Arseniy Tyurin, Maksim Mikhailov and Nadezhda Luchinkina (Nizhny Novgorod State University of Architecture & Civil Engineering) called simply *Pyramiden* proposes creating an Internet site that tells about the history of each building with the aim of raising money for the restoration of, for example, the sports arena.

In *Black Hole*, Daria Nasonova and Pavel Nasonov (Moscow Architectural Institute) propose installing several small particle accelerators in each building that will preserve past reality for us at the site, using the supposed properties of black holes, while Liliya Kucherenko (Southern Federal University) with her *Ice Piramid* (sic), suggests preserving the buildings like mammoths using cryo-technology, placing each of them within a non-melting cube of ice linked to its neighbours by clear galleries. *A ghost-town "pyramid". The town without people. The town of birds* by Milyausha (Kazan) calls for bird-boxes to be put up all over the settlement's buildings.

The number of entries was very high, and so I have had to restrict myself to just a few that, perhaps subjectively, seemed the most striking.

It is pleasing to see that students representing all Russia's leading architectural institutions of higher education have become involved in international competition activity. It is obvious that the entrants do carefully study the competition rules and listen to the lectures provided. Unfortunately, though, in this 2015 competition, in which participants from Russian might have gained an advantage from their knowledge and understanding of the specifics of Soviet architecture, that potential was not exploited. The Russian projects stood out little among others produced with talent and at a fairly high professional standard. Only in a few, including the one given an honourable mention, can one detect a distinctive tradition. In saying this, let me note that representatives of prominent European architectural institutions do to a large extent retain the distinctive character of the national achievements of their own architectural schools. An identifiable set of French, British and German projects directly draw upon, interpret and update aspects of European architectural theory, including restoration theory in its historical aspect. Entrants evidently drew upon the ideas of Piranesi, Winckelmann,

Viollet-le-Duc and Le Corbusier, the modernist icons of Tatlin, Buckminster Fuller, Pei (the Louvre Pyramid) and Niemeyer. In Scandinavian and Finnish projects the emphasis is most often on preserving the ecological environment.

Very many became enchanted with the magic of a utopia, a striving to preserve its spirit or its content. A distinctive feature of the 2015 competition was the predominance of an approach to the architecture structure(s) as a piece of contemporary art: an art object, an installation, a performance, a show. This, too, was preordained by the competition organizers, among other things by inviting onto the jury not just experts on architectural issues – the architect Julien De Smedt, known for his works in Oslo (Holmenkollen Ski Jump) and Århus; Maria Fedorchenko, who teaches the re-programming and transformation of the historical centres of Russian cities (Architectural Association School of Architecture in London) – but also Pernilla Ohrstedt, an author of the *Future Memory Pavilion* commissioned by the Preservation of Monuments Board in Singapore and a curator of the Canadian Pavilion at the 2010 Venice Architecture Biennale.

The overwhelming majority of projects did not make use of actual experience of construction in Arctic conditions, problems of design and materials that have been actively tackled by the engineers of Arctic countries from the second half of the twentieth century onwards. It would be very desirable for the results not to become a cause of controversy, but, on the contrary, strengthened collaboration between Russian and Norway and would be to the benefit of the Russian settlement of Piramida-Pyramiden that still exists on the map of Spitsbergen. Without a doubt, this brainstorming exercise for young minds should also be of benefit to their teachers and practicing architects who encounter a similar task.

In any event, this competition provides a very interesting cross-section for analysis in various fields in and around architecture – and an occasion to ask many questions, both national and global. What is being taught in architectural higher education in different parts of the world? How is the vision of architecture changing, and what new tasks is the architectural rising generation setting itself? Is there a danger of architectural extremism emerging from the extremism in contemporary society?

We have received several hundred answers to the question, what is "experimental preservation" in Arctic conditions, but can we say that we have found the right one? It seems unlikely.

References

Blankholm, Hans Peter (2009). "Long-Term Research and Cultural Resource Management Strategies in the Light of Climate Change and Human Impact". In: *Arctic Anthropology*, Vol. 46, No. 1/2, The Tops of the World, pp. 17–24.

Emmerson, Charles (2010). *The Future History of the Arctic*. New York: Public Affairs.

Ikonnikov, Andrei (2006). *Prostranstvo i forma v arkhitekture i gradostroitelstve* [Space and Form in Architecture and Urbanism] Moscow: Kom-Kniga

Lukin, Iurii (2014). "Sovremennaia situatsiia v Arktike v kontekste globalnykh trendov" [The Present Situation in the Arctic in the Context of Global Trends] In: *Arktika i Sever* [*The Arctic and the North*], No 16. pp. 41–71.

Osnovy gosudarstvennoi politiki Rossiiskoi Federatsii v Arktike na period do 2020 goda i dal'neishuiu perspektivu [Fundamentals of State Policy of the Russian Federation in the Arctic for the period until 2020 and beyond] (signed by the President of the Russian Federation, 18 September 2008) https://rg.ru/2009/03/30/arktika-osnovy-dok.html. Accessed 12 March 2017

Portsel, Alexander (2011). "Spor o Shpitzbergene: tochka ne postavlena" [The Dispute Over Spitsbergen: The Issue Is Not Yet Settled]. In: *Arktika i Sever [The Arctic and the North]*. No 3. pp. 1–22.

Portsel, Alexander (2014). "Shpitsbergen, norvezhskaia strategiia v Arktike i interesy Rossii" [Spitsbergen, Norwegian Strategy in the Arctic, and Russia's Interests] In: *Arktika i Sever [The Arctic and the North]*. No 15. pp. 109–124.

Riabtsev, Vladimir (2015). "Arktika kak novyi (formiruischiisia) geopoliticheskii region" [The Arctic as a New (Forming) Geopolitical Region] In: *Sovremennaia nauka i innovatsii [Contemporary Science and Innovations]* No 3 (11). pp. 158–165.

Terebikhin, Nikolai (1993). "Sakral'naia geografiia Russkogo Severa: religiozno-mifologicheskoe prostranstvo severnorusskoi kul'tury" [The Sacred Geography of the Russian North (The Religious-Mythological Space of North Russian Culture)]. Arkhangelsk: Pomorsky University Publishing House.

Zinger, Evgenii (1975). *Mezhdu polusom i Evropoi.* [Between the Pole and Europe] Moscow: Mysl.

Index of names

Index of places